WRITING FOR ART

Manchester University Press

Writing for art

The aesthetics of ekphrasis

Stephen Cheeke

Manchester University Press
Manchester and New York
distributed exclusively in the USA by Palgrave Macmillan

Published by Manchester University Press
Oxford Road, Manchester M13 9NR, UK
and Room 400, 175 Fifth Avenue, New York, NY 10010, USA
www.manchesteruniversitypress.co.uk

Distributed in the United States exclusively by
Palgrave Macmillan, 175 Fifth Avenue,
New York, NY 10010, USA

Distributed in Canada exclusively by
UBC Press, University of British Columbia, 2029 West Mall,
Vancouver, BC, Canada V6T 1Z2

British Library Cataloguing-in-Publication Data is available

Library of Congress Cataloging-in-Publication Data is available

ISBN 978 0 7190 8324 2 paperback

First published by Manchester University Press in hardback 2008

This paperback edition first published 2010

Printed by Lightning Source

For Suzy

CONTENTS

ILLUSTRATIONS

Photographs © the museum or gallery unless otherwise indicated.

ACKNOWLEDGEMENTS

A SMALL SECTION of Chapter 8 was first published in the *Keats–Shelley Journal* (2007) and I would like to thank the editors for their permission to reproduce that extract here.

I would like to thank Faber and Faber Ltd for permission to quote extracts from T.S. Eliot's *Burnt Norton*, Randall Jarrell's 'The Old and the New Masters', extracts from Samuel Beckett's *Endgame*, W.H. Auden's 'Musée des Beaux Arts', John Berryman's 'Winter Landscape', Thom Gunn's 'Song of a Camera', Philip Larkin's 'MCMXIV', Ted Hughes's 'Fulbright Scholars' and 'Perfect Light'. Thanks to Lorna Dodds at Faber for persuading them to knock the price down a bit. Thanks to Macmillan, London, for permission to quote extracts from Don DeLillo's *White Noise*. The extracts from *Mao II* by Don DeLillo, published by Jonathan Cape, reprinted by permission of the Random House Group Ltd. Lines from 'Self-Portrait in a Convex Mirror', copyright © 1974 by John Ashbery, from *Self-Portrait in a Convex Miror* by John Ashbery, used by permission of Viking Penguin, a division of Penguin Group (USA) Inc., and Carcanet Press Ltd. Thanks to Carcanet Press Ltd for permission to quote William Carlos Williams's 'Landscape with the Fall of Icarus' and 'The Hunters in the Snow' from *The Collected Poems of William Carlos Williams: Volume II 1939–1962*, ed. Christopher MacGowan (Manchester: Carcanet, 2000). Wallace Stevens, 'Anecdote of a Jar' and lines from *The Man with the Blue Guitar*, first published by Alfred A. Knopf Inc., New York and Random House of Canada, reproduced by permission of Pollinger Limited and the proprietor, and Faber and Faber Ltd. 'Courtyards in Delft' by Derek Mahon reproduced by kind permission of the author and The Gallery Press, Loughcrew, Oldcastle, County Meath, Ireland, from *Collected Poems* (1999). Reprinted by permission of Farrar, Straus and Giroux, LLC: 'Winter Landscape' from *Collected Poems: 1937–1971* by John Berryman.

I would also like to thank the Bristol University Arts Faculty Research committee and the Bristol Institute for Research in the Humanities and Arts for their help in completing this book. Particular thanks to Professor Tim Unwin and Professor David Punter.

I am especially grateful to Stephen James, who read an early draft with great care, improved my writing and responded to my arguments with his own insights. Donna Maclean first made me notice the link between photography and contemporary elegy. I'm very grateful to the following people among friends and colleagues who offered general support and encouragement: Elizabeth Archibald, Andrew Bennett, Michael Bradshaw, Lesel Dawson, George Donaldson, Naomi Fowler, Helen and John Hockenhull, David Hopkins, John Lyon, Tom Mason, Elizabeth Prettejohn, Ad Putter, Matthew Ray and Timothy Webb. My thinking was shaped in conversations with students, and I would like to thank all those who have sat with me over the last three years. Matthew Frost at Manchester University Press has been warmly supportive of the project from the very beginning. Thank you to Ranulph Redlin and the two readers at MUP.

My greatest debt is to Suzy Hockenhull who has helped with everything. My experience of art and ekphrasis has been shared with her.

INTRODUCTION

I T I S B E S T not to lose sight of the obvious differences between poetry and painting, their great unlikeness: 'In its imitations painting uses completely different means or signs than does poetry.'[1] If the force of this is so often resisted it is because *complete* difference is hard to conceive – there is always some path of comparison. But the common sense of the statement is worth keeping in mind: poetry is not painting; *ut pictura poesis* is only ever a partial, explorative truth. And from this it might seem like perfect sense also to observe that 'one art does not attempt what another can do better'.[2] A sensible person might prefer to leave the discussion there.

The second statement is helpful though only in so far as it is clear what a painting does better than a poem (and vice versa), and poems about paintings are always partly about discovering what that is. The poem may attempt to reproduce the supposed advantage of the rival art in its own medium, which is of course to deny or steal that avowed capacity – however it is defined. And while any reader might be impatient with the idea that a poem could be a better picture than a painting, since this would be possible only if we take 'picture' as a metaphor, in variously complex ways poems about paintings are testing the strength of that metaphor. Is 'picture' itself, in fact, ever anything other than a figure? In a literal sense, the impossibility of ekphrasis – the doom of an ultimate and inevitable failure, the absurdity or unnaturalness in writing a poem for a painting – seems obvious to all those who approach the task, and yet this understanding has not acted as a deterrent at all. Critical writing everywhere also sounds the warning: how can poetry hope to represent, describe or reproduce painting? How can literary language find a parallel or an analogy with art? How could we conceive of a poet being *successful* in his or her attempt to write about a visual representation? 'The relation of language to painting is an infinite relation', writes Michel Foucault:

It is not that words are imperfect, or that, when confronted by the
visible, they prove insuperably inadequate. Neither can be reduced to the
other's terms: it is in vain that we say what we see; what we see never
resides in what we say. And it is in vain that we attempt to show, by
the use of images, metaphors, or similes, what we are saying; the space
where they achieve their splendour is not that deployed by our eyes but
that defined by the sequential elements of syntax.[3]

Despite these kinds of warning, the practice of addressing works of art
in poetry is an ancient one, and widely indulged in recent decades. Indeed
it seems as if the pairing of poems for paintings is more or less obligatory
in the work of contemporary poets – and it is obvious that this has been
the case for a while. Edna Longley's essay of 1992 'No More Poems about
Paintings?' began by quoting Kingsley Amis's declaration of 1955 that 'nobody
wants any more poems about paintings ... or art galleries'.[4] But they kept
coming. Various explanations have been offered for this: that there has been
a pictorial or visual 'turn' in contemporary culture and that the immersion of
poets in the 'image-world' has produced a corresponding struggle to render
or control the image verbally; that there is a certain stability or accessibility
inhering in the artwork as object, particularly the object in the museum or
gallery, which makes it appear available to literary representation in a world
of more general epistemological crisis and despair; or, less grandly, that there
is a laziness in contemporary poets who discover in art a subject ready-made
(and a fashionable one to boot), and whose experience of the painting or the
sculpture, the foreign holiday of gallery visits, is largely that of the tourist.[5]
Whatever the cause, the phenomenon is assured, and this present book is a
symptom of it.

The first point to make then is that writing for art exists and thrives under
the knowledge of failure, indeed seems to be spurred on by the certainty that
there is something hopeless in what it is attempting to do. This fact might
seem only marginally interesting in and of itself however. What I have found
more stimulating are the larger questions and problems prompted by the space
between poetry and painting, the gap between language and the visual image.
How to understand the nature of this gap not merely as an abstraction (as
'failure' or as a 'site of ambivalence') but in the particular form it takes between
specific poems and paintings? For anyone who grew up in a household with
sisters of proximate age the usefulness of the metaphor of the 'sister arts'
will be clear. Envy, rivalry, emulation, quarrelling, imitation – the ordinary
human trouble of kinship helps to make some sense of, even if it can never

clarify, the awkward intimacy and reserve that we discover between poems and paintings.[6] The relationship is difficult, perhaps even unhappy, and the present book hopes to comprehend that difficulty by connecting it to the larger questions and problems which frame the subject, and which I shall argue belong to the category of the aesthetic, broadly speaking.

The 'category of the aesthetic' is of course a monster-term broad enough to cause consternation. I am neither a philosopher nor an art theorist and, even though literary studies in recent years have welcomed the return of the aesthetic, the venturing of this word still seems to require an explanation. The type of problems and questions which recur in conversations about ekphrasis in teaching the subject seem to belong to wider and sometimes more philosophical lines of enquiry than previous studies have acknowledged.[7] Indeed this book will argue that in many cases poems for paintings offer a particularly sharp focusing of questions which have traditionally been treated as aesthetic – recognising that the aesthetic is a protean notion especially apt to escape attempts at inter-artistic focusing. But in some respects the nature of aesthetic experience is always explored when a poet writes about visual art. And the best poems for paintings are themselves works of art, offering a commentary upon or an interpretation of an artwork that is simultaneously open to interpretation or appreciation as an artwork in its own right. In the strongest examples of ekphrasis there is always therefore a sense of extension or enlargement, but one which brings with it a pressure to discriminate and differentiate between the two media, the two kinds of experience. To help clear the ground of the aesthetic category for the plastic arts philosophers sometimes distinguish an object or content-oriented approach from an affect-oriented emphasis – concentrating upon what the work is *about* as distinct from what reaction the work produces in a viewer, or vice versa. With poetry for paintings it is less easy to make such a distinction because the multidi-rectional lines of reception between poem and painting, reader, poet and artist, complicate this model. When we read a poem for a painting what exactly is our object, and what is our affect? What, exactly, is being represented? The kinds of formal, rhetorical or generic characteristics I identify suggest that there are things common to poems of ekphrasis that can be usefully contemplated – things that ekphrastic poetry tends to be about. But these characteristics cannot be separated from the notion of a reader, who may also be in this case a viewer of the artwork (as the poet has also been a viewer). In this sense then the 'aesthetics' of my subtitle also indicates an affect-oriented enquiry (or multi-affect) and takes us back to the root meaning in Greek of an act of perception, a sensory response, literally a 'breathing or taking in' (*aisthesis*).[8]

What kind of sensuous understanding is offered by a poem for a painting? What kind of knowledge of the artwork is possible? Do these poems help to reveal or conceal their objects? Do they reveal or conceal the original objects represented by the artwork? And how does the reader/viewer in turn *take in* a poem for a painting – how do the several overlapping acts of perception fit together? The reader whose inspirations I have ideally imagined for this book would be someone looking for a brief introduction to the subject who has felt a particular curiosity in reading poems for paintings, or 'literary' prose descriptions of artworks. Someone who may have found that it is more stimulating to look at paintings alongside a verbal description – and especially one that is, as it were, creative in its own right. This inclination to match the visual with the verbal whenever possible does not necessarily betray a limited approach to picture gazing, but has something in common with the first impulse of art criticism to describe its object. The division between the rhetoric of art criticism and the poetry of ekphrasis is only a matter of degree. And whether the visual may be thought of as a category available to any kind of pre- or non-verbal understanding, whether it is ever possible to encounter artworks meaningfully without words – we would require words to tell us how to do so – is a question still debated by art theorists.[9] The struggle between word and image from which the question derives is a central subject of this book.

But the 'category of the aesthetic' will always incur more than appears at first sight. In teaching the poetry of ekphrasis I have found that the conversation with students quickly arrives at the largest kind of questions imaginable: of beauty and truth, time and eternity, will and agency. I have attempted to reproduce that rapid ascent without becoming either too cagey or too unreflective about the big terms with which the subject is burdened. The central question is one of representation, or more specifically of the verbal representation of visual representation.[10] How do poems for paintings engage with the visible, the visual, with the image, as these are represented or embodied in artworks? How do they respond to the visually beautiful? The question (some would say the problem) of 'beauty' has a feverish life in the nineteenth and twentieth century that can be traced through a series of writings about art: in poems for paintings or art objects, in dramatic monologues written for artists, and in the doctrines of Aestheticism. There is a parallel argument concerning the nature of the 'real' and the proper relation of art to the 'real' that can also be seen unfolding across those two centuries, and which is often connected with writing about visual art. In the rivalry between poetry and painting there is always the fundamental question of

which medium comes closest to rendering the 'real', and how the very nature of the 'real' is contested and described in the encounter between the two. Related to this is the problem of representing the reality of suffering – which arguably lies at the centre of the 'real' – the limits to such representation, and the argument between poems and paintings about these limits. Is there an analogy between the muteness of painting, its dumb materiality, and the insentience of the object-world in relation to human pain? Or is there something more profound to be understood about the nature of suffering in the kind of witness offered by pictures, and rewitnessed by ekphrastic poems? A congruent problem is the nature of the unreal, or of illusion. Here I have concentrated upon the significance of the illusion of a work of self-portraiture, an experimental work from the late Renaissance, for a contemporary poet who is seeking to construct his own self-portrait – a verbal portrait grounded in scepticism about the possibility of self-representation, whether in paint or print. If the self is in part constituted by an alterity that refuses representation, is this most apparent in the illusoriness of a painting or in that of a poem?

Perhaps the most cogitated of all aspects of the subject is the traditional binarism of space and time: the distinction between the sister arts (made most boldly by Lessing in the eighteenth century) which ascribes painting to the spatial realm and poetry to the temporal, and which denies their ability to cross over. This means firstly that the notion of a transcendent or eternal realm of 'Art' is interrogated by the temporal and historical dimensions of the poem. The kind of 'immortality' offered by the unchanging nature of the artwork may be specious, and yet the poet is nevertheless transfixed by its promise, or bewildered by its paradoxes. More significantly perhaps, poetry opens up the static image to the temporal schema of language, to the 'sequential elements of syntax'. By saying what happens next the verbal description returns the picture to the world of narrative and agency, often revealing an ethical dimension – a moral pulse, a turn or decision, an occasion of will – that has been suspended in the still moment of the picture. But in what sense can the picture ever be said to escape that ethical or historical life? In what ways does the 'pregnant moment' of the image already partake of agency and adumbrate ethical consequence? A quarrel over the ethical nature of the visual (and in particular of the beautiful) occurs in any serious critique of the ideology of the aesthetic – and particularly in that largely distrustful and materialist reading of the history of aesthetic thinking that has shadowed the subject from its origins.[11] Ekphrastic poems often seem to call out the ideology of the aesthetic in its relation to visual art by making explicit what is disguised or assumed by the image, or what is hidden within the sensuous field of the visual. At

other times they seem to reinforce the mystique of beauty or pleasure by which ideological motivation is enfolded and hidden. During the latter part of the nineteenth century the notion of the 'moment' in art (the single instant of time captured by a picture) is adopted as a paradigm for the cultivation of the individual sensibility of the aesthete: life will be ideally composed of a series of exquisite and art-like 'moments'. And yet this movement from 'Art' towards life-as-art is one carrying obvious ethical danger, principally that of egotism or of the type of self-involvement in which life imitates not only the sensuous richness of the artwork but also its indifference or neutrality. Poems for paintings present these kinds of questions – of the relation between aesthetics and ethics, beauty and politics – in sharp definition.

If the relationship between poetry and painting is best thought of not in terms of sisterly bonds at all but rather as one of radical difference or alterity, then this will take on various manifestations at specific historical moments. The fruits of 'otherness' have been the staple diet of literary criticism for a while now: we celebrate 'difference' and 'otherness', we lament them. Of course 'difference' is not quite the same as 'otherness', but in the present book the fundamental alterity on which the whole subject sits and which (as I've said) seems to go without saying takes contradictory forms. It opens the field to the play of power – often figured in terms of gender politics: the 'male' realm of speech and language seeking to violate the 'female' silence of the image (a paradigm which seems permanently open to question and often to parody). We discover in poems for paintings the pain of an insuperable difference, the rejection or denial of the artwork in the crucible of the poem – the exposure of its ruses. If poems for paintings are paradigms of aesthetic experience, then often this seems to follow the pattern of a fall into knowledge and experience. The poem *knows* something or *tells* something that had been held back by the silent image. But there is also the notion of transgression, of crossing borders, of translation. Sometimes the encounter with alterity takes on a special charge when it is not merely an occasion for the discovery of difference but a place of *relation* and therefore of the possibility of exchange. As such it may be the model for a more positive evaluation of aesthetic experience in terms of recognition or assent. What then do poems and paintings see in each other? What do they give to each other? In what ways is the materiality of painting an 'other' to language? Is there a sense in which the verbal may be said to bring a non-material element (sometimes thought of as a spiritual element) to the carnality of the visual? Is it equally the case that the visual image offers a 'spiritual' or non-material element to the body of language and print? In one sense the visual is undeniably *there* in ways which language can merely envy

and emulate. In another sense, it seems that language is more fundamental and intrinsic – more constitutive of interiority – than the world of appearance. Which is flesh to the other's spirit?

The present book has aimed to stretch the subject not merely in terms of aesthetic enquiry but also in what we are actually prepared to think of as ekphrastic writing. Interpreting this freely I have included a chapter on poems written for photographs and a final chapter on famous 'literary' prose descriptions of artworks. In the former case, the elegiac nature of photography has had a marked influence on modern poets – particularly elegists – largely because poems for photographs have reengaged the question of the relationship between representation and the 'real'. But at the same time the privileged relation photography has with the 'real' has created some curious problems. Photographs both are and are definitely *not* true memorials. There is always potentially an excess of pathos or irony in the photograph's 'moment', a sentimentality inherent to its calibration of loss, which is a challenge to the elegist. Paradoxically, this emerges from the very 'objectivity' of the medium when it comes to be written about. Can poets resist what seem to be the aesthetic imperatives of photography towards the bitterly, sweetly poignant? And do we discover in photographs of loved ones in particular an 'aura' resistant to verbal reproduction, one which recalls earlier cultic functions of the image – the transformation of which is routinely taken as a marker of modernity? In the case of prose descriptions of artworks – the basic currency of art history – I have attempted to track some of the ways in which famous examples of such descriptions have determined how the paintings they describe have been perceived and received, not merely in terms of how a prose appreciation goes about spreading the glory of an artwork, but in how it may also work as an obstruction to seeing the painting; that is, when the celebrated prose description becomes something like a parasitic or phantasmal presence – a troublesome distorting thing – living upon the surface of the painting itself: Ruskin on Turner, Pater on the *Mona Lisa*. The rhapsodic, sometimes hallucinatory nature of much nineteenth-century art criticism derives from the complex process by which the gallery and the museum come to represent new holy spaces for the worship of art. The chronological scope of this book falls within the parameters of that process, which is still unfolding in our culture.

In risking these kinds of topics I have departed from the pathway of a general historical survey of the subject and have sometimes sought out unexpected pairings of texts and authors. Keats's Grecian urn is linked to the imprisoning urns and funerary jars in the writings of Beckett; Browning's

ventriloquism for Fra Lippo Lippi with Wilde's Dorian Gray and with the solipsism of Nabokov's Humbert Humbert; Don DeLillo's anxiety about photography and terrorism with the nostalgia of Philip Larkin. These connections are intended to sustain my thinking upon a general aesthetic question and to watch it change shape across time, occasionally in texts that are not about artworks. But in each case the connection is intended to be illuminating rather than arbitrary, and to invigorate the central arguments of the book.

NOTES

1 Gotthold Ephraim Lessing, *Laocoön: An Essay on the Limits of Painting and Poetry*, trans. Edward Allen McCormick (Baltimore and London: Johns Hopkins University Press, 1962), p. 78. Lessing's important treatise was first published in 1766. I shall have more to say about its specific arguments in Chapters 1 and 8.

2 The phrase is Hugh Kenner's from *The Pound Era* (Berkeley: University of California Press, 1971), p. 428. Kenner is discussing verbal descriptions of the Tempio Malatestiana in Rimini. On the 'impossibility' of ekphrasis see for example the opening paragraphs of John Hollander's *The Gazer's Spirit: Poems Speaking to Silent Works of Art* (Chicago: University of Chicago Press, 1995), or W.J.T. Mitchell's *Picture Theory: Essays on Verbal and Visual Representation* (Chicago: Chicago University Press, 1994), pp. 152–68. There is more on this in Chapter 1, where I also discuss the provenance and meaning of the *ut pictura poesis* tradition ('as in paintings, so in poems').

3 Michel Foucault, *The Order of Things: An Archaeology of the Human Sciences* (London and New York: Routledge, 2004), p. 10.

4 Edna Longley's essay first appeared in 1992, but is reprinted in *The Living Stream: Literature & Revisionism in Ireland* (Newcastle: Bloodaxe, 1994), pp. 227–51. On the recent (or not so recent) popularity of ekphrastic poetry see also Willard Spiegelman, *How Poets See the World: The Art of Description in Contemporary Poetry* (Oxford: Oxford University Press, 2005), p. 8. A journal taking the title *Ekphrasis* 'focussing on the growing body of verse based on individual works from any artistic genre', founded in 1997, is published twice yearly from Sacramento, California. The passion contemporary poets have for paintings seems to be unrequited – are there any contemporary paintings about poems?

5 The possibility that our culture has suffered a drastic visual 'turn' has been considered (with varying degrees of scepticism) in the work of Mitchell. Most recently he has had this to say about the 'pictorial turn': 'Since this is a phrase that I have coined [in *Picture Theory*], I'll try to set the record straight on what I meant by it. First, I did not mean to make the claim that the modern era is unique or unprecedented in its obsession with vision and visual representation.

My aim was to acknowledge the perception of a "turn to the visual" or to the image as a *commonplace*, a thing that is said casually and unreflectively about our time, and is usually greeted with unreflective assent both by those who like the idea and those who hate it. But the pictorial turn is a *trope*, a figure of speech that has been repeated many times since antiquity.' W.J.T. Mitchell, *What Do Pictures Want? The Lives and Loves of Images* (Chicago: University of Chicago Press, 2005), p. 348.

6 The best discussion of the kinship metaphor is by E.H. Gombrich, *Symbolic Images: Studies in the Art of the Renaissance* (London: Phaidon, 1972), p. 130.

7 The previous studies of the subject I have found most stimulating have been John Hollander's *The Gazer's Spirit* (see above); James Heffernan, *Museum of Words: The Poetics of Ekphrasis from Homer to Ashbery* (Chicago: University of Chicago Press, 1993); Wendy Steiner, *The Colors of Rhetoric: Problems in the Relation between Modern Literature and Painting* (Chicago: University of Chicago Press, 1982); Jean Hagstrum, *The Sister Arts: The Tradition of Literary Pictorialism and English Poetry from Dryden to Gray* (Chicago: Chicago University Press, 1958); Murray Krieger, *Ekphrasis: The Illusion of the Natural Sign* (Baltimore: Johns Hopkins University Press, 1992); Grant F. Scott, 'The Rhetoric of Dilation: Ekphrasis and Ideology', *Word & Image*, 7:4 (1991): 301–10. (More on these in Chapter 1). I have chosen to anglicise the plural of ekphrasis as ekphrases.

8 There are very many general introductions to the subject of aesthetics. Useful for my purposes have been: Noël Carroll, *Philosophy of Art: A Contemporary Introduction* (London and New York: Routledge, 1999); David Maclagan, *Psychological Aesthetics: Painting, Feeling and Making Sense* (London: Jessica Kinglsey, 2001); Peter Osborne (ed.), *From an Aesthetic Point of View: Philosophy, Art and the Senses* (London: Serpent's Tail, 2000); Arthur C. Danto, *The Abuse of Beauty: Aesthetics and the Concept of Art* (Chicago: Open Court, 2003); Anne Sheppard, *Aesthetics: An Introduction to the Philosophy of Art* (Oxford: Oxford University Press, 1987); Berys Gaut and Dominic McIver Lopes (eds), *The Routledge Companion to Aesthetics* (London and New York: Routledge, 2001).

9 For a good summary of the argument between those theorists who would seek to find a visual semiotics (that art is a system of non-verbal determinate signs) and those who would insist on a perceptualist reading of artworks (that art is fundamentally a record of perception, and as such may always be translated into verbal description) see the opening chapter of James Heffernan's *Cultivating Picturacy: Visual Art and Verbal Interventions* (Waco, TX: Baylor University Press, 2006), pp. 1–9. Heffernan's study asks 'why we have no word to denote the visual counterpart of literacy, no word that designates the capacity to interpret pictures' (p. 1). He offers the term 'picturacy' to fill this gap, and makes a strong case for the verbal component to the experience of visual art. 'Just as no poem can be perfectly paraphrased, no painting can be perfectly translated into words ... Nevertheless, words are indispensable to the understanding of pictures. It is not just obvious – banally obvious – that the interpretation of a painting must be

couched in words; it is also clear that any attempt to *think about* the meaning of a painting, about what it signifies, requires them. In my own efforts to understand painting, I need all the verbal help I can get' (p. 6).

10 'Ekphrasis is the verbal representation of visual representation.' Heffernan, *Museum of Words*, p. 3. 'In so far as art history is a verbal representation of visual representation, it is an elevation of ekphrasis to a disciplinary principle' (Mitchell, *Picture Theory*, p. 157).

11 This is a vast subject, and is something which returns repeatedly in the following chapters.

Ekphrasis

I N THE CATALOGUE of the Royal Academy Exhibition of 1864 there appeared a prose piece entitled 'A fragment', written by Robert Browning to accompany Frederic Leighton's picture *Orpheus and Eurydice* (figure 1). Four years later the same words appeared as a poem entitled 'Eurydice to Orpheus' in Browning's *Dramatis Personae*:

Eurydice to Orpheus
A Picture by Leighton

But give them me, the mouth, the eyes, the brow!
Let them once more absorb me! One look now
 Will lap me round for ever, not to pass
Out of its light, though darkness lie beyond:
Hold me but safe again within the bond
 Of one immortal look! All woe that was,
Forgotten, and all terror that may be,
Defied, – no past is mine, no future: look at me![1]

In Greek legend the poet/musician Orpheus, whose singing and lyre-playing enchanted not only humans but animals and plants, rocks and stones, even the immortal Gods, journeyed into the underworld to seek his dead wife Eurydice. There, the beauty of Orpheus's music persuaded Pluto to allow Eurydice to follow her husband out of Hades to return to the living world, on condition that Orpheus not look back at her. On the point of emerging from the darkness of Hades into the light of the world, Orpheus of course looked back, and Eurydice disappeared for ever.

The myth was a popular one for artists in the nineteenth century and

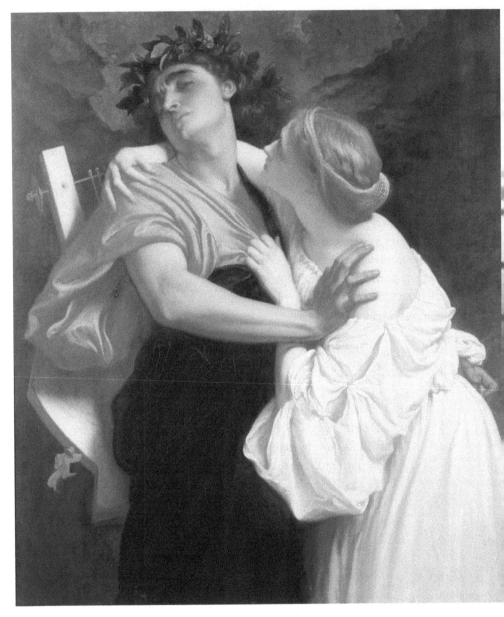

1 Frederic Leighton, *Orpheus and Eurydice* (1864) (Leighton House, London.
Photo: Bridgeman Art Library)

Leighton had already drawn upon the tale in 1856 for a work entitled *The Triumph of Music: Orpheus by the Power of His Art Redeems His Wife from Hades*. The emphasis of the 1864 version is rather different. The painting arrests the story at the instant just before the catastrophe: Eurydice is grasping her husband, as if imploring him to turn around. Browning's poem gives voice to that desire, that moment before the final moment of loss. In doing so the poem does not attempt to describe what Leighton has painted; instead it is written for a figure inside the silent picture, whose desire is simply allowed to speak out. As the painting is itself based upon famous literary versions of the myth, Browning is in a sense returning the painting to a verbal or spoken world, a world left behind or translated in the act of picturing – while there is an irony in the fact that by disappearing Eurydice will in the very next instant leave the world of the visible for ever.

All poems for paintings can be read as commentaries upon the nature of the encounter between the verbal and the visual, or as broad allegories of this relationship. Browning's 'Eurydice to Orpheus' seems a particularly good example of this though since it gives voice to a desire to be *seen* which is fundamental to painting. Eurydice begs her husband to turn around and look at her. In the versions of the myth told in Ovid's *Metamorphoses* and in Virgil's *Georgics* there is no such entreaty; Orpheus simply longs to look at his wife, and finally gives in to this longing. In the Leighton–Browning version this longing is explicitly reciprocal: 'Look at me!' We cannot know whether the demand is made with the knowledge of the consequences (whether her desire to see and be seen by her husband is so overwhelming that she is consciously prepared to die again, as it were, for one look), or whether her plea is in ignorance of the god's condition that Orpheus should not look back. Either way, in the eight short lines of desire given to her by Browning, the urgency of Eurydice's plea is absolute. For Orpheus to look back at her would be for him to '*give*' her 'the mouth, the eyes, the brow!' in the sense of offering her the sight and touch of his own beloved features, and by doing so to make her own body thrill back to life. At the same time the 'look' will somehow fix them for ever within a single moment that never ends or changes, an 'immortal' look analogous to the look with which a painting captures its subject 'for ever', and in which that subject could be said to be neither quite alive nor ever wholly dead. 'One look now / Will lap me round for ever'. To be lapped around by a look, like being framed as a picture, is to have one's existence witnessed and therefore confirmed; to be seen thus by a lover is to be absorbed and protected, to have the distance between the two disappear. (There is a faintly erotic pun on *lap*.) And yet

is this 'for ever' really something to be desired? Can *one* look really be *for ever*? Is Browning's Eurydice conscious of the other pun in her word 'lap', drawing upon the Latin 'lapis', or stone? To 'lap me round for ever': to turn me into stone. (In the book of Genesis Lot's wife is turned into a pillar of salt when she looks back on fleeing the city of Sodom.) Perhaps Eurydice's desire to see and to be seen betrays a deeper awareness that somehow this look will be fatal, or final:

> One look now
> Will lap me round for ever, not to pass
> Out of its light, though darkness lie beyond:
> Hold me but safe again within the bond
> Of one immortal look!

Eurydice's plea is for two kinds of 'immortality', neither of which will last for ever. As an image within the eye of her beloved Eurydice will feel immortal because the 'bond' between lovers is strong enough for all 'woe that was' to be forgotten and 'all terror that may be' to be defied. She will feel immortal as lovers feel that their love will conquer all and last for ever. But the 'bond' of that one immortal look will also be her death sentence. Secondly, as an image in a picture by Leighton, Eurydice will be 'immortal' in the way art is said to be 'immortal'; that is, she will never pass out of the light of the picture, though darkness lies beyond the picture frame. But her words give away the fact that her desire for 'one look' is in fact stronger than her wish to live. She is begging to be seen at any cost, prepared to sacrifice her life (again) for the one look: to be seen by her husband, to be turned into Leighton's image. This is to be made 'immortal' in the sense in which love sometimes makes us feel immortal, but also in the sense in which myth and the representations of myth in poetry and painting immortalise their subjects; in other words, with the tragic knowledge or secret that this is no immortality at all: 'no past is mine, no future: look at me!'

The myth of Orpheus and Eurydice is centred upon this 'one look'. What is this 'one look' worth? Browning grasped what Leighton had understood, which is that the subject is eminently suited for visual representation since it carries this great and tragic sense of the absolutes of *seeing*, and how this might have a claim upon us that defeats the redemptive power of music or poetry. Browning, however, also understood that the complicated relation of art gazer to art object could be figured here in the drama of Orpheus and Eurydice. If Eurydice stands for the picture or image, we might ask

the question: what do pictures want? A picture desires to be brought into a relation with a viewer and to be made alive; 'one immortal look' will realise the will to live of the image. If we anthropomorphise the image in this way, then every painting desires never to pass out of the light of the eye, to be safe again within the 'bond' of the person who stands before it at an exhibition: 'Look at me!' But it is a command or plea that only becomes explicit in the presence of someone who is there to look. Only the viewer of paintings, or perhaps the poet who speaks *for* paintings, makes it possible to perceive the drama of this relationship between the image and the human subject. W.J.T. Mitchell puts it this way:

> The picture [is] not just ... an object of description or ekphrasis that comes alive in our perceptual/verbal/conceptual play around it, but [is] a thing that is always already addressing us (potentially) as a subject with a life that has to be seen as 'its own' in order for our descriptions to engage the picture's life as well as our own lives as beholders. This means that the question is not just what did the picture mean (to its first historical beholders) or what does it mean to us now, but what did (and does) the picture want from its beholders then and now.[2]

Is the picture's desire to have "its own" life confirmed, like Eurydice's, also a desire to die, or at least a desire to exchange life for the spurious 'immortality' of the undying moment of art or love? It is one of the paradoxes of painting, and a recurring theme of this book, that the immortality or timelessness of the image is a kind of death-in-life. In it there is a forgetting of 'all woe', a defying of 'all terror', and yet as the image does not exist within the structure of time it does not really exist at all, but is rather a mere sign for existence, a representation. When we look at an image we are looking at the sign of something that has disappeared.

But Eurydice is also giving voice to the desires of the viewer, the visitor to a gallery who becomes rapt before a painting, absorbed in the 'light' or 'bond' of the image. (Originally Browning's words would have been read in the context of an exhibition.) The art gazer wants the painting to acknowledge her presence ('look at me!': return my look) as if the feeling aroused by looking at a painting somehow demands or requires reciprocation. And here is the special case of a *poet* in the presence of a work of art, experiencing an envy or rivalry because he wants his poem to be read with the same intense act of attention that we might give to a painting that captivates us. For all his powers as a poet, Orpheus was defeated by the inability to resist 'one look'. The potency

of the visual world overcame his verbal gifts. Can poetry then ever hope to achieve the direct (or what seems to be the direct) representational power of a work of art, the immediate charge, the presence of a visual image? Does the poet's desire to possess the representational skills of the painter betray a latent anxiety about writing? 'Give them me, the mouth, the eyes, the brow!' That is, let me enjoy the same ability to represent these *things*, to give them form and substance and to make them come alive within the mind's eye. 'Look at *me*!' Look at these words, this poem. It too has no past, no future, but is suspended on the page in a mime of 'immortality'. And these words too are merely signs of something (a feeling, a presence, a thought) that is no longer really there.

Browning's encounter with Frederic Leighton's painting was the immediate occasion for the poem, but the piece may also be remembering Elizabeth Barrett Browning, who had died in June 1861. Her tomb in Florence had been designed by Leighton ('lap me round for ever': turn me into stone). Read in this context, 'Eurydice to Orpheus' gives voice to a dead lover and expresses an even more painful and complex sense of grief and longing *as if* she were speaking to her husband (the living poet, the Orpheus) from the 'underworld'. Elizabeth had been much interested in spiritualism, to her husband's annoyance and distaste, and so the notion of a dead wife imploring her husband to turn around and *see* her there as if alive perhaps resonates with a sharper personal significance. The piece was placed immediately after the poem 'Prospice', meaning 'Look Forward', in the collection *Dramatis Personae* (1868 edition), and formed an obvious pairing since 'Prospice' envisions passing through pain and death into a final light and reunion:

> O thou soul of my soul! I shall clasp thee again,
> And with God be the rest!

Look forward, and don't look back. Look to heaven, and not to ghosts or spirits. Read as a pair in this biographical context, then, Browning's self-command to look ahead to a future in heaven is followed by the imagined longing of his dead wife for him to look back at the past, at their life together, at the possibility of her communicating with him still. Here is the imagined desire of the dead in the minds of the living to be made alive or to be 'safe again within the bond / Of one immortal look'; the kind of imagined desire that might persuade some to consult a medium, others to cherish hope of a divine reunion.

So much depends upon *looks*. Browning's short poem for Leighton's

painting is a brief, intense encounter and pairing, meditating upon other intense encounters and pairings: of viewer and picture; poem and painting; husband and wife. It is about relations and exchanges of critical urgency, discovering in Leighton's painting an allegory for the encounter between writing and art. But is it possible to see further connections between poem and painting? Are there family resemblances that tie poem and painting to the year 1864? Could there be analogous characteristics of technique (a shared 'language' perhaps), which would allow us to talk of their historical relation in a significant way? Frederic Leighton became famous in the mid-Victorian period for his pictures of classically inspired subjects depicted in the vivid and painstakingly researched costume we see here, subjects which seemed to inhabit an ancient world as imagined by a Victorian artist much inspired by the Elgin marbles and Renaissance painting: a kind of triple historical overlap. Along with artists such as George Frederick Watts, who also produced several paintings based on the Orpheus myth, Leighton is associated with what is called the new aesthetic classicism of that period. The clarity and dynamism of the form, the bold colours, the strong rendering of light and shadow, the large and dramatic gestures arrested at the moment of significant action, perhaps recall an artist such as Caravaggio, but also seem influenced by Pre-Raphaelite art, and are melodramatic in a way that might even suggest Victorian stagecraft and acting styles. Could any of this be applied to Browning's poem, or to the collection *Dramatis Personae* in which it appeared? What do these works have in common that makes them both recognisably mid-Victorian? It might feel as if we are on shaky ground as soon as we embark upon such parallels. Even though in an immediate sense there is no mistaking the fact that both poem and painting belong to the same period, when we begin to make broad statements about historical analogies between the 'sister arts' of poetry and painting we enter an uncertain space that has traditionally been treated either with suspicion or with outright hostility. How do we make connections between poems and paintings that belong to the same historical moment? 'Unregulated analogy has been the plague of those who would generalize about period style', Martin Meisel has argued.[3] But can we make any such generalisations without a certain liberty or openness in our analogies? And the question grows larger if we ask how we go about comparing poetry and painting *at all*: is it possible? And how, moreover, do we pursue the older, hoarier aesthetic questions that inevitably arise from parallels and analogies between the arts? To remain with the smaller question for the moment: the study of poems about paintings (poems of ekphrasis) seems dogged by the fear of transgression. 'Everywhere in ekphrastic studies we encounter the language

of subterfuge, of conspiracy', writes Grant F. Scott: 'there is something taboo about moving across media, even as there is something profoundly liberating. When we become ekphrastics we begin to act out what is forbidden and incestuous; we traverse borders with a strange hush, as if being pursued by a brigade of aesthetic police.'[4] Browning's poem 'for' Leighton's picture expresses a longing to act out what has been forbidden, to cross over between things that are eternally separate and which are doomed not to be together. It discovers this longing in Leighton's interpretation of the Orpheus myth. The critical practice of analysing poems about paintings and theorising on the broader analogies between the sister arts merely follows the poems themselves into a border terrain or no-man's-land in which separated entities encounter each other. This sense of crossing a threshold or desiring something impossible lies at the heart of so many poems about paintings that it inevitably comes to haunt the critical practice of writing on the subject too. And the myth of Orpheus and Eurydice could be read as dramatising something of that desire. This is the key moment of John Dryden's 1697 translation of Virgil's fourth Georgic, which relates the story:

> For near the Confines of Etherial Light,
> And longing for the glimm'ring of a sight,
> Th'unwary Lover cast his Eyes behind,
> Forgetful of the Law, nor Master of his Mind.
> Straight all his Hopes exhal'd in empty Smoke;
> And his long Toils were forfeit for a Look.[5]

By making Eurydice implore Orpheus for the 'one immortal look', Browning (following Leighton) had crucially shifted the emphasis of Virgil's account. The burden of responsibility did not belong wholly with Orpheus, but arose as much from the desire of Eurydice. As an allegory for the relation of poetry to painting, or of language to the visible, the picture (Eurydice) begs to be looked at, and the poet who turns his gaze in that direction – although, as Dryden puts it, he may be 'forgetful of the Law, nor Master of his Mind', although he risk forfeiting his toils and losing his hopes in empty smoke – nevertheless, he responds in Browning's version to a plea that he feels comes from outside himself. Browning grasped what Mitchell has described as the 'animation or vitality … the agency, motivation, autonomy' that is attributed to images, and which makes them 'not merely signs *for* living things but signs *as* living things'.[6] And yet Browning also understood that, paradoxically, the sign for the living is also the sign for the dead. His short poem for Leighton's

picture is an example of ekphrasis that also meditates upon the impossibility (the doom) of that ancient rhetorical activity.

The term 'ekphrasis' is composed from the Greek words *ek* (out) and *phrassein* (to tell, or speak), and has had a long history, experiencing something of a critical and practical boom in recent times.[7] As a technical term within the study and practice of rhetoric, its origins have been traced to the first century CE when it was used to denote 'any elaborate digressive description embedded within rhetorical discourse'.[8] This early sense lingers in the subsequent use to which the term has been put, and from the outset raises the larger question of its purpose. A digression embedded within a surrounding discourse might be taken as ornamentation or amplification, or conversely perhaps as excess or superfluity. (Why digress at all?) An elaborate description might seek to reveal its subject in greater depth or clarity, or merely distract attention, seduce or otherwise spellbind an audience. Hence there is the suggestion of ambivalence, perhaps even suspicion (over and above the conventional suspicion of rhetoric), which endures in the critical anxiety about the term and its risky, borderline sense described above. In the third and fourth centuries CE ekphrasis was used as a term for the description of visual art, employed, for example, by the sophist philosopher Callistratus as the title of a work describing a series of statues. It therefore has a discursive, or we might even say proto-art theoretical sense, which anticipates the catalogue entries of exhibitions and the battlegrounds of art criticism. As we shall see, the act of describing art is always an act of interpretation.[9] As a literary mode, however, the practice of describing works of art, whether real or fabulous (or in John Hollander's terms 'actual' or 'notional'), goes back to the Homeric period (circa 810–730 BCE), the most famous example being the description of Achilles's shield in the eighteenth book of *The Iliad*.[10] The shield that Homer imagines the god Hephaestus fashioning for Achilles is both a work of art and a formidable weapon; it is a miracle of design and craftsmanship that has a specific function. As an artwork it is a marvel of representation or 'picturing', with elaborate scenes of war and peace forged across its surface and around its edges. The process of crafting the shield is itself inset within a narrative of war and peace, while of course Homer's description of this act of creation is in rivalry with and emulation of such skill, 'picturing' this miracle of picturing. Moreover, the notion of a primary act of creation and a secondary act of reproduction is further complicated by the fact that the scenes depicted on the shield seem to have an allegorical relation (though one much argued over) to the events unfolding in the narrative of the poem. Who or what then is doing the

'picturing', and what exactly is being pictured? Similar interactions of picture and narrative occur in the first book of Virgil's *Aeneid* (19 BCE), when the wanderer Aeneas, refugee from Troy, arrives in Carthage and sees a tapestry depicting scenes from the Trojan War. Marvelling at the fame these events have already acquired, Aeneas suddenly notices himself depicted in one of the friezes. Here then Virgil represents a figure from historical mythology (the legendary founder of Rome) looking at a representation of himself in art: in other words, a fictional character looking at a fiction or depiction of himself – the kind of thing we mistakenly think of as modern. Frozen tableaux in medieval and Renaissance literature, often taken from classical subjects, open interpretative possibilities, most often mysteriously or prophetically, perhaps representing a symbolic moment in the progress of the story or figuring the larger themes of the surrounding narrative. A work of art may be described within a story, perhaps produced or crafted by a character within the story, or revealed to another. Murals, tapestries, 'painted pieces', woven designs, frescos, are introduced to be read and deciphered by characters within the narrative, as well as readers of the work as a whole; to be understood or half-understood, sometimes even to be misunderstood. Famous examples occur in Spenser's *The Faerie Queene* and Shakespeare's *The Rape of Lucrece*, although as these are examples of ekphrases based on notional or non-real works of art, they fall outside the scope of this book.[11] Here I am confining my attention to writing about art from Keats to the present day, and since this is the period of the museum and gallery, and a little later the beginnings of the period Walter Benjamin called the 'age of mechanical reproduction', the writing I will be concentrating on is most often about actual paintings and sculptures seen either in galleries or in prints.

As a literary mode or topos, then, ekphrasis has one kind of history. But there is also a theoretical tradition of thinking and arguing about the relation of poetry and the visual arts, and meditating upon the meaning of this relation. The history of ekphrasis as a literary mode and practice is intimately bound up with the body of thought and theory upon the broader relation of the sister arts. And in this the Renaissance notion of the *paragone* (a debate about the relative merits of the different arts) has an enduring significance in western literature. Plutarch's famous apophthegm dating from the second century CE (derived from Simonides of Ceos), that painting is mute poetry and poetry speaking picture, sows the seeds of a whole tradition of thinking about the meaning of what each art *lacks* in relation to the other: the silence of paintings (or as 'mute' suggests, the inability of paintings to speak, which is not the same as a refusal to speak); and the pictorialism of poetry: the way

poetic language may strive to produce pictures or images for the mind's eye.[12] Leonardo da Vinci's Renaissance reformulation of the apophthegm was this: 'Painting is mute poetry, and poetry blind painting', which perhaps restores a balance, albeit of different deprivations, but again remains wholly open-ended. Painting is poetry that perhaps would wish to speak but cannot, and therefore requires poetry to speak for it. (Is this so?) And poetry is painting that would wish to see, and therefore requires painting to illustrate it. (But 'to see' in what sense? To be visualised? To be pictorial?) Leonardo's formulation asserts a mutual necessity through symmetrical disadvantages and limitations, but the argument over which is greater in the hierarchy of the arts, which arises historically from the attempt to raise the status of painting to the level traditionally given to poetry, is clearly one never to be resolved. Nevertheless, as a means of investigating the nature of each art through thinking about what they *cannot* do, and through assuming that each art is therefore driven by a *desire* to do what it cannot do, as if the nature of the rivalry were a means of illumination, this debate has proved extraordinarily fertile. And the notion of the *paragone*, a struggle, a contest, a confrontation, remains central to all thinking about ekphrasis.[13]

When the Roman poet Horace in his (unfinished) *Ars Poetica* (c. 20–10 BCE) made an analogy between the viewing of paintings and certain kinds of literary effect, and coined the phrase *ut pictura poesis* ('as is painting, so is poetry'), he could not have foreseen the wonderful afterlife these words would enjoy, wrested from their context.[14] The phrase, which seemed usefully reversible ('as is poetry, so is painting'), came to stand for a whole tradition of inter-artistic comparison, the *ut pictura poesis* tradition, which would dominate the theory of western art from the sixteenth to the end of the eighteenth century. Bolstered by certain hallowed tenets from Aristotle's *Poetics* (e.g. that human action was the proper subject for artistic imitation, and that art should represent life not as it is but as it ought to be), *ut pictura poesis* was the template by which the correspondences and analogies between painting and poetry were systematically defined, the rivalry explored and developed, and the pairing supposed to have produced canons of taste and judgement. It is a tradition of thinking about the relation of poetry and painting that assumes the relation is vital, mutually illuminating, and richly parallel. The doctrine also assumed that the highest form of painting, following poetry, would be 'history painting', that is painting drawing upon Biblical and classical *texts* for its subject, and presenting narratives that would display heroic virtue in action. Likewise, the greatest form of poetry (the epic) would be rich in striking images and tableaux for the pleasure of the imagination or mind's eye.

Although Ben Jonson's translation of Horace's *Ars Poetica* was well known in the seventeenth century, the *ut pictura poesis* tradition gained a proper foothold in British culture through John Dryden's 1695 translation of Charles-Alphonse Dufresnoy's Latin poem *De Arte Graphica* ('The Art of Painting'). In Dryden's preface we can see the extent to which a linking analogy of style or technique between the sister arts had been pushed to extremes:

> Expression, and all that belongs to words, is that in a poem which colouring is in a picture. The colours well chosen in their proper places, together with the lights and shadows which belong to them, lighten the design, and make it pleasing to the eye. The words, the expressions, the tropes and figures, the versifications, and all the other elegancies of sound, as cadences, turns of word upon the thought, and many other things which are all parts of expression, perform exactly the same office both in dramatic and epic poetry.[15]

The ascendancy of *ut pictura poesis* emerged from the strict virtues of neoclassical taste and theory, particularly strong in the first half of the eighteenth century. Although it survived well into the nineteenth century, the tradition received a formidable challenge from the German theorist Gotthold Ephraim Lessing's *Laocoön*, published in 1766. Lessing sought radically to undermine the assumptions of sisterly bonds and mutual emulation between the arts by insisting that they belonged to separate and incommensurable spheres. His central argument was that pictures work within the spatial dimension, whilst poetry (the linguistic sign) operates within time: 'The rule is this, that succession in time is the province of the poet, coexistence in space that of the artist.'[16] Although Lessing's thesis had been anticipated by other dissenters from mainstream thinking, the forcefulness and sustained brilliance of his argument, with its strong bias against painting, ensured that the *Laocoön* enjoyed considerable influence in the latter part of the eighteenth and early nineteenth centuries.[17] For Lessing, poetry seemed fundamentally bound to the narrative mode rather than the 'pictorial' or descriptive mode; the multiplying of successive details in verbal description could produce only confused images, whereas painting, working within a spatial and material medium, could produce clear and vivid images that could be apprehended in a single moment, or *punctum temporis*. The terms that he focuses upon and makes into a binary opposition, i.e. space and time, have been central to all discussions of ekphrasis to this day, even though the assumption of a binary opposition has been thoroughly questioned. Clearly, paintings such

as Leighton's *Orpheus and Eurydice* arrest, or, as we might say, freeze-frame, a certain point in a known narrative, what Lessing called the 'pregnant moment'. In doing so they certainly create the illusion and thematise the notion of stopped action. As Browning understood, Leighton's painting is actually about the idea of a single moment, its terror and its desire. But part of the illusion of a painting involves story-telling, and the 'pregnant moment' itself has meaning only within the sequence of what-happened-before and what-happens-next, in this case in reference to the legend of Orpheus and Eurydice. In paintings like this we also clearly have the idea or the illusion of movement (albeit in the negative sense of movement arrested), what E.H. Gombrich called 'memories and anticipations of movement', so that, although Leighton's painting is literally still, we would probably not describe it as a 'still' painting; on the contrary, it seems rhythmic and dynamic.[18] The physical 'movements' of Orpheus and Eurydice have in turn been translated into a matching dramatic expression by Browning. Moreover, even though a viewer's encounter with a painting may involve more immediate comprehension, a quicker cognitive processing than, say, reading a sonnet, nevertheless it does *take time* to look at paintings, to grasp their meaning, and even (as modern art historians prefer) to *read* them. And this is the case even with paintings relatively free of iconographical 'language'. As Michael Baxandall has argued, 'if a picture is simultaneously available in its entirety, *looking* at a picture is as temporally linear as language'.[19] Further still, the illusions of poetry, particularly perhaps narrative poetry, involve ideas and conceptualisations of space, place, dimension and body. The printed word itself remains on the page, in space, and the idea that a poem's meaning (in the interaction of form and content) exists like an object in space, or at least emulates the existence of such an object, has been a powerfully influential if contested notion in modern literary theory, as we shall see. In other words, Lessing's strict division of the proper spheres (paintings like women: passive, beautiful, silent; poems like men: active, rigorous, noisy) has been challenged on several grounds, quite apart from its gender assumptions. Even so, the strange interrelation of time and space somehow remains intimately connected to the idea of ekphrasis. In particular, the notion of the 'stillness' of art representing a kind of death-in-life, or life-in-death (the French *nature morte* 'dead nature' we translate as 'still life') is an important awareness in many ekphrastic poems. In his mock Socratic dialogue, 'The Critic as Artist' (first published in 1890), Oscar Wilde rearticulated Lessing's theory of difference, with its implicit privileging of literature over the plastic arts. The following excerpt, in which the aesthete Gilbert reflects upon the

question of 'movement' in time, could stand as a prose catalogue entry to accompany Browning's poem for Leighton's picture:

> The image stained on the canvas possesses no spiritual element of growth or change. If they know nothing of death, it is because they know little of life, for the secrets of life and death belong to those, and those only, whom the sequence of time affects, and who possess not merely the present but the future, and can rise or fall from a past of glory or of shame.[20]

The Picture of Dorian Gray would of course reverse this law of the image.

Perhaps we should ask not what the term 'ekphrasis' means but how it has been used. Technical discussions of the term tend both to describe a set of relations already there and to prescribe a field of usefulness. Ekphrasis *is* this, and therefore ekphrasis *should be* used in this way: the argument quickly becomes circular. The *Oxford Classical Dictionary* offers the definition: 'a rhetorical description of a work of art', though this might raise the question: what description of a work of art isn't rhetorical, in some sense? 'Ekphrasis is the verbal representation of visual representation', is James Heffernan's useful definition, which is a slightly broader variation of Murray Krieger's 'the name of a literary genre, or at least a *topos*, that attempts to imitate in words an object of the plastic arts'. Jean Hagstrum emphasises the sense Browning had picked up of envoicing (after Leonardo): 'that special quality of giving voice and language to the otherwise mute art object'; whilst Mack Smith draws upon earlier traces of a classical rhetoric when he describes ekphrasis as 'a digressive description used as an appeal to narrative credibility'. Leo Spitzer suggests, 'the reproduction, through the medium of words, of sensuously perceptible *objets d'art*' – an interesting use of the word 'reproduction', to which I will return. John Hollander confines his use to poetry: 'Poems addressed to silent works of art, questioning them; describing them as they could never describe – but merely present – themselves; speaking for them; making them speak out or speak up'.[21]

Almost all theorists of ekphrasis emphasise the paragonal aspect of the mode, or 'the struggle for dominance between image and word'.[22] But what, we might ask, are they struggling over? In what sense, in what activity, do they wish to dominate, out-do, or eclipse each other? At the heart of this lies a philosophical question that goes back to Plato: the problem of representation. Book ten of Plato's *Republic* (c. 360 BCE) explores the notion of artistic

imitation (or *mimesis*). If every thing or object in the world is already a copy of an ideal and unchanging form or essence beyond the world (every bed is merely a single copy of a template of 'the bed'), then every artistic representation of that object will constitute a copy of a copy. It follows that a verbal description of a work of art produces a copy of a copy of a copy; and if the aim of verbal description is to 'reproduce' the picture as a picture in the mind, then this final mental image will be a copy of a copy of a copy of a copy. At such a remove from the ideal Platonic form or essence, verbal description seems a poor substitute, a meagre thing hovering somewhere at the back of a queue to shake hands with 'reality'. And painting seems ahead of poetry in this queue. Painting is a 'natural sign' and therefore closer to the object to-be-represented than the arbitrary or non-natural sign system of language.[23] In the Belgian Surrealist painter René Magritte's painting *The Betrayal of Images* (1928–29) (figure 2), a painting of a pipe appears above the words 'Ceci n'est pas une pipe' ('this is not a pipe'). What the words say is true, because an image of a pipe is not a pipe, just as the word 'pipe' is not a pipe, even though the sentence seems in another sense flatly to contradict the idea (the illusion) we experience when we look at a painting of a pipe, that 'this is a pipe'. 'Ceci' (this) may point to the image of a pipe or merely to itself (the word 'this' is not the word 'pipe', even though here the shape of the 'C' in 'Ceci' matches the curve of the pipe as a kind of visual rhyme); either way, this is not a pipe. Magritte is offering a meditation on the strangeness of representation, of this apparently natural (and yet in fact not natural) chain of signs linking the idea of the pipe in the viewer's mind to the 'real' pipe being represented. It is perhaps a lame joke, but one with an ancient philosophical context; and the lameness of the joke is part of the point: we live, perceive, communicate, we are stranded, within this illusionary chain of signification.[24]

The best of the western world's later philosophical disputes have their origins in Plato, and in the case of ekphrasis the notion of a contest between poetry and painting derives from this idea of getting as close as possible to the real thing.[25] But how do we go about measuring proximity to the real thing? One of the deeply grounded philosophical assumptions behind such a model of mimesis is that the perceiving mind contains 'pictures' which are traces of real objects in the world. In the seventeenth and eighteenth centuries this idea of mental imagery as decaying sense impression was developed in the writings of Hobbes, Locke and Hume, and became a model for epistemology. Thinking and picturing and knowing were thought of as mutually interactive processes: our 'ideas' were principally derived from sensory experience, and chief among our senses was sight. But what this model assumes and privileges

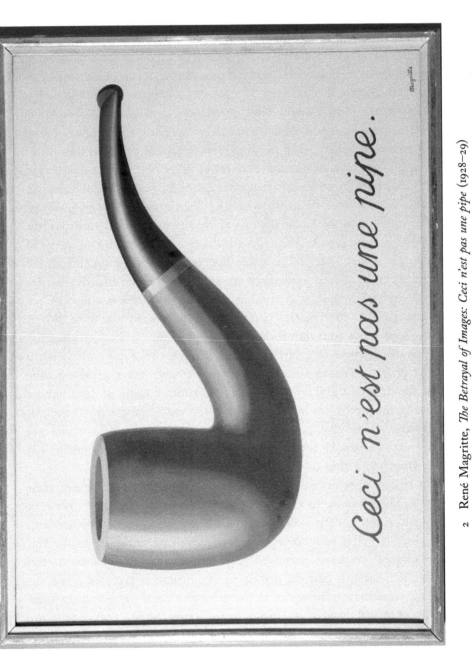

2 René Magritte, *The Betrayal of Images: Ceci n'est pas une pipe* (1928–29)
(Los Angeles County Museum of Art, Los Angeles. © ADAGP, Paris and DACS, London 2006)

is the notion of vision as a direct apprehension of an objective reality. Images in the mind, it therefore follows, even though they may be incomplete or fading, are nevertheless unmediated representations of a reality to which we have full access through the eye. According to this model, a painter will be working in a purer and more direct relation to objective reality since he or she will be reproducing images which, to greater or lesser effect, correspond to our visual experience of the world, or to what Norman Bryson calls the myth of 'Universal Visual Experience'.[26] Painting was thus thought to have a privileged connection to sensory experience, to perception, and therefore, it could be argued, to the most fundamental processes of feeling and cognition. Many modern thinkers have argued against this notion (this myth) that the visible world is simply 'out there' for our eyes to take in and print as copies upon the mind, as they have questioned the very notion of mental imagery, or 'pictures'. W.J.T. Mitchell, for example, in tracing some of the main arguments against this model of perception, stresses the fact that 'vision itself is a product of experience and acculturation'.[27] In other words, vision is structured by the mind, by convention, by experience, and is no more a transparent window upon reality than is a painting. Moreover, 'mental imagery' (something we can never literally *see*) deserves to be treated with extreme caution if being used as a model for perception.[28] We should be sceptical in other words of the notion of a straight line leading from the object-in-the-world to the picture-in-the-mind to the copy of that picture in a painting, this privileged chain of representation that has dominated western thought (and thought about thought, and thinking about art) since Plato.[29]

The straightforward question 'what is an image?' leads us into a particularly charged area of literary studies. Some people have doubted whether there is any use at all in a critical vocabulary that draws upon such terms as 'verbal imagery' or 'poetic images'. William Empson, for example, writing from a point in history in which the 'image' enjoyed a particularly high status in literature and literary criticism, decried the whole notion of literary imagery as 'a great delusion' (itself perhaps an image).[30] Anyone who has taken or taught a poetry class will understand his frustration or confusion. It partly derives from the fact that the word 'image' can be taken either in a literal sense, i.e. a verbal image is a likeness, picture, imitation or copy of a thing or action ('Groping back to bed after a piss', writes Larkin in his poem 'Sad Steps', offering us a graphic image of his nightly routine) or in a figurative sense, i.e. an image can be a metaphor, meaning it signifies a comparison, a linking of one thing with another ('With what sad steps, O moon', from Sir Philip Sidney's sonnet, which gave Larkin his title).[31] Mitchell draws our

attention to the numbing fact that the phrase 'verbal imagery ... seems to be a metaphor for metaphor itself', though in neither of the above examples is it clear whether a 'mental picture' is what is produced in the mind as we read.[32] But if language is able to produce imagery, and images have a privileged connection to perception and sense experience, then it is easy to see how the art of poetry could be assumed to have as direct a connection to the 'real thing' as a painting is supposed to have. Perhaps more so, since a painting may produce a mere resemblance or likeness of a thing, whereas through the combinatory power of language, the figurative aspect whereby images are woven into other images, my idea or sense of a thing in the world as a result of a verbal description of that thing may be more 'real', more vivid and alive to me, brought closer to my comprehension, than either the thing itself, or a painting of the thing. The Greek word for this effect of language was *enargeia*: 'the capacity of words to describe with a vividness that, in effect, reproduces an object before our very eyes (i.e. before the eyes of the mind)'.[33] Over the centuries the argument over the exact relation language has with 'reality', or with the perception of truth (whether that is figured as visible or invisible), has swung this way and that way, but the assumption has more often than not been that the word is in competition with the image, and that the image has an advantage over the word since it is closer to life. (This has not always been the case, but usually so.)[34] And so when poems come to describe paintings, or give voice to them, these rival claims to a potency of *representation* seem inevitably to clash.

One example of this paragonal theory is to be found in the important work of Mitchell. In his study *Picture Theory* (1994), he outlines three modes of ekphrastic process: firstly, 'ekphrastic indifference', that is the 'commonsense perception that ekphrasis is impossible'. How could any verbal description ever hope to 'reproduce' a work of art? (It is an 'impossibility' that has proved to be an endlessly generative one). Secondly, there exists precisely that 'ekphrastic hope', that is 'when the impossibility of ekphrasis is overcome in imagination or metaphor'. This hope would be what Mitchell describes as the hope of overcoming 'otherness': the hope that the word might stand in for the image and that no one will notice the difference, or that the difference will disappear. The third mode Mitchell outlines is 'ekphrastic fear'. This constitutes the 'moment of resistance or counter desire ... when the difference between visual and verbal mediation becomes a moral, aesthetic imperative'. (The specific link between moral and aesthetic imperatives will be explored at length in later chapters.) These three modes, Mitchell argues, are simultaneously present in ekphrastic writing: indifference/hope/fear; and they emerge

from the primary idea of the *paragone*. Ekphrasis, then, thematises the visual 'as other to language'; at some level it takes such otherness or difference as its subject, regarding it as 'a threat to be reduced', a 'potential same-to-be' and a 'yet-not-same'.[35] What broadly characterises this nexus of reactions (and notice how each of Mitchell's terms refers to a human emotion) is ambivalence. Grant F. Scott makes a similar point:

> In truth, ekphrasis may be both a selfless, generous project, and a self-serving and diabolical one. It is a gift which writing bestows on images, a way of helping the statue say that which it can only suggest (Simonides's speaking picture), *as well as* a way of demonstrating dominance and power. The motivations of ekphrasis are thus much more divided than most critics have acknowledged, and far more ambivalent.[36]

But from where, exactly, does that 'ambivalence' arise? Is it part of the motivation or intention of the poet, who in writing a poem about a painting must be either consciously or unconsciously influenced by ambivalent feelings about the 'image'? If so, then why? Is it because 'images' are somehow ambivalent in themselves, or because writing is necessarily ambivalent towards pictures, or pictures to writing? Is it in some way a question of gender politics (the 'male' word confronts the 'female' image), or is it because what occurs in the encounter of word and image is a process of translation between different sign systems?[37] Do we mean by ambivalence primarily an emotional reaction to an object, or do we mean a semantic outcome, something closer to ambiguity, undecidability, complexity, paradox or indeterminacy? How is an emotional ambivalence connected to ambivalent meaning? Or is the discovery of ambivalence just another way of recognising the risks involved in thinking about ekphrasis theoretically, due to the very nature of this particular kind of analysis as interdisciplinary and cross-borderline? As a critical tool, particularly as an end to be discovered in poems about paintings, the term 'ambivalence' is suspiciously easy to use, whilst also seemingly impossible not to use (even with ambivalent feelings about its use). In this book I will try to add something more to the discovery of ambivalence in ekphrastic poems by treating that as a given rather than an end. One more example of a poem about a painting will help to explain what I mean.

Some philosophers of art posit the concept of *aboutness* as the defining feature of the artwork. Paintings and sculptures are always 'about' something.[38] Within such a definition, however, it is obvious that the little word 'about'

has to do a lot of work. And whenever we say a poem is *about* a painting, the notion of *aboutness* comes under further pressure. This is a poem by Derek Mahon about a painting by Pieter de Hooch (figure 3):

> *Courtyards in Delft*
> <div align="right">Pieter de Hooch, 1659</div>
>
> (*for Gordon Woods*)
>
> Oblique light on the trite, on brick and tile –
> Immaculate masonry, and everywhere that
> Water tap, that broom and wooden pail
> To keep it so. House-proud, the wives
> Of artisans pursue their thrifty lives
> Among scrubbed yards, modest but adequate.
> Foliage is sparse, and clings. No breeze
> Ruffles the trim composure of those trees.
>
> No spinet-playing emblematic of
> The harmonies and disharmonies of love;
> No lewd fish, no fruit, no wide-eyed bird
> About to fly its cage while a virgin
> Listens to her seducer, mars the chaste
> Perfection of the thing and the thing made.
> Nothing is random, nothing goes to waste.
> We miss the dirty dog, the fiery gin.
>
> That girl with her back to us who waits
> For her man to come home for his tea
> Will wait till the paint disintegrates
> And ruined dikes admit the esurient sea;
> Yet this is life too, and the cracked
> Out-house door a verifiable fact
> As vividly mnemonic as the sunlit
> Railings that front the houses opposite.
>
> I lived there as a boy and know the coal
> Glittering in its shed, late-afternoon
> Lambency informing the deal table,
> The ceiling cradled in a radiant spoon.

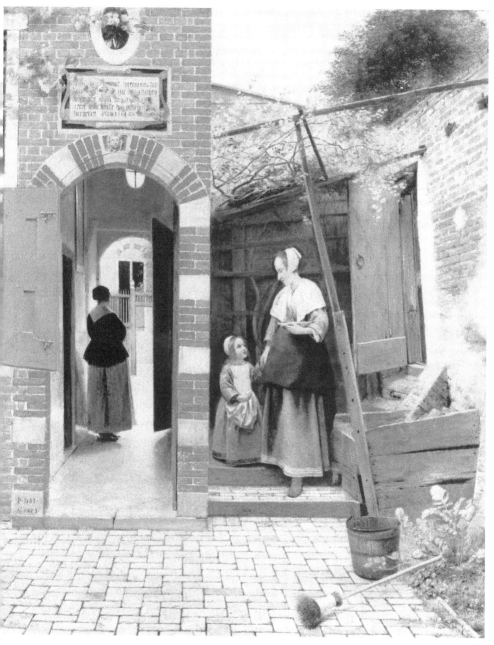

3 Pieter de Hooch, *Courtyards in Delft* (1658) (The National Gallery, London.
Photo © The National Gallery, London)

I must be lying low in a room there,
A strange child with a taste for verse,
While my hard-nosed companions dream of fire
And sword upon parched veldt and fields of rain-swept
 gorse.[39]

Mahon encounters here both a painting and a social culture, and recognises that the two are inseparable. The masterpiece of Dutch genre-painting, with its 'oblique light', the cleanliness, the fastidiousness of detail, its clarity, its modesty and pride, its order and care, derive from, record, and sanctify the Protestant culture of Delft in the seventeenth century: the solidity, the thrift, the 'modest but adequate' lives of those who live there. At the same time the poem describes what is *not* there in the picture, invoking both a different genre or tradition of painting (the Renaissance tradition of the Catholic South) and quite another set of cultural codes, values and assumptions. The painting is *not* an allegorical narrative painting; it is not burdened with the emblems of an iconography to be deciphered or read.[40] A certain lasciviousness, a sensuality is missing from the painting. There is no excess, 'Nothing is random, nothing goes to waste'. The generic distinction is also a differentiation of the Protestant from the Catholic, the northern European from the southern, as the northern Protestant might perceive this distinction. There is a distrust of the art and religion of the South, a suspicion of the opposing culture and its representations. At the same time, perhaps, Mahon records a curiosity, a flicker of desire for that 'other' world: 'We miss the dirty dog, the fiery gin' (the dirty dogs wandering through the large canvases of Veronese or Tiepolo; the 'fiery gin' (infernal machine) of a Bosch). Perhaps there is something 'trite' about the order and stillness of this world. Nothing seems to ruffle its 'trim composure', as no breeze or life moves the stillness of the painted trees. The very perfection of form is also a kind of deathliness. The girl who waits for her man to return will wait for ever, until the end of the world, such is her fidelity; but as she waits 'with her back to us', indifferent or unconscious, she is a metonym for the painting itself, for the stopped action and the mute insentience of the object, and for its refusal to disclose a story. Here is the moment in which real life is suspended and the 'immortality' of an artistic representation achieved (the scene will endure until the 'paint disintegrates'). The moment is not pregnant with an immediately imminent narrative event, merely the long vista of nothing changing. Her waiting then is both a form of faith and a futile death-in-life. And yet, despite the apparent futility or inertia, despite the smallness of the scene and the lack of narrative incident,

'this is life too', this is a human existence, a culture, and a vivid representation. And a devotion to the tangible and to the 'verifiable fact' of the quotidian, to what is here before us, is something palpably alive, valuable and enduring, even though the same 'cracked / Out-house door' hints at the disintegration of paint, the inundating sea, that will bring this thrifty art and life to an end.

This scene reminds Mahon of the terraced streets and the Protestant culture he knew as a boy in Belfast. The details are 'vividly mnemonic'; it is a fabric and form of life Mahon *knows*, and his recognition allows him to fantasise around the painting, placing himself within its frame, although hidden: 'I must be lying low in a room there'. But the sense of belonging or remembering is shadowed by a sense of alienation. He is 'A strange child with a taste for verse', the boy who hides away to protect himself and who practises the dubious art of poetry ('lying low' is a pun) whilst his 'hard-nosed companions' dream of war. Their dreams are ominous, since the 'parched veldt' and the 'fields of rain-swept gorse' point towards the foreign campaigns of Dutch Protestant culture in Africa and Ireland: the wars of William of Orange, the struggles of the Boers in the Transvaal and the Orange Free State. These are the hidden desires that a culture may mask, not least in the forms of representation with which that culture seeks to present itself, and they are the hidden desires or dreams that history will eventually release into the world. In other words, the apparent fixity of the painting, its superb fidelity to a particular day, is opened out by the poem to a future (for Mahon a past), an unfolding narrative to which the poet claims witness. The suggestion seems to be that an art and a culture will also harbour an ideology; that it may be home both to the 'strange' boy who is vividly sensitive to its material reality, and to the 'hard-nosed companions' who dream of expanding their culture in opposition to others. The very distinctness of its Protestant life, the *non*-Catholic nature of this scene and this art, may be connected in complex ways with a future of 'fire / And sword', a future in which the pride that this culture has in itself steps beyond the scrubbed and modest courtyards. Perhaps there is also a sense in which, through its pronounced attention to the domestic and to the feminine – the house-proud wives, the cleaning, the girl waiting, the 'chaste perfection' – the painting disguises the masculine life which shapes this culture. But the men live here too, and the 'strange child' who is 'lying low' there may be afraid of the violence he perceives in his 'hard-nosed companions' not least because he understands and knows those dreams himself, in the same sense in which the material reality of the scene lives in his blood, in his body's memory. Mahon's having 'lived there as a boy', then, is both a recognition of belonging to a culture, of being placed

within that culture, and an uneasy acknowledgment of a tribal allegiance, a distrustful submission to the nostalgia that masks ideology in the sanctified forms of memory and art.

Mahon's ekphrasis sees into and sees through Pieter de Hooch's *Courtyards in Delft*. It describes what it sees, but as with any description of a painting, it selects, edits, and *reads* the image even as it ostensibly goes about merely recording or transcribing its details. All such descriptions are forms of interpretation, reading *into* and *through* and *about* the image, even though the notion of keeping faith with the painting and of recording what is there with fidelity (perhaps even in emulation, or with the strictest hopes of 'reproduction') may be an important motive within this particular poem. In the seventeenth century Pieter de Hooch was painting with a certain idea of fidelity to the facts of an existence, to the 'reality' of a domestic courtyard, and Mahon invokes an analogous 'composure' in his own initial descriptions. Nevertheless, even though there is no decoding of iconographic symbols and signs in Mahon's ekphrasis (as the poem makes much of their absence), his language (as he knows) will not lie as still as the painting. In other words the poem will inevitably try to say what a picture of stillness and perfection *means*, opening the static image to the life of temporal sequence in which the moral assumptions of the artwork are made explicit. In the polysemous nature of his language Mahon's signification moves beyond the apparent objectivity of the visual: 'oblique light on the trite', 'immaculate', 'To keep it so', 'House-proud', 'ruffles the trim composure': each phrase suggests a perceiving subject who stands outside and is therefore able to pass comment upon what he sees. Interestingly however, Mahon chooses not to notice the inscription upon the wall above the passageway, which had come from the Hieronymusdael Cloister in Delft and translates as: 'This is St. Jerome's vale, if you wish to repair to patience and meekness. For we must first descend if we wish to be raised.' The inclusion of the inscription by de Hooch explicitly points to the moral of the painting, that there is religious significance in the domestic virtues represented here, and that the artist is engaged in a parallel act of patience and meekness in the hope of elevating his subject matter in such a way as to confirm or embody this significance in the painting itself. Mahon prefers to discover the same moral in the non-verbal details of the scene, as if insisting upon the full capacity of the visual to present its own meanings without a tag or text. But paradoxically of course, in the very act of insisting upon the painting's visual autonomy, Mahon is contradicting or undoing that sufficiency, interrogating it, turning it over to verbal explanation.

Mahon's suspicion is indeed that the apparent surface perfection of the painting itself, the very idea of a *transparency* of representation or a window on reality, is a complex part of the painting's own meaning, and one that should not simply be taken at face (or surface) value. A painting of a courtyard is not the thing itself, and the very idea of fidelity to the 'verifiable fact' opens up a range of further ideas: social, cultural, political, religious. Indeed the very notion of 'meaning' simply being *there* in what the eye sees or takes in is a complex and challenging assumption, as Svetlana Alpers has shown us, and one determined by the fact that what is *not* there in a painting may be a significant part of this 'meaning' too – what has been left out, excluded or banished.[41] A poem can describe or speak out of these absences and so illumine the assumptions, principles, beliefs that inform what *is* there, and which privilege the very idea of '*what is there*'. Moreover, just as the most scrupulously faithful description must inevitably offer an interpretation of its object, so every narrative drives towards an end or moral, which is why Mahon's imagining of a future for the painting hints at the difficult – we should certainly say the ambivalent – moral meanings 'lying low' within the painting itself. All paintings, whether they are narrative paintings or, as here, domestic genre scenes, tell the story of a context and a culture, and are therefore open to moral interpretation and evaluation. They are not innocent or disinterested, even though they may present themselves as such. We might wish to argue with Mahon's interpretation, to say that the poet has misrepresented the context or the meaning of the painting, but the idea of a 'moral' is not a secondary one imposed by the act of ekphrasis upon the visual; rather it is an imperative within the very act of representation, indeed within the process of visualisation itself.

This is what makes the 'one look' so significant. Mahon's poem, then, is 'about' the moral life of both a culture and the self-representations of that culture. It is 'about' the painting therefore in the sense of being within, speaking from the inside, or talking *for* the painting, but also in the sense of being simultaneously outside or against de Hooch's image, illuming its 'other' and evoking its negative.[42] Its 'aboutness' is as vivid and yet as oblique as de Hooch's sunlight. In this sense the poem both is and is not paragonal. That is, it seems intended to break through the surface perfection of de Hooch's painting, certainly to ruffle its composure, and even perhaps to mar its 'chaste perfection', or its assumption of such a virtue. But its suspicion or inquiry does not amount to hostility. Rather, it recognises and confesses to a deeper identity with the sensuous memory of the picture, to the disturbing life of the image. It assumes such a connection can be made across the distance of four

hundred years. And so it would not quite be correct to say that the poet (or poem) somehow harbours a wish to control or dominate the image-as-other, or to overcome the differences between poem and painting, even though these differences are also at the root of the exchange. Ambivalence, obviously, is everywhere; but it is the particular ways in which ambivalence is manifested *here* that are worth observing. In other words, specific examples of ekphrasis such as this are rarely straightforward allegories of the relationship between poetry and painting, or between word and image. Instead, as is often the case in literary studies, each example of a generic type (each poem-about-a-painting) seems to complicate the broader definitions of the genre. What is most complex and interesting about these encounters may not be the abstract dynamics or modalities of a general theory of ekphrasis then, but the larger, more compelling aesthetic and moral questions which take a particular form, an individual shape, in the specific encounter. In what ways has Mahon's poem helped us to 'see' de Hooch's picture? What, exactly, has it made visible? These kinds of questions (Mitchell calls them 'imperatives') recur over the following chapters in the examples of ekphrasis I have taken from the last two hundred years.

NOTES

1 *The Complete Works of Robert Browning*, ed. Roma A. King Jnr, Morse Peckham, Park Honan and Gordon Pitts, 16 vols (Athens: Ohio University Press, 1969–), VI, p. 169.

2 W.J.T. Mitchell, *What Do Pictures Want? The Lives and Loves of Images* (Chicago: University of Chicago Press, 2005), p. 49. 'There is simply no getting around the dialectics of life and death, desire and aggression, in the fundamental ontology of the image. The Freudian *fort-da* game of appearance and disappearance, the endless shuttling of the image between presence and absence, duck and rabbit, is constitutive of the image. Which is also to say that the capacity for image formation is constitutive of desire in both the Freudian and Deleuzian framework. Images both "express" desires that we already have, and teach us how to desire in the first place' (p. 68).

3 Martin Meisel, *Realizations: Narrative, Pictorial, and Theatrical Arts in Nineteenth Century England* (Princeton: Princeton University Press, 1983), p. 4. Meisel continues: 'Not knowing how to take analogy seriously enough has been the defect of traditional historians of several arts' (p. 5). His own study is a magnificent example of a serious exploration of the inter-artistic relations of a period.

4 Grant F. Scott, 'The Rhetoric of Dilation: Ekphrasis and Ideology', *Word & Image*, 7:4, 301–10; (309). See also W.J.T. Mitchell, *Iconology: Image, Text,*

Ideology (Chicago: University of Chicago Press, 1986), p. 43: 'The history of culture is in part the story of a protracted struggle for dominance between pictorial and linguistic signs, each claiming for itself certain proprietary rights on a "nature" to which only it has access. At some moments this struggle seems to settle into a relationship of free exchange along open borders; at other times … the borders are closed and a separate peace is declared … Why do we have this compulsion to conceive of the relation between words and images in political terms, as a struggle for territory, a contest of rival ideologies?'

5 *Virgil: The Georgics, with John Dryden's Translation*, ed. Alistair Eliot (Ashington: Mid Northumberland Arts Group, 1981), p. 173.

6 Mitchell, *What Do Pictures Want?*, p. 6.

7 For etymologies see Scott, and also James A.W. Heffernan, *Museum of Words: The Poetics of Ekphrasis from Homer to Ashbery* (Chicago: University of Chicago Press, 1993), p. 1. Scott traces the tension between the double rhetorical sense of, on the one hand, exposition, revelation, clarification, and, on the other, ornamentation, dilation, digression.

8 Mack Smith, *Literary Realism and the Ekphrastic Tradition* (University Park: Pennsylvania State University Press, 1995), p.10. Emilie L. Bergmann emphasises not the sense of speaking out or digression, but 'report[ing] in detail', or 'elaborat[ing] upon'. See *Art Inscribed: An Essay on Ekphrasis in Spanish Golden Age Poetry* (Cambridge MA: Harvard University Press, 1979), p. 2.

9 In this I disagree with the distinction drawn by David Carrier between ekphrasis and interpretation: 'An ekphrasis tells the story represented, only incidentally describing pictorial composition. An interpretation gives a systematic analysis of composition. Ekphrases are not concerned with visual precedents. Interpretations explain how inherited schema are modified. An ekphrasis only selectively indicates details; an interpretation attends to seemingly small points which may, indeed, change how we see the picture as a whole when they are analysed. An interpretation treats the picture as an image, and so tells both what is represented and how it is represented.' Carrier is concerned with historical developments in writing about art, and so his account has a different emphasis to my own. 'Ekphrasis and Interpretation: Two Modes of Art History Writing', *The British Journal of Aesthetics*, 27:1 (1987), 20–31 (21).

10 John Hollander explores the distinction between 'notional' and 'actual' ekphrasis in the introduction to *The Gazer's Spirit: Poems Speaking to Silent Works of Art* (Chicago: University of Chicago Press, 1995), pp. 3–91.

11 I have confined myself primarily to examples of ekphrasis from the nineteenth and twentieth centuries, but the tradition of ekphrastic writing and inter-artistic encounter is a particularly rich one in the Renaissance. For a thorough explication of these and other early modern literary ekphrases see Heffernan, *Museum of Words*, pp. 46–90. See also Alastair Fowler's *Renaissance Realism: Narrative Images in Literature and Art* (Oxford: Oxford University Press, 2003). Fowler's exploration of narrative time in history painting overlaps in

some respects with the notions I raise in Chapter 3. Mack Smith explores the relation of ekphrastic digression to the shifting history of the novel's claim to verisimilitude, or 'realism': 'many ekphrastic scenes in novels contrast forms of art illustrating different modes of rendering. Either two textual artefacts representing the aesthetic views of two characters are paired in a debate on artistic representation, or a single artefact informs this debate. The debate, an interpretive code for the text's mimesis, is often replicated in corresponding scenes throughout the narrative and creates an ekphrastic system in which literary language refers, through these interpolated artefacts, to the rhetorical dimension of its mimesis' (p. 11).

12 Poetry, for Sir Philip Sidney, was 'an art of imitation, for so Aristotle termeth it in the word *mimesis* – that is to say, a representing, counterfeiting, or figuring forth – to speak metaphorically, a speaking picture – with this end, to teach and delight'. *A Defence of Poetry* (c. 1580), in *Miscellaneous Prose of Sir Philip Sidney*, ed. Katherine Duncan-Jones and Jan Van Dorsten (Oxford: Clarendon Press, 1973), pp. 78–9.

13 Christopher Braider, *Refiguring the Real: Picture and Modernity in Word and Image 1400–1700* (Princeton: Princeton University Press, 1993): 'the doctrine of the Sister Arts is the single most tangible fact about Western art and poetry alike from the sixteenth to the end of the eighteenth century' (p. 6).

14 The classic study of the subject is Rensselaer W. Lee, *Ut Pictura Poesis: The Humanistic Theory of Painting* (New York: Norton, 1967). Lee identifies five categories in which the closest analogies were drawn between the Sister Arts: Imitation, Invention, Expression, Decorum and Learning. 'Critics for two centuries believed that it was in pictorial vividness of representation, or, more accurately, of description – in the power to paint clear images of the external world in the mind's eye as a painter would record them on canvas – that the poet chiefly resembled the painter' (p. 4). See also Henryk Markiewicz, '*Ut Pictura Poesis*: A History of the Topos and the Problem', *New Literary History*, 18 (1987), 535–58. See also Roy Park, '"Ut Pictura Poesis": The Nineteenth Century Aftermath', *Journal of Aesthetics and Art Criticism*, 28 (1969), 155–64; and John Barrell's study of the civic humanist theory of painting in *The Political Theory of Painting from Reynolds to Hazlitt* (New Haven and London: Yale University Press, 1986).

15 *The Works of John Dryden: Prose 1691–1698*, ed. A.E. Wallace Maurer (Berkeley: University of California Press, 1989), XX, p. 71.

16 Gottfried Ephraim Lessing, *Laocoön*, trans. Ellen Frothingham (New York: Sampson, Low Marston, Low & Searle, 1957), p. 109.

17 By the Renaissance writer Lodovico Castelvetro, for example, and in England in the early eighteenth century by Lord Shaftesbury and James Harris; in France by La Fontaine. (See Lee, *Ut Pictura Poesis*, and John Bender, *Spenser and Literary Pictorialism* (Princeton: Princeton University Press, 1972), p. 13.)

18 E.H .Gombrich, *Art and Illusion* (6th edition; London: Phaidon, 2002), p.306.

Gombrich's work has been the most influential study of the ways in which we read or perceive pictures within time.

19 Michael Baxandall, *Patterns of Intention: On the Historical Explanation of Pictures* (New Haven: Yale University Press, 1985), p. 3.

20 Oscar Wilde, *Plays, Prose Writings and Poems* (London: Everyman, 1996), p. 119.

21 *Oxford Classical Dictionary*, p.191; Heffernan, *Museum of Words*, p.3; Murray Krieger, *Ekphrasis: The Illusion of the Natural Sign* (Baltimore: Johns Hopkins University Press, 1992), p. 6; Jean Hagstrum, *The Sister Arts* (Chicago: University of Chicago Press, 1958), p. 18; Smith, *Literary Realism and the Ekphrastic Tradition*, p. 5; Leo Spitzer, 'The "Ode on a Grecian Urn", or Content vs. Metagrammar', in *Essays on English and American Literature* (Princeton: Princeton University Press, 1962), p. 72; John Hollander, 'The Gazer's Spirit: Romantic and Later Poetry on Painting and Sculpture', in Gene W. Ruoff (ed.), *The Romantics and Us: Essays on Literature and Culture* (New Brunswick and London: Rutgers University Press, 1990), p. 130.

22 Heffernan, *Museum of Words*, p. 1.

23 This distinction dates back to Plato's *Cratylus* (360 BCE).

24 A fuller exploration of Magritte's painting can be found in Michel Foucault's *Ceci n'est pas une pipe* (1973), trans. James Harkness (Berkeley: University of California Press, 1982) and Heffernan's *Cultivating Picturacy* (Waco, TX: Baylon University Press, 1993), pp. 23–5. Magritte painted several versions of *Ceci n'est pas une pipe*, and the painting, or the image-text, has become familiar enough to be borrowed for the Nike logo in an advertising campaign carrying the tag: *Ceci n'est pas une nike*.

25 The most extensive study of the history of the notion of a struggle between the 'natural' and the 'arbitrary' sign is Krieger's *Ekphrasis*.

26 Norman Bryson, *Vision and Painting: The Logic of the Gaze* (Basingstoke: Macmillan, 1983), p.6. Bryson's study is an important demolition of this myth. See also Roland Barthes, *Image Music Text*, trans. Stephen Heath (London: Fontana, 1977): 'general opinion … has a vague conception of the image as an area of resistance to meaning – this in the name of a certain mythical idea of Life: the image is re-presentation, which is to say ultimately resurrection, and, as we know, the intelligible is reputed antipathetic to lived experience. Thus from both sides the image is felt to be weak in respect of meaning: there are those who think that the image is an extremely rudimentary system in comparison with language and those who think that signification cannot exhaust the image's ineffable richness. Now even – and above all if – the image is in a certain manner the *limit* of meaning, it permits the consideration of a veritable ontology of the process of signification. How does meaning get into the image? Where does it end? And if it ends, what is there *beyond*?' (p. 32).

27 Mitchell, *Iconology*, p. 38. Or in David Carrier's phrase: 'Visual thinking is verbally structured by the rhetoric of art writing.' *Writing about Visual Art* (New York: Allworth Press, 2003), p. 14.

28 Mitchell seeks to 'retrace the steps by which the notion of the image as a transparent picture or "privileged representation" took over our notions of mind and language. If we can understand how images have come to possess their present power over us, we may be in a position to repossess the imagination that produces them' (*Iconology*, p. 31). See also, P.N. Furbank, *Reflections on the Word 'Image'* (London: Secker and Warburg, 1970): 'You can never stand back and scrutinize a mental image, since you are fully occupied in creating it – it represents your consciousness in action' (p. 13). See also Richard Rorty, *Philosophy and the Mirror of Nature* (Princeton: Princeton University Press, 1979).

29 John Bender's distinction between description and pictorialism is also significant when we think about the relationship between word and image: 'poetry is pictorial not when its formal organization reminds us of a painting or drawing, but when its relationship to our experience of the visual world is analogous to the relationship of the visual arts to that world. We must try to account for the apparent fact that the effect of reading poetry can seem like the effect of seeing these formal analogues of the visual world called pictures ... The fascinating question is not what great paintings a particular poem evokes, but how poems which attempt to imitate our experience of real and imagined visual worlds can seem like pictures at all.' *Spenser and Literary Pictorialism* (Princeton: Princeton University Press, 1972), p.24.

30 William Empson, 'Rhythm and Imagery in English Poetry', *The British Journal of Aesthetics*, 2:1 (January 1962), 36–54 (45). Addressing himself specifically to the 'Imagist account of the human mind', Empson complains that such an account results in a model of mind that is 'totally subhuman, sub-canine for that matter, the mind of a blackbeetle' (50). The classic essay arguing for the non-equivalence of verbal and pictorial media is E.H. Gombrich's 'The Visual Image', *Scientific American*, 227 (September 1972), 82–96. For a further explanation of some of the difficulties in thinking about 'image' as a term in literary studies see Albert Cook, *Figural Choice in Poetry and Art* (Hanover and London: University Press of New England, 1985), especially chapter two, 'The Range of Image'. For a study of 'visual imaging' as a part of literary analysis, which draws upon research in the fields of cognitive science, neuropsychology and psychoanlysis, see Ellen J. Esrock, *The Reader's Eye: Visual Imaging as Reader Response* (Baltimore: Johns Hopkins University Press, 1994).

31 'If you use the word "image" as a synonym for "metaphor" – that is to say, to signify a comparison – it is hard to see how this squares with the natural sense of the word "image", as meaning a likeness, a picture, or a simulacrum. For, after all, a comparison is not a picture' (Furbank, *Reflections* p. 1). See also Ray Frazer, 'The Origin of the Term *Image*', *English Literary History*, 27 (1960), 149–62. According to Frazer, 'The figurative meaning of image was first employed by Dryden' (158).

32 Mitchell, *Iconology*, p. 21. See also the opening of John Berger's *Ways of Seeing* (London: BBC and Penguin, 1972).

33 Krieger, *Ekphrasis*, p. 68. A brief summary of the concept can be found in David Marshall, *The Frame of Art: Fictions of Aesthetic Experience, 1750–1815* (Baltimore: Johns Hopkins University Press, 2005), p. 216.

34 The best study of this see-saw history is Krieger's *Ekphrasis*.

35 W.J.T. Mitchell, *Picture Theory: Essays on Verbal and Visual Representation* (Chicago: University of Chicago Press, 1994), pp. 152–63.

36 Scott, 'The Rhetoric of Dilation', 302. Christopher Braider (*Refiguring the Real*) sets out to illumine 'the deep ambivalence toward the incorrigible "carnality" of visual art reflected in the way Western culture has consistently privileged the spiritualising scriptural Word, the simultaneously hieratic and aristocratic intelligibility of the Text, over the vulgar visibility of idolatrous pictures' (p. 13).

37 'The contest it [ekphrasis] stages is often powerfully gendered: the expression of a duel between male and female gazes, the voice of male speech striving to control a female image that is both alluring and threatening, of male narrative striving to overcome the fixating impact of beauty poised in space' (Heffernan, *Museum of Words*, p. 1).

38 See the work of Arthur C. Danto, especially *The Transfiguration of the Commonplace* (Cambridge, MA: Harvard University Press, 1981). For a gentle refutation of this theory see Noël Carroll, *Philosophy of Art* (London: Routledge, 1999), pp. 30–3.

39 *Derek Mahon: Selected Poems* (London: Penguin, 1990), pp. 120–1.

40 Svetlana Alpers's important study, *The Art of Describing: Dutch Art in the Seventeenth Century* (Chicago: Chicago University Press, 1983), argued that 'central aspects of seventeenth-century Dutch art – and indeed of the northern tradition of which it is part – can best be understood as being an art of describing as distinguished from the narrative art of Italy' (p. xx). Alpers argued against readings of Dutch art such as Erwin Panofsky's, which sought out the 'disguised symbolism': 'northern images do not disguise meaning or hide it beneath the surface but rather show that meaning by its very nature is lodged in what the eye can take in – however deceptive that might be' (p. xxiv).

41 See Alpers, *The Art of Describing*, pp. xv–xxvii.

42 Jacques Derrida's notion of the 'parergon' is worth quoting: 'A parergon comes against, beside, and in addition to the *ergon*, the work done (fait), the fact (le fait), the work, but it does not fall to one side, it touches and co-operates within the operation, from a certain outside. Neither simply outside nor simply inside. Like an accessory that one is obliged to welcome on the border, on board.' *The Truth in Painting*, trans. Geoff Bennington and Ian Mcleod (Chicago: University of Chicago Press, 1987), p. 54.

BEAUTY AND TRUTH

'BEAUTY' AND 'TRUTH': those words to make us pause. The old man in the Lewis Carroll poem who offers advice to the aspiring young poet has no hesitation:

> 'Then, if you'd be impressive,
> Remember what I say,
> That abstract qualities begin
> With capitals alway:
> The True, the Good, the Beautiful –
> Those are the things that pay!'[1]

If for centuries poets had capitalised upon these abstract qualities, the cynicism of the old man's advice would have reassured Carroll's readership of the 1860s that such impostures were a thing of the past. The platitude of our own time would be to assume that to risk saying anything at all about 'beauty' and 'truth' without the self-consciousness and modesty implied by the quotation marks is to risk appearing naive, or worse. This is because, notwithstanding the fact that there has never been an end to arguments about the nature of the good, the beautiful or the true, or what if anything they have in common, it is now often assumed that these very categories have been changed for us. And so it is assumed that this in turn radically alters our relation to art, both to contemporary art and to the art of the past (where we have traditionally discovered a clear relation to the 'things that pay'). The first sentence of Theodor Adorno's *Aesthetic Theory* (1970) is uncompromising: 'It is self-evident that nothing concerning art is self-evident anymore, not its inner life, not its relation to the world, not even its right to exist.'[2] The intense act of attention John Keats paid to a Grecian urn in 1819 certainly went so far as to question

its 'inner life' and its 'relation to the world'. But was it so bold as to question its right to exist?

Ode on a Grecian Urn

Thou still unravish'd bride of quietness,
 Thou foster-child of silence and slow time,
Sylvan historian, who canst thus express
 A flowery tale more sweetly than our rhyme:
What leaf-fring'd legend haunts about thy shape
 Of deities or mortals, or of both,
 In Tempe or the dales of Arcady?
 What men or gods are these? What maidens loth?
What mad pursuit? What struggle to escape?
 What pipes and timbrels? What wild ecstasy?

Heard melodies are sweet, but those unheard
 Are sweeter; therefore, ye soft pipes, play on;
Not to the sensual ear, but, more endear'd,
 Pipe to the spirit ditties of no tone:
Fair youth, beneath the trees, thou canst not leave
 Thy song, nor ever can those trees be bare;
 Bold lover, never, never canst thou kiss,
 Though winning near the goal – yet, do not grieve;
She cannot fade, though thou hast not thy bliss,
 For ever wilt thou love, and she be fair!

Ah, happy, happy boughs! that cannot shed
 Your leaves, nor ever bid the spring adieu;
And, happy melodist, unwearied,
 For ever piping songs for ever new;
More happy love! more happy, happy love!
 For ever warm and still to be enjoy'd,
 For ever panting, and for ever young;
 All breathing human passion far above,
That leaves a heart high-sorrowful and cloy'd,
 A burning forehead, and a parching tongue.

Who are these coming to the sacrifice?

To what green altar, O mysterious priest,
Lead'st thou that heifer lowing at the skies,
 And all her silken flanks with garlands drest?
What little town by river or sea shore,
 Or mountain-built with peaceful citadel,
 Is emptied of this folk, this pious morn?
And, little town, thy streets for evermore
Will silent be; and not a soul to tell
 Why thou art desolate, can e'er return.

O Attic shape! Fair attitude! with brede
 Of marble men and maidens overwrought,
With forest branches and the trodden weed;
 Thou, silent form, dost tease us out of thought
As dost eternity: Cold Pastoral!
 When old age shall this generation waste,
 Thou shalt remain, in midst of other woe
Than ours, a friend to man, to whom thou say'st,
'Beauty is truth, truth beauty,' – that is all
 Ye know on earth, and all ye need to know.[3]

If for Keats the urn 'dost tease us out of thought / As dost eternity', we might ponder what *'out of* thought' might mean to us. Are we able to understand and share Keats's response to this particular object, or is the experience one that is *'out of'* our own field of comprehension? What is our relation to the 'beauty' of the urn, or indeed to the poetic achievement of Keats's celebrated ode for that object? The philosopher of art Arthur C. Danto has described the twentieth-century break with the art of the past as one characterised by a crisis surrounding the notion of the beautiful and its use as a description of artworks:

> 'Beautiful' itself just became an expression of generalised approbation, with as little descriptive content as a whistle someone might emit in the presence of something that especially wowed them ... To speak of something as beautiful ... is not to describe it, but to express one's overall admiration. And this could be done by just saying 'Wow' – or rolling one's eyes and pointing to it.[4]

This sense of redundancy isn't simply one to do with the overuse of an

adjective, but a deeper suspicion of the very concept itself. In this chapter I would like to place Keats's ode in relation to this 'problem', which is central to the aesthetics of ekphrasis. And it is an aesthetic question that the ode, arguably the most famous example of ekphrasis in our language, invites us to think about with a general emotive power, a beauty, which may itself be a temptation to roll the eyes and whistle.

In the general cultural uproar following the arrival and exhibition of the Parthenon or Elgin marbles in London in 1816, John Keats thought carefully about classical art. As it is doubtful whether there ever was a single Grecian urn that Keats had a mind to write an ode 'on' (rather than 'for'), but rather a range of funerary urns, decorative vases and other grand objects seen either in collections of illustrations or at the British Museum, the permanent object seems to be the ode itself – if we can think of a poem as a permanent object, and especially one that foresees a future moment of 'other woe / Than ours' in which it is the urn rather than the poem that 'shalt remain ... / a friend to man'.[5] Nevertheless the poem remains, like a thing in the world, and fascinates us with its own rapt attention and excitement in the presence of an ideal and beautiful, if imaginary object. It is probably the most sustained and densely worked meditation we have upon a certain set of paradoxes that, as we shall see, are central to ekphrasis, in a poet much drawn to the exploration of paradox and contradictoriness. Principally, these are the paradoxes of silence/speech, of stillness/movement, and of time/eternity. The Grecian urn is a silent object, a 'bride of quietness', a 'foster-child of silence', and yet the poet is breaking that silence in speaking for the mute object. At the same time the silence of the urn speaks more forcefully and more 'sweetly' than the poem, although it is the poem, paradoxically, that must speak of this envied ability to 'express'; as it is the poem that must hint at this spiritual music of 'no tone'. And so as the 'leaf-fring'd legend haunts' about the urn's 'shape', the poem haunts the urn, encircles it with thought, seeking perhaps to violate this (female) silence with the 'mad pursuit' of male speech (as the 'maidens loth' depicted on the urn 'struggle to escape' their pursuers). The ode, then, submits the urn to the interrogation of description and response, to what has been described as a 'drama of cross-questioning', as if compelled to enact such a drama, even though it knows that its questions are unanswerable ('What men or gods are these?') and its emotions unreturned.[6]

Most potently of all the ode dwells upon the paradox of what I have called the 'for ever now', that is the intersection of the eternal with the pulse and flow of the temporal, the single living moment with the ever-lastingness of that moment as it is frozen in marble. Keats is profoundly drawn to such a

poet gives his assent or suspends his resistance to the power of the aesthetic object.[13] Even in the contemplation of the harsh truth that the urn has transformed the suffering of actual human life and history into the cold marble attitudes of art, there may be (the poet might claim) something beautiful, or something perceived as profoundly significant. Nowhere is beauty or truth equated with the good or the easy or the merely comforting, since the ode famously modulates between the pleasure and pain given by contemplation of the object. This feeling then of assent or of recognition – perhaps it lies at the heart of an aesthetic response – seems to resist interrogation, seems in fact to define a limit of knowledge: 'that is all / Ye know on earth, and all ye need to know'. There is (the poet might claim) something self-enclosed and unparaphraseable about the beauty of the Grecian urn, something surplus to description, irreducible. The feeling this produces is one that belongs to a unique category of emotion (an aesthetic one). But this does not mean that it is a state of feeling or affect unburdened by thought. On the contrary, it involves the steadfast contemplation and cognitive apprehension of difficult paradoxes and truths, a process envisaged in the poem perhaps as a form of 'sacrifice': the impossibility, for example, of imagining eternal happiness; the difficulty of reconciling artistic representation with historical truth; the inevitable impotence or indifference of art in the face of suffering. The poet John Keats had moved towards the point where he could grasp this 'truth' and experience this aesthetic feeling. 'What the imagination seizes as Beauty must be Truth', he wrote to his friend Benjamin Bailey in a letter of November 1817, cashing in on the capitals and demonstrating his predilection for what he called 'axioms', sayings that have since acquired an almost embarrassing currency as systematic or philosophical. 'I am certain of nothing but the holiness of the Heart's affections and the truth of Imagination', the same letter argues, rapidly and suggestively working through a sequence of thoughts that connects sensation with imagination, in order to distinguish an intuitive (imaginative) understanding of 'Truth' from the fruitless method of 'consequitive [sic] reasoning'. The letter speculates too about an after-life where 'we will enjoy ourselves here after by having what we called happiness on Earth repeated in a finer tone'.[14] (Like the finer ditties of 'no tone' in which silence offers us the finest tone of all.) 'All ye know on earth' might imply a more perfect state in the hereafter, an unearthly place, where we, like the urn, will know more. A month later, in a letter to his brothers George and Tom, Keats spoke of 'negative capability', that is the ability to remain in 'uncertainties, Mysteries, doubts' without any 'irritable reaching after fact & reason'.[15] It is just such an openness to 'mystery' that the ode invites us to

receive at its close. The heart, the affections, sensation, imagination, holiness, the Beautiful, the True, the hereafter, Mysteries: the aphorism in the ode seems to give succinct expression to a complex body of ideas and feelings, and ideas about feelings, through which Keats had been working over the previous two years. Reduced to 'Beauty is truth, truth beauty' the statement may seem tautologous and unproved by the poem, but its oracular or cryptic shorthand is part of the point – firstly, of a sense of difficult knowledge achieved by the poet and the poem, but perhaps more importantly, of the limits to what a Grecian urn is able to 'say' to human beings. Finally, as Keats knows, the urn cannot explain itself to us.

Susan Wolfson gives voice to an understandable frustration with such failure: 'Urn and aphorism together go round and round, each serenely self-enclosed, endlessly circular, resonating with mysterious promise, but "still unravish'd" at last'.[16] The reader then might find himself or herself forced into a position in relation to Keats's ode entirely analogous to that of Keats and the urn, i.e. one of a burning desire to penetrate its meaning, a desire which is frustrated in some way by resistance.[17] The ode might seem in fact to *fail* to express a coherent or potent truth, even a truth about the limits of knowledge or the nature of aesthetic experience. Some critics read the ode as working in an openly ironic mode and therefore as offering this failure as the whole point of the poem: the speaker of the ode is mocked for sententiousness or, with a pun Keats might have liked, attitudinizing.[18] If, finally, there is something self-enclosed, unparaphraseable and inscrutable about 'beauty' or 'aesthetic feeling', what can be usefully said on the subject? What do poems hope to achieve through being discursive, talkative, even garrulous about art? We might be tempted to say that there is something wrong or fraudulent about such talk; that is, it might seem like a way of ignoring certain realities (political, social, economic), or hiding away from them by preferring to concentrate upon the ineffable and the mysterious; a way of retreating to the comforting though imaginary realm of the 'eternal' in reaction to the uncomfortable conditions of history. The estrangement and alienation that Keats discovers in contemplation of the urn might then mirror his own anxiety as a poet struggling to find an audience and discovering poetry itself to be a marginalised activity in the marketplace. One way of easing this anxiety would be to project his self-image as a poet into posterity, and so the notion of the urn as an object of transhistorical or 'eternal' value, preserved in the sacred and decontextualised space of the museum, might simply reflect this act of wishful thinking (sometimes called 'bad faith') on the part of the poet. Does Keats have the right to treat the urn purely as an artwork, to

read and respond fancifully to the scenes represented on its surface, rather than contemplate its practical or specific function within a culture? If there is a sense of there being, as Danto puts it, 'something almost derelict or even indecent in the pursuit of beauty', then a poem in which the notion seems to be positively *enthroned* deserves to be treated with a definite scepticism.[19] On the other hand it might be argued that at some fundamental level a sense of beauty is a physiological reaction, a part of the body's response to a stimulus in the world, and therefore to deny or repress its expression – to suggest that it is ethically wrong – would be absurd. This particular type of question – of the ideology of the aesthetic – is one to which I'll return in later chapters, but this is the poem to have provoked most disagreement on the subject.

Whether the ode reverberates then with a mysterious promise of significant but rarely accessed 'truth', or merely chases its own tail and finally disappears in a hole, is actually what makes the poem most interesting. Is this circularity a great ring of light or the circumference of an abyss? The durability of these arguments has made of the ode a special case in the literary critical debates of the last fifty years. In Cleanth Brooks's *The Well Wrought Urn: Studies in the Structure of Poetry* (1949), a collection usually described as a seminal text for the New Criticism, the ode is presented as an example of coherence and self-integration, of an 'achieved harmony' arising from an 'organic context', or, in other words, from an internal richness of balanced contrarieties and paradoxes. As such it is taken by Brooks as one of several exemplary texts for a certain view of literature as finally unparaphraseable, mysterious, possibly redemptive.[20] The very figure of the 'well-wrought urn' (taken from Donne's 'The Canonization') is presented as analogous to the verbal icon of the well-written poem. Good poems are like beautiful urns: self-enclosed, autonomous, enigmatic. As William Wimsatt put it in his study *The Verbal Icon* (1954): 'A literary work of art is a complex of detail (an artefact, if we may be allowed that metaphor for what is only a verbal object), a composition so complicated of human values that its interpretation is dictated by the understanding of it, and so complicated as to seem in the highest degree individual – a concrete universal.' A poem as carefully wrought and as skilfully constructed as Keats's ode, a poem that seems in fact to be more like an object or artefact, or a literary monument, is both uniquely itself and 'universal' in its complex of essential human values. 'Complexity of form is sophistication of content', wrote Wimsatt; to grasp the meaning of the verbal icon we must understand and appreciate its form, for therein lies the sophistication.[21] And so poems such as the ode, according to this mode of criticism, enrol themselves among the priceless objects of our culture, as if John Keats himself, overawed by

the British Museum, had produced a museum piece to rival that of the most dazzling items in its collection.[22]

The notion of the verbal icon in the context of ekphrasis was developed furthest in the 1960s by Murray Krieger who explored the idea, which he argued is prominent in modernist poetics, of poetry as a spatio-temporal form in which a reconciliation may be achieved between the temporal and the timeless. A poem exists in the space of the printed page while its 'meaning' unfolds in time or in semantic sequence as we read, but that 'meaning' may be comprehended in a single moment, existing in some sense outside the temporal sequence of each individual reading and the spatial confines of the page. The concretely individual and unique verbal artefact may participate then in a universal meaning that transcends its specific context and its particular condition; and this is achieved through the mystique of form. The figures on Keats's urn have an intense individuality and historical specificity, but, through the aesthetic patterns, echoes and repetitions into which they are incorporated upon the urn, they enter the 'for ever now' of art's eternity and 'in this sense attain universality'.[23] Aesthetic patterning and form, not merely in the sense of high technical competence, but also in the sense (and the two are indivisible) of complex intelligibility, promise a marvellous and perhaps mystical intersection of the timeless with the temporal or chronologically linear. This is a 'for ever now' that yields powerful meaning. For T.S. Eliot the analogy is with the Christian incarnation, in which the divine *Logos* or Word (eternal, transcendent) achieves embodiment in the flesh of Christ (mortal, individual). Is there a connection then between Keats's urn and the Chinese jar Eliot describes in the fifth section of 'Burnt Norton'?

> Words move, music moves
> Only in time; but that which is only living
> Can only die. Words, after speech, reach
> Into the silence. Only by the form, the pattern,
> Can words or music reach
> The stillness, as a Chinese jar still
> Moves perpetually in its stillness.
> Not the stillness of the violin, while the note lasts,
> Not that only, but the co-existence,
> Or say that the end precedes the beginning,
> And the end and the beginning were always there
> Before the beginning and after the end.
> And all is always now.[24]

Eliot's 'still' is indebted to the first line of Keats's ode, with its multiple sense of the spatially still (unmoving, fixed) and the temporally still (meaning 'yet' or 'always' or 'ever'), as well, I think, as the aurally still (meaning silent). And there is the further paradoxical sense of movement in stillness, of form simultaneously inhabiting time and timelessness. Could the formal properties of poems be like the form of Grecian urns and Chinese jars? Circularity, meaningful simultaneity: the end and the beginning are always already there, while the stillness of perfect form reaches into the absolute silence of eternity. These are intoxicating ideas, and they represent a kind of apotheosis for the Grecian urn, indeed for the notion of the artwork as a foretaste of eternity. Even so, for Eliot the parallels between the Chinese jar, the formal 'music' of poetry and the silence of eternity fall short of absolute correspondence, principally because these analogies are metaphorical; in other words they are parts of speech, and therefore part of the inevitable failure of speech to enter the silence or the stillness of eternity.

But this may be so for Keats too. Another way of thinking about Keats's ode is to ponder the idea of its failure or impotence as speech, with speech as a violation of a sacred silence. This possibility, that speech or language inevitably fail to reach the mute art object and that this very failure constitutes a kind of violation or insult, is often a latent assumption in thinking about ekphrasis. Poems about paintings or about objects such as the urn are often assumed in some sense to invade the sacred precincts, the silent and hallowed halls of 'art', like a vulgar and noisy visitor. Behind this assumption is the deeper sense that visual 'beauty' is superior to language because it seems not to refer to anything in the world except itself; 'beauty' in other words appears not to be a sign for something else, even though it is self-evidently meaningful – indeed it seems to radiate meaningfulness. It is in this apparently double sense of non-reference and plenitude of meaning that 'beauty' might resemble a sacred or holy silence. And we can best contemplate this silence in silence ourselves.[25]

But we could read Keats's 'failure' as entirely in harmony with the object he describes. Neither ode nor urn prefigures the silence of eternity since both are human artefacts, so that any value they have as substitutes for the 'eternal' must be limited. 'The clichés of art's reconciling glow enfolding the world are repugnant', writes Theodor Adorno. 'Art is condemned to provide the world as it exists with a consolation that – shorn of any hope of a world beyond – strengthens the spell of that from which the autonomy of art wants to free itself.'[26] In other words, art is often taken as a consolation for the fact that death annihilates our consciousness. Art softens the blow (if we take this view of death). When read as a testament to the failure of such a cliché

about art, the non-consolatory effect of the ode proves Adorno's point about the 'autonomy' of the artwork seeking to escape the 'spell' of the 'reconciling glow' for which we look in vain. Both ode and urn fail to offer figures or types of eternity that are anything other than cold and terrifying. Keats fails to wrest from the aesthetic object anything more than a certain recalcitrance, which he reads as enigmatic: 'Beauty is truth, truth beauty'. The urn is not, finally, reconciling or consoling, either as a type of eternity (is this what heaven is like?) or as a substitute for our 'hope of a world beyond'. The poem cannot enter the urn's self-enclosing, self-perpetuating form; and so the human subject (Keats) is finally unable to speak from the silent numinous centre of the artwork, except in riddles. And from this we might wonder whether in fact the urn has a silent numinous centre at all. What this failure and doubt might then signify is that the aesthetic process is working autonomously to escape an easy cliché about 'beauty' or 'eternity'. That Keats's ode has so frequently been read as strengthening the spell of art as a 'reconciling glow', whether in the Romantic sense of discovering types or foreshadowings of 'eternity' or in the New Critical idea of the verbal icon, merely confirms the commonplace trap of the aesthetic outlined by Adorno. But in its very failure to offer circular consolation we might argue that Keats's ode frees itself from an illusion. In other words, if we think of the ode as possessing a movement of thought that is self-undoing, self-exceeding and radically questioning (Adorno would call this a 'negative dialectic'), the poem seems to offer the powerful example of a strong and perhaps even revolutionary consciousness. And this would seem to present a counter-argument to those who would accuse Keats of hiding away from historical reality.[27] We might crudely put it like this: Keats moves through several stages of response to the urn, each growing out of the stage before, and each becoming both more complex and more threatening to the stable assumptions with which Keats began. The willed resolution at the poem's close merely betrays the fact that such a process is ongoing and open-ended. This is to read the poem as a drama of awakening consciousness.

Much of the critical argument about the ode and about Keats in general betrays a wider unease with the idea of writing about an art object rather than, say, what England was like in 1819. But part of our understanding of the historical period in which Keats wrote his odes may come from an understanding of the struggle this young poet had with a Grecian urn. Disturbed and moved by the beauty of the object, but unable to say exactly why or how such an object could be a 'friend to man' in historical periods distant from its own – unable in other words to connect the beauty of the object with the human story of its making, and therefore unable to make the

connection either with his own moment or with 'eternity' – Keats reveals the contradictions experienced by many in the early nineteenth century who went to look and wonder at the antiquities of the expanding British museum. And these contradictions are wholeheartedly to do with history. Nevertheless, to return to the question with which I began: the Grecian urn certainly seems to insist upon its right to exist for Keats, indeed seems to occupy a privileged place among the things of the world; moreover, for him it certainly *is* a thing of 'beauty' to be contemplated and to be described. But if we now occupy a place in time in which, as Danto puts it, the idea of 'beauty' has been in some sense 'dethroned' – a world in which a 'conceptual revolution' has taken place whereby the 'beautiful' has been purged of the kind of moral authority Keats wondered at – then how does this affect the way we read the ode?[28] I would like briefly to consider what might be thought of as two deeply contrasting afterlives for Keats's urn. The first comes from Wallace Stevens, a writer sometimes linked with Keats, and the second from Samuel Beckett who is not (but who might be). In them we may trace divergent perspectives upon the ideas of 'beauty' and 'truth', and upon the aesthetic questions and problems posed by the ode, which will be central to the chapters that follow. And in them both we find the urn transformed.

My first example is a poem from Stevens's collection *Harmonium* (1923), which tells a frustrated or awkward parable (Stevens calls it an 'anecdote') of 'the jar':

Anecdote of the Jar

I placed a jar in Tennessee,
And round it was, upon a hill.
It made the slovenly wilderness
Surround that hill.

The wilderness rose up to it,
And sprawled around, no longer wild.
The jar was round upon the ground
And tall and of a port in air.

It took dominion everywhere.
The jar was gray and bare.
It did not give of bird or bush,
Like nothing else in Tennessee.[29]

If we think of the jar as a relative of the Grecian urn, then we might say it has either been reduced to straitened circumstances (in contrast to Eliot's Chinese jar) or, if you prefer, raised to a disturbing and bewildering glory. The placing of the jar – the original function of which is not recalled – seems to have inaugurated a kind of ordering over the landscape, a certain power or dominion, as if a spell had been cast and mysterious homage had been paid to this simple object. And yet it is a mere 'jar' (not a funerary urn, not a monument), 'gray and bare' and not itself participating in natural process ('It did not give of bird or bush'). Unique, cold, and yet talismanic, alchemic, the jar and its dominion perhaps offer a sly commentary upon the Grecian urn and upon the kind of aesthetic, cultural or mystical meanings Keats had discovered in that object (and which Eliot would discover in the Chinese vase); thereby also commenting upon the homage criticism has paid to Keats's ode. But in this case the strange magic of the Tennessee jar cannot be separated from the workings of the poem. If complexity of form is bound up with sophistication of content, then here that critical precept seems part of the challenge of the poem. 'Anecdote of the Jar' in fact enacts a kind of speech-act spell or incantation. With its flat, obvious, internal rhyming ('around ... round ... ground') and self-returning close, it offers an ugly impression or perhaps a parody of numinous circularity, of internal coherence. Is this then a rebuke or a tribute to John Keats? Is it a contradiction or a validation of the kind of critical reading that would privilege the verbal icon? Is the point of Stevens's conceit that we should distrust any notion of a mystique of form that promises to transform ordinary objects into powerful and commanding symbols? Or is it perhaps participating itself in the idea of the verbal icon, with its achieved harmony, its unparaphraseable luminosity, and with the promise of redemption? 'The wilderness rose up to it, / And sprawled around, no longer wild.' Tennesse is not Hellas, which may be part of the point, and yet the jar, placed there by the poet, is capable of summoning (perhaps conjuring) a transcendent potency that is both inscribed and mocked by the deadpan banality of the poem. This then is a poem both more and less sceptical than Keats about the aesthetic power of the object and the capacity to participate in that power through poetry. It half-believes in and half-mocks the idea of the potency of the art object, but discovers such potency in ordinary things: a jar, an anecdote.

What happens when we deny this potency outright? What happens to the urn and to the ode when their aesthetic qualities are cancelled out, when the notion of 'beauty' and 'truth' (those 'topical preferences of the philistine', as Adorno calls them) cease to function, or function only problematically?[30]

One strand of modernist writing in the twentieth century develops what we might think of as an anti-aesthetic, i.e. writing which foregrounds or privileges categories of the ugly and the dissonant, the disgusting and the non-consolatory. Samuel Beckett's novels and plays for example disabuse us of any easy notions of 'beauty' and 'truth', choosing rather to explore the consciousness of those to whom aesthetic bliss is unavailable, unknowable, or even execrable. As Beckett puts it, his is an 'art that turns from [these things] with disgust, weary of puny exploits, weary of pretending to be able, of being able'.[31] Or as Adorno, one of Beckett's most acute readers, describes his work: '[It is] poetry retreated into what abandons itself unreservedly to the process of disillusionment.'[32] Throughout Beckett's writing we encounter urns and jars, dustbins, dirty receptacles, and ash-heaps, far removed from the Grecian urn or the Chinese jar, not artworks at all in fact but incarcerating objects that may recall the idea of the ornamental or decorative only in their own dereliction, and yet which are inevitably in a relation to the same larger arguments as Keats's ode – in Beckett's case to the insistence that 'eternity' is a hole and not a halo. The heads of the actors in Samuel Beckett's *Play* (written 1962–63) protrude from 'three identical grey urns ... about one yard high ... Faces so lost to age and aspect as to seem almost part of urns.'[33] His urns and jars and dustbins are receptacles of consciousness, props and cells for the body from which thinking and talking continue in the circles or cycles of discourse, never silent and never reaching an end. The narrator of Beckett's *The Unnameable* (1952; translated from the original French by the author in 1959), the final part of his great trilogy, describes his circumstances thus: 'Stuck like a sheaf of flowers in a deep jar, its neck flush with my mouth, on the side of a quiet street near the shambles, I am at rest at last.'[34] His situation is meant to recall that of the damned in the ninth circle of Dante's hell, and yet he is 'at rest at last'. Taken out of his receptacle once a week by the proprietress of 'the chop-house across the street' so that the jar might be emptied, the speaker keeps on living on. His jar is festooned 'with Chinese lanterns' (a memory of Eliot perhaps) and has been raised on a pedestal 'so that the passer-by might consult with greater ease the menu attached to it'. His severely limited movements are further restricted by 'a collar, fixed to the mouth of the jar' which now 'encircles [his] neck, just below the chin'. Beckett's speaker is obviously far removed from the possibility of experiencing the mystery of the aesthetic object in the sense in which Keats experienced such mystery. He wouldn't be allowed inside the British Museum, even if he could get there. But it is precisely this incapacity that places Beckett's writing in an interrogative relation to

the literature of normative aesthetic experience, as exemplified by Keats's ode. That is, the *inability* of Beckett's characters radically calls into question the *ability* of Keats to conduct a dialectical argument around a work of art. The work of art is no longer there at all in fact, but has been reduced to a collar restricting the movements of the speaker. If then we are tempted to believe that the turns and counter-turns of the ode have exhausted the questions posed by the urn, or have perfectly encompassed an idea, either with internal coherence and 'organic' unity or with thrilling indeterminacy, then Beckett's jar collapses such an illusion in upon itself by transforming the notion of circularity completely, so that it no longer stands for a plenitude of meaning but rather signifies an absolute emptiness or void. In other words the attraction and repulsion Keats displays towards the urn are shown merely to be two sides of the same assumption, which is that the aesthetic object, whatever its teasing nature may be, nevertheless exists in the world. The opposite of this assumption is that it has ceased to exist, or that its right to exist has been denied.

And yet Beckett's speaker is 'at rest at last'. This 'rest' may be the repose of a consciousness excluded from all possibility of what we think of as normative experience, the experience within which we discover the beautiful and the true. We might ask then, what is the significance of a mode or category of knowledge that is not, at least potentially, available to each of us? Eighteenth-century philosophers of aesthetics had sought to build their theories upon the assumption of a shared category of affect and judgement: i.e., that there was such a thing as an aesthetic feeling which we all (at least potentially) might share, and that this experience involved a certain kind of intuitive knowledge. In Beckett's writing this is often presented as an impossible or insufferable assumption to live with. Any notion of the 'beautiful' and 'true' as normative, healthy, as a part of 'culture', certain to be enriching, determining our humanity, merely exerts a severe and intolerable pressure, which is in part a moral pressure, and which is resisted and denied or more often simply not known by Beckett's characters. *Must* we understand what Keats felt for a Grecian urn? What of those who are weary of pretending to see these things, weary of acclaiming the 'beauty' of artworks? What of those who are weary of such beauty in itself? And what of those who seem abandoned to places and conditions far removed from the social discourse in which arguments about the beautiful and the true take place at all? Freed from the pressure of these abstract qualities, might we not find ourselves 'at rest at last'? Beckett's writing labours indefatigably to reveal the fact that 'beauty' might also be a kind of burden and offence. Here in *Endgame*, for example, Clov (having

tended to Nag and Nell incarcerated in their dustbin-urns), gives memorable expression to this pressure-to-see:

> CLOV: [*Fixed gaze, tonelessly, towards auditorium.*] They said to me, That's love, yes yes, not a doubt, now you see how –
> HAMM: Articulate!
> CLOV: [*As before*]: How easy it is. They said to me, That's friendship, yes yes, no question, you've found it. They said to me, Here's the place, stop, raise your head and look at all that beauty. That order! They said to me, Come now, you're not a brute beast, think upon these things and you'll see how all becomes clear. And simple! They said to me, What skilled attention they get, all these dying of their wounds.[35]

'All that beauty. That order!' Clov knows the words but not their meaning. The normative discourse of beauty and friendship and love and order seems to him alien, even punitive. His failure to learn how to live in this mode marks him out to himself as a beast, and yet this is not Clov's own failure, merely how Clov happens to be. It would therefore be wrong to assume that Clov must be an 'abnormal' or 'dysfunctional' person who unfortunately cannot see what others can see (although this alone might pose an unanswerable challenge to the 'beautiful'). Rather, his alienation, his sense of being tyrannised by those who are able to speak of beauty and order and love, is actually or potentially the condition of anyone. His displacement from the world of 'common' feeling or understanding, which he hears as the disciplining voice of a captor or gaoler goading him to see how simple and easy it is to grasp such communality, represents the resistant, unassimilable element that haunts all such appeals to shared knowledge. At the centre of the philosophy of aesthetics, and also at the heart of literary ekphrasis, lies this potential negative: the denial of the work of art.

Beckett described all art as 'the desecration of silence'.[36]

NOTES

1 'Lewis Carroll' (Charles Dodgson), 'Poeta fit, non nascitur' ('Poets are made, not born'), *Phantasmagoria and Other Poems* (1869), in *Lewis Carroll: The Complete Works* (London: CRW Publishing, 2005), p. 33.

2 Theodor Adorno, *Aesthetic Theory*, trans. Robert Hullot-Kentor (London and New York: Continuum, 2002), p. 1; originally published in Germany as *Ästhetische Theorie* (1970).

3 All quotations from Keats's poetry are taken from *John Keats: Selected Poetry*, ed. Nick Roe (London: Everyman, 1995).

4 Arthur C. Danto, *The Abuse of Beauty: Aesthetics and the Concept of Art* (Chicago: Open Court, 2003), pp. 7–8.

5 See Ian Jack, *Keats and The Mirror of Art* (Oxford: Oxford University Press, 1967), pp. 214–24.

6 Susan J. Wolfson, *The Questioning Presence: Wordsworth, Keats, and the Interrogative Mode in Romantic Poetry* (Ithaca and London: Cornell University Press, 1986), p. 319. Andrew Bennett comments: 'The questions are rhetorical, both because they have no answers and because it is not the answers that are important but the effect of the questions.' *Keats, Narrative and Audience* (Cambridge: Cambridge University Press, 1994), p. 137.

7 Adorno, *Aesthetic Theory*, p. 27.

8 For full discussion of textual variants see Jack Stillinger, *The Texts of Keats's Poems* (Cambridge, MA: Harvard University Press, 1974), pp. 245–7.

9 William Empson, *The Structure of Complex Words* (London: Chatto & Windus, 1969), p. 368.

10 Helen Vendler, *The Odes of John Keats* (Cambridge MA: Harvard University Press, 1983), p. 147.

11 I.A. Richards, *Practical Criticism: A Study of Literary Judgement* (London: Kegan Paul, 1929), pp. 186–7; Stuart M. Sperry, *Keats the Poet* (Princeton: Princeton University Press, 1973), p. 278; T.S. Eliot, 'Dante', in *Selected Essays* (London: Faber, 1964), pp. 230–1; Cleanth Brooks, *The Well Wrought Urn: Studies in the Structure of Poetry* (London: Denis Dobson, 1949), p. 152; Empson, *The Structure of Complex Words*, p. 371; Jean-Claude Sallé, 'The Pious Frauds of Art: A Reading of the "Ode on a Grecian Urn"', *Studies in Romanticism*, 11 (1972), 79–93 (91). Mitchell, *Picture Theory*, p. 171; Sperry, *Keats the Poet*, p. 276; Kenneth Burke's famous 'joycing' of the lines – though never explicitly spelled out – is to be found in *A Rhetoric of Motives* (Berkeley: University of California Press, 1969), p. 204; Quiller-Couch's remark is quoted in W.J. Bate, *John Keats* (London: Oxford University Press, 1963), p. 517. William Empson attributes the remark to Robert Bridges (Empson, *Structure of Complex Words*, p. 368). Andy Warhol's formulation accompanies a design for shoes and is part of the larger collection of such designs (with doctored proverbs and mottos) entitled *A la Recherche du Shoe Perdu* (1955). See *Andy Warhol: A Retrospective* (New York: MOMA, 1989), p. 105.

12 See, for example, Plato, *Symposium*.

13 Empson, *The Structure of Complex Words*, p. 4.

14 *Letters of John Keats*, ed. Robert Gittings (Oxford: Oxford University Press, 1970), pp. 36–7 (hereafter, *Letters*). See also Keats's important poem 'Dear Reynolds, as last night I lay in bed', Roe, *Selected Poetry*, pp. 140–2.

15 *Letters*, p. 43.

16 Wolfson, *The Questioning Presence*, p. 327.

17 'The story of "Ode on a Grecian Urn" is the story not only of desire and seduction, but also of the desire and seduction of the reader: our apprehension of Keats's poem is prefigured word for word by the narrator's apprehension of the urn: the story – history, tale, legend – involves the necessary connection not between events within the story but between the poem and its audience.' Bennett, *Keats, Narrative, Audience*, p. 143.

18 See David Simpson, *Irony and Authority in Romantic Poetry* (Totowa, NJ: Rowman and Littlefield, 1979). Douglas Wilson positions the poem in relation to Friedrich von Schiller's theories of Romantic irony: 'Reading the Urn: Death in Keats's Arcadia', *Studies in English Literature, 1500–1900*, 25:4 (Autumn 1985), 823–44.

19 Danto, *The Abuse of Beauty*, p. 28. The best summary of these arguments is offered by A.W. Phinney, 'Keats in the Museum: Between Aesthetics and History', *Journal of English and Germanic Philology*, 90 (1991), 208–29.

20 Brooks, *Well Wrought Urn*, pp. 179; 152.

21 W.K. Wimsatt, *The Verbal Icon: Studies in the Meaning of Poetry* (Kentucky: University of Kentucky Press, 1954), pp. 77; 82.

22 This is an argument best formulated by Marjorie Levinson in *Keats's Life of Allegory: The Origins of a Style* (Oxford: Oxford University Press, 1988).

23 Murray Krieger, *Ekphrasis*, pp. 277–8. Krieger's well-known essay '*Ekphrasis* and the Still Movement of Poetry; or *Laokoön* Revisited' is reprinted as an appendix to his longer study.

24 T.S. Eliot, 'Burnt Norton', *The Complete Poems and Plays of T.S. Eliot* (London: Faber and Faber, 1969), p. 171.

25 I will have more to say about this in later chapters.

26 Adorno, *Aesthetic Theory*, pp. 1–2.

27 These arguments are brilliantly summarised in Robert Kaufman's essay 'Negatively Capable Dialectics: Keats, Vendler, Adorno, and the Theory of the Avant-Garde', *Critical Inquiry*, 27 (Winter 2001), 354–84.

28 Danto, *The Abuse of Beauty*, pp. 25; 28.

29 *Wallace Stevens: Collected Poems* (London: Faber and Faber, 1955), p. 76.

30 Adorno, *Aesthetic Theory*, p. 93.

31 Samuel Beckett, *Proust and Three Dialogues with Georges Duthuit* (London: John Calder, 1965), p. 103.

32 Adorno, *Aesthetic Theory*, p. 16.

33 'Play', *Samuel Beckett: The Complete Dramatic Works* (London: Faber and Faber, 1986), pp. 307; 319 (hereafter, *SBCDW*).

34 Samuel Beckett, *Molloy, Malone Dies, The Unnameable* (London: John Calder, 1959), p. 329.

35 *Endgame, SBCDW*, pp. 131–2.

36 Quoted in Adorno, *Aesthetic Theory*, p. 134.

The moment

Zeno's famous paradoxes of motion take the assumption that time is composed of infinitely divisible moments or 'nows' to prove that Achilles will never be able to catch up with the tortoise, and that an arrow in flight must actually always be at rest: both of which we might describe as teasing thoughts. The single moment or 'now', which presents no conceptual difficulty in a painting, is actually impossible to grasp in normal time. When does one moment become the next? Can we imagine a single indivisible instant, the smallest measurable unit of time, and how would such an instant also belong to a moving sequence? Are stillness and movement possible at once? In the ekphrases of Browning and Keats the stillness or fixity of the artwork elicits a fascination with the 'for ever now' of the arrested moment. Eurydice begs Orpheus to turn his face towards her; the bold lover pursues his 'goal' without end; the 'happy melodist, unwearied' pipes songs 'for ever new'; the ritual procession is always in progress, emptying the town of its folk. These figures are frozen in this silent form for 'eternity', while generations of readers have been teased in thought by simultaneously imagining the stopped action as a kind of eternal life, or as a life-in-death. Another way of thinking about the stillness of an artwork, however, is to unlock that fixity and to imagine what happens next. Since the stopped action makes sense only if we imagine it within a temporal sequence (the bold lover is always *about* to win his goal), poems about paintings often seek to revive or reanimate that sequence, to release the figure from the stasis of its visual representation and return it to time. Lessing's distinction between painting working spatially and writing working temporally seemed to suggest that this would always be the nature of the encounter between the sister arts: the poem (discursive, descriptive, unfolding its meaning linearly) would always seek in some way to breathe a temporal life and motion, a future, into the painting. But a painting may

already be working in subtle ways to contain a future within its frozen present. The so-called 'pregnant moment', in which a painting stops the action on the point of dramatic significance, is determined by an important future tense, but paintings also frequently employ a complex iconographical code, a language of signs and symbols to suggest things that will happen in the future. These future events are already there, in a sense, in the present of the picture, legible to the viewer, though perhaps remaining a secret to the figures represented.

In Christian depictions of the annunciation or portraits of the Holy family, for example, the future of the narrative (most importantly the crucifixion) may be explicitly signposted by the painting. Christian thinking about time imagines this cotemporal meaningfulness, the simultaneous presence of ends and beginnings: 'the end precedes the beginning, / And the end and the beginning were always there / Before the beginning and after the end' (Eliot, 'Burnt Norton'). Dante Gabriel Rossetti's sonnet for an 'Early German' picture of the annunciation describes the Virgin in prayer while the Dove of the Holy Spirit descends. This is the final sestet:

> So prays she, and the Dove flies in to her,
>> And she has turned. At the low porch is one
>> Who looks as though deep awe made him to smile.
> Heavy with heat, the plants yield shadow there;
>> The loud flies cross each other in the sun;
>> And the aisled pillars meet the poplar-aisle.[1]

The flies crossing each other produce a figure (a prefigure) of the crucifixion, which is reproduced in the verbal chiasmus of the final line: 'aisled pillars meet the poplar-aisle'. (Are these also the 'aisled pillars' of single-point perspective, the technique that inaugurated a new epoch in religious painting?) The forefiguring is there too in the plants 'heavy with heat' (as if pregnant); they yield (as a womb yields its child, as the Virgin yields to God's will) shadows of death and foreshadowings of Christian meaning. The Virgin has 'turned' to meet the Holy Spirit, just as the sonnet has turned between octave and sestet, just as the world has turned (in a Christian sense) around this moment.

Dante Gabriel Rossetti (1828–82) wrote several poems for and about paintings, including those for his own paintings and drawings. He chose to write the majority in the form of sonnets because the brief but replete duration and 'turn' of the sonnet (octave 'turning' into sestet) were perfect analogues for the pregnant moments of visual art. As one instant succeeds another, or as one thing turns into another. In the division and movement between the two

parts of the poem, the sonnet, like the painting, could magnify the significant or charged moment, the pulse between two points in a narrative that are separated and yet included within each other. Rossetti's sonnet sequence *The House of Life* (1881) is prefaced with a sonnet-on-the-sonnet, which describes this formal aptitude:

> A Sonnet is a moment's monument, –
> Memorial from the Soul's eternity
> To one dead deathless hour. Look that it be,
> Whether for lustral rite or dire portent,
> Of its own arduous fulness reverent ...[2]

Like a painting, the sonnet is a monument to the 'moment', to the short temporal space in which its meaning unfolds, but which, as its life endures in print, is for ever now ('dead deathless'). Such a monument offers both a trace of the future (a 'portent') and a 'memorial' of a moment already absorbed in the flow of time. This paradox – of a portent that is also a memorial – something *about* to occur that has always already occurred – preoccupied Rossetti throughout his life. In the reverent and arduous attention he gave to such moments and monuments, he produced sonnets for paintings by Leonardo da Vinci, Giorgione, Mantegna, Ingres, Memling, Burne-Jones, Michelangelo and Botticelli, on both Christian and pagan subjects. Perhaps the best known is his sonnet 'For Our Lady of the Rocks by Leonardo da Vinci':

> Mother, is this the darkness of the end,
> The Shadow of Death? and is that outer sea
> Infinite imminent Eternity?
> And does the death-pang by man's seed sustain'd
> In Time's each instant cause thy face to bend
> Its silent prayer upon the Son, while He
> Blesses the dead with His hand silently
> To His long day which hours no more offend?
>
> Mother of grace, the pass is difficult,
> Keen as these rocks, and the bewildered souls
> Throng it like echoes, blindly shuddering through.
> Thy name, O Lord, each spirit's voice extols,
> Whose peace abides in the dark avenue
> Amid the bitterness of things occult.[3]

Leonardo's *Virgin of the Rocks* (figure 4) groups the Virgin, the infants Christ and John the Baptist, and the angel Gabriel (with whom the poet shares a name) within a cave beside the sea, in the background of which a jagged opening reveals a gradually intensifying light. Rossetti's sonnet is both an ekphrasis and a prayer occasioned by the picture (he claimed in fact to have written the piece in front of the painting in London's National Gallery). It is a solemn meditation upon the difficulty and fear of mortality, on the promise of eternal life offered by the Son, and on the relationship between this fear and this promise. Most interestingly, it takes the sonnet's divided form (octave 'turning' into sestet) as an analogue for the difficult 'pass' between life and death, the threshold or exit-entrance that all must go through, and which Rossetti interprets as pictorially represented in the rough entrance of the cave opening upon a divine light. The terror of that crossing, that passing through the pain of the keen rocks, through death, is modulated both by the trust implied by the prayer to the 'Mother of Grace', her ability to sustain the poet's strength, and by the quiet belief that 'peace abides in the dark avenue / Amid the bitterness of things occult'.[4]

Rossetti's sonnet, then, is a monument to the 'moment' it sees pictured by Leonardo, the moment *before* the pain of death, attendant with fear and with hope. The spatial arrangement and grouping of the picture is read in terms of a temporal drama. As the octave asks its hushed questions (questions to which neither painting nor the 'Mother of Grace' responds), there is a development of sense within them as we move from the imminence of the end, to the death-pang of dying, to the Virgin's prayer to her Son, to the Son's blessing of the dead, to the 'long day which hours no more offend' (i.e. the eternal day, with a pun on hours/ours). In other words a Christian schema of overcoming death through Christ's sacrifice is unfolded in the octave, even as such a schema is expressed only in the provisional form of anxious questioning or petition. This proleptic or future-oriented shape, this fore-prayer if you like, is Rossetti's verbal equivalent of the iconographical 'pointing' of the painting, the forefiguring of events that are in the future (John's baptism of Christ, Christ's universal blessing), but which have, in a providential sense, always already taken place. The sestet seems indeed to enact the difficult pass between life and death, 'shuddering through' the dark moment or death-pang of 'Time's each instant' with the other 'bewildered souls'. The grammatical ambiguity ('Thy name, O Lord, each spirit's voice extols') suggests the reciprocity of the relationship between Christ and believer: each extols or praises the other. The reciprocity (but also the ambiguity) is there too in the notion of an abiding 'peace': a peace that belongs to Christ, and/or to the spirits of the dead.

4 Leonardo da Vinci, *The Virgin of the Rocks* (c. 1495–1508) (The National Gallery, London. Photo © The National Gallery, London)

Perhaps we would expect a modern-day reader of Rossetti, someone who had not grown up in the rarefied Italian-Catholic milieu of the poet and who might not understand the impulse to fall into prayer in the National Gallery, to find this pairing of poem and painting especially 'difficult'. It is sometimes argued that one of the consequences of the gallery and museum is to make such intense experiences in front of religious paintings less possible, since the removal of the work from its original context will have undermined its religious function. Rapture before a painting such as the *Virgin of the Rocks*, therefore, might nowadays have more to do with the work's object-value or the fact that we are seeing the 'real thing' after long familiarity with prints and reproductions.[5] But this is a poem of Catholic sensibility that is also about what Hegel called 'art religion' – that is, the capacity for art to produce a reaction in its viewers that is akin to the emotion and truth-recognition of a religion, even in a gallery. To pray to Leonardo's depiction of the Madonna is also in a sense to pray to Leonardo and to the art of the Italian Renaissance. It is to take the encounter of viewer and painting as an occasion for complex thinking and emotion, and to acknowledge that a painting, something artificial, might in itself and regardless of the context of its exhibition momentarily reveal the most mysterious and hidden aspects of life to us. Rossetti's sonnet then is neither a casual work of piety nor a mere gallery piece. It interprets the painting as being about the most difficult pass of all, the 'dark avenue' or the moment that divides life from death and death from the possibility of eternal life. Leonardo (according to Rossetti) had figured such a passage in spatial and pictorial terms, whilst the sonnet, unfolding its own drama of fear and hope within the short space of fourteen lines, and particularly in the turn between octave and sestet, makes explicit the dynamic of this temporal drama, this crisis that is the crisis of human existence in Time.

I would suggest that the 'difficult pass' Rossetti sees in Leonardo's painting, that borderline between one state and another (like the edge of light approached by Orpheus and Eurydice), is again paradigmatic of the relationship between poetry and painting. This is because poem and painting, prayer and icon, must remain distant from one another, even for such an intense art gazer as Rossetti. That word 'occult', rhyming or echoing with 'difficult' in both sound and sense, means 'hidden, concealed or cut off from view by passing in front'. It closes the sonnet and draws the limit to what the poem is able to say of the painting. The painting will always, finally, remain concealed by the poem, and concealed to the poem, cut off or hidden from view, 'occulted' by the intervention of speech. And the limit suggested by

'occult' connects the relationship of poem to painting with the relationship of man to Christ. Finally, the terms of this relationship abide amid the bitterness of that which is concealed from view, that which comes between man and God, or between 'Time' and 'Eternity'.

Rossetti's fascination with the encounter of word and image led him to produce companion pieces of his own, poems for paintings or paintings for poems – double works of art in which neither medium takes precedence over the other.[6] With the exception perhaps of William Blake (who is always an exception), we have no comparable example in Britain of an interaction of this sort in the works of an artist/poet. What do these pairings tell us more broadly about the relationship of poetry and painting? One of the most complex examples is the poem 'Venus Verticordia' for the painting of the same name (figure 5):

> She hath the apple in her hand for thee,
>> Yet almost in her heart would hold it back;
>> She muses, with her eyes upon the track
> Of that which in thy spirit they can see.
> Haply, 'Behold, he is at peace,' saith she;
>> 'Alas! The apple for his lips, – the dart
>> That follows its brief sweetness to his heart,
> The wandering of his feet perpetually!'
>
> A little space her glance is still and coy;
>> But if she give the fruit that works her spell,
> Those eyes shall flame as for her Phrygian boy.
>> Then shall her bird's strained throat the woe foretell,
>> And her far seas moan as a single shell,
> And through her dark grove strike the light of Troy.[7]

'Verticordia' means 'Turner of Hearts', so that here again the notion of a 'turn', a fatal moment, a dangerous single instant, is central to the sense and is exploited by the sonnet form. Rossetti was a passionate reader and interpreter of John Keats as well as a friend and housemate of Algernon Charles Swinburne, and the 'Venus-Turner-of-Hearts' is clearly related to the enchanting females we discover in those writers, women who seem compounded of the divine and the unholy. William Rossetti wrote to his brother in August 1869, however, to warn him that the title might be misleading:

5 Dante Gabriel Rossetti, *Venus Verticordia* (1864–68) (Russell-Cotes Art Gallery,
Bournemouth. Photo: Bridgeman Art Library)

Venus Verticordia – I think this title has been discussed with you before. Lemprière [author of a standard classical dictionary] makes a very startling statement: 'Venus was also surnamed ... Verticordia because she could turn the hearts of women to cultivate chastity.' If this is at all correct, it is clear that the Verticordian Venus is, technically, just the contrary sort of Venus from the one you contemplate.[8]

On receiving this information Rossetti removed 'Verticordia' from the title in his 1870 *Poems*, only to replace it in 1881, perhaps enjoying the idea of a defining ambiguity.

Rossetti's models have a certain look, one we now chastely associate with Pre-Raphaelitism but which Rossetti thought of as sexually provocative. Even though Rossetti had elsewhere employed Alexa Wilding, who sat for the head of *Venus Verticordia*, for the representation of types of feminine spirituality, it seems obvious that the effect here is designed to be one of sexual danger – 'I mean to make [her] a stunner', as Rossetti put it himself. (Evelyn Waugh later described this look as 'vapid', while Rossetti's friend and champion John Ruskin was so turned off by its 'coarseness' in this particular painting that a coolness developed in their friendship.)[9] The apple held 'in her hand for thee' is the golden apple of discord or strife given by Paris to Venus/Aphrodite and is therefore bound up with the origins of the Trojan war (Paris is poisoned by an arrow at Troy); it is also of course the apple of the Tree of Knowledge offered by Eve to Adam. The painting seems also unmistakably to suggest the Virgin Mary (Venus is brightly haloed), while the garish bordering of roses and honeysuckle again recalls the kind of thickening or cloying bowers we find in Keats and Swinburne.[10] 'Freudians would find no difficulty in identifying these as dream symbols of the female sexual organs', claim Brian and Judy Dobbs.[11] The bluebird is an omen of ill-luck, and Robert Upstone has suggested that the butterflies represent 'flitting from pleasure to pleasure', Elizabeth Prettejohn that they are 'symbols of souls, perhaps of men enthralled by the goddess of beauty'.[12] 'Venus-Turner-of-Hearts' then is what we might call an overdetermined image, loaded with iconographic signs and symbols. As a strange hybrid, a 'syncretic figure' (in Jerome McGann's phrase), she brings together associations that would normally be held in tension or contradiction, but which are here presented as creating a potent compound.[13] How do we respond to her meaning so many different things at once? The feverish and perhaps upsetting force of the picture is concentrated in the direct gaze of Venus at the viewer and the too obvious threat of danger implicit in the iconography (apple in hand, arrow pointing to breast, etc.), a danger that is

even implicit in the vibrant texture of the oils, which seem in a sense to throb. The quasi-mystical or Christian associations of the composition as a whole are offset, perhaps even upset, by these conscious excesses in iconography and in technical execution, and the accompanying sonnet takes up that direct, almost confrontational gaze to develop this idea of a dangerous moment. If for some people the image is more likely to be a turner of stomachs than that of a *femme fatale*, the provocation in this has always been the point. Rossetti is presenting a visible and material challenge, and through this exploring the idea of the temptation and threat of the visible and material, which he represents as female.

The apple is for 'thee' (male reader or male viewer or Rossetti himself), and yet in her heart Venus would '*almost* … hold it back' (my italics). What makes her hesitate? Does she pause for pity, or for the cruel pleasure of delaying and toying with her victim? Does this suggest that she *almost* feels pity, which is not to feel pity at all, or that her heart rebels against her crueller instinct, and yet isn't quite strong enough to prevent her from following that instinct? Or does it suggest a kind of chaste coyness, a reluctance to take the next step? William Sharp described Rossetti's Venus as 'a queen of Love who loves not herself', so perhaps the '*almost*' holding-back is explained by some such self-alienation.[14] This might be what Ruskin meant when he described the painting as embodying a certain 'non-sentiment', of which he disapproved.[15] The important point is this: that the hesitation derives from the nature of painting. Rossetti takes the fixity of the artwork not as a perfect stillness but as a pause or pulse in a temporal sequence. And so the still moment of the painting, the pivoting of *almost*, is pregnant with different psychological possibilities. How should we interpret this silent hesitation or mid-way gesture, this terrifying pause, which is reproduced in the structure of the sonnet?

Rossetti entertained what some would think of as eccentric and exalted notions of sexual desire: the possibility, for example, that a divine or mystical element could be discovered within sexual relations. These notions were derived from a passion for Dante's poetry, which was then refracted through his reading of Keats and Swinburne. In his art (both writing and painting) Rossetti consequently sought to represent the interpenetration of the divine and the human, of the flesh and the spirit, or what he called 'the momentary contact with the immortal which results from sensuous culmination and is always a half-conscious element of it'.[16] Here then he is interested not only in the potential danger or folly of raising an idol to sexual love, but also in the possibility that such love may in fact contain a religious truth. To put it more prosaically, Rossetti seems to be exploring the difficulty of representing the

sheer density of a phenomenon such as desire, the impossibility of a complete analysis or explanation of such a phenomenon. He then wants to try and link this sense of irreducible or elusive desire to religious mystery. Inevitably, of course, this means exploring *male* desire and its distortion or transfiguration of the female, so that there is an irony here, of which Rossetti is at least partly conscious, that the male artist may be trapped within figures and shapes of his own making and wanting. This self-awareness seems evident in the split between Rossetti and the addressee of the sonnet ('She hath the apple in her hand for *thee*'), as if Rossetti is able to detach himself from his own desire and observe its operation. If the painting seems to border on the grotesque and the poem seems nervy or perhaps neurotic, there is in this a kind of troubled self-diagnosis. But self-diagnosis can never be straightforward. Since the poem reads the painting as the source of a dense and irreducible desire, and as this is Rossetti's own painting – and, moreover, as the poem explicates or reveals the painting as if to an *other* – the nature of this desire is even more mediated or reflected than usual. Obviously this complicates traditional theories of ekphrasis that would read the relation of poem to painting as clearly gendered (male speech violating the female silence and visibility of the image). Such a conceptual model is problematised not only by the fact that Rossetti is responding to his own picture but also, and more provocatively, since this picture is one of a goddess-whore. If poems for paintings often disguise a dynamic of sexual tension then here the dynamic could hardly be less disguised – in fact it might seem as if Rossetti had read twentieth-century theories of ekphrasis and had produced a magnificent parody of them, a hideous archetype or original upon which these theories may be inscribed. Here is Venus–Mary with her genitalia-mouth, her poisoned apple and arrow, the picture of pictures. If we read the image naively then it simply reveals a rather tawdry drama of psychosexual temptation, the Victorian melodrama of the 'essence of the female', terrible and thrilling, as painted and as written by a male artist, and then as re-presented to a silent male reader or viewer. But in another sense what we have is an especially entangled double act of representation, or representation of representation. The apple proffered by Venus might then be read as the dangerous gift of 'Art', the promise of the visible or the beautiful. 'She hath the apple in her hand for thee'. But if we are trying to identify what Rossetti really desires or fears, then who, exactly, is 'thee'?

The notion of a *relation* between poem and painting becomes particularly interesting when the artist is also the poet. As the same hand produced both, it is tempting perhaps to think that the pairing will offer a complete or authentic

interpretive encounter – even an ideal one. But in fact the single origin or authorship makes the relation of poem to painting especially complex. Is the painting an interpretation of the poem, or the poem of the painting? Rossetti the poet imagines his painting as possessing a desire and agency of its own, an ability to see into him and a design upon him. The Venus 'muses' (a pun) and keeps her 'eyes upon the track / Of that which in thy spirit they can see', comprehending the inner movement of thought and motive in 'thy spirit', foreseeing the future direction and choice of action. But who is seeing into whom? Whose are the 'eyes' that shall 'flame' with desire? And who or what exactly is speaking these words, which are both gentle and cruel?

> Haply, 'Behold, he is at peace,' saith she;
> 'Alas! The apple for his lips, – the dart
> That follows its brief sweetness to his heart, -
> The wandering of his feet perpetually!'

Walter Pater, exaggerating, wrote of Rossetti that 'to him life is a crisis at every moment'.[17] Certainly the sonnet for *Venus Verticordia* takes one kind of crisis life has to offer, and which life repeatedly offered Rossetti, that is, the 'mystery' of sexual experience in its aspect of temptation and danger to the self, in its exaltation and participation with the sense of the divine, or with 'desire in deity' as Rossetti called it elsewhere.[18] The crises of living were felt most keenly by Rossetti in these kinds of moments, in the pause, the 'difficult pass' or 'dark avenue', which simultaneously separates and unites one state from, and with, an other: life and death, desire and pain. And so the sonnet 'Venus Verticordia' again exploits the octave/sestet division as an analogue for the suspended pulse of the still painting, the moment of turning or committing, the pregnant or charged instant. 'A little space' is what divides the two parts of the sonnet, and it is this little space (which is both temporal and spatial) that Rossetti finds so fascinating and so fraught. This is the space in which agency works, in which the human will makes its irreversible decisions and choices; but it is simultaneously the space in which agency and will are blocked or held in suspension, spell-bound to the will of another. In this little space the glance of Venus is 'still and coy' (the Keatsian pun on 'still'). Whether she gives the apple or not hangs in the balance ('*If* she gives'). And yet of course she *will* give the apple, she *has* given the apple, and of course it will be, it has been, received. Such is the moment before something terrible occurs, but which somehow contains that which occurs, that which has always already occurred (the fall of man, the fall of Troy).[19] For Rossetti

these moments are of a complexity and subtlety, a giddiness, a hyper-reality, and most importantly of an erotic quality, that is finally irreducible, and for which he uses the word 'mystery'.

Robert Buchanan emerged as Rossetti's nemesis when he refused to take such exaltations seriously and instead submitted their claims to a very British scepticism. In an article published in *The Contemporary Review* of October 1871, entitled 'The Fleshly School of Poetry: Mr D.G. Rossetti', written under the pseudonym 'Thomas Maitland', Buchanan went about the process of demystification:

> We get very weary of this protracted hankering after a person of the other sex; it seems meat, drink, thought, sinew, religion for the fleshly school. There is no limit to the fleshliness, and Mr Rossetti finds in it its own religious justification ... Whether he is writing of the Holy damozel, or of the Virgin herself, or of Lilith, or Helen, or of Dante, or of Jenny the street-walker, he is fleshly all over, from the roots of his hair to the tip of his toes; never a true lover merging his identity into that of the beloved one; never spiritual, never tender; always self-conscious and aesthetic.[20]

'Aesthetic' seems to have acquired a derogatory force in Buchanan's prose, in which it is antithetical to 'true' love, to tenderness and to spirit. Interestingly, it is aligned with fleshliness, with sexual desire, rather than the refinement *out of* these things that we might expect. (I will say more about this in the next chapter.) Is there, however, a parallel between the insistence of a separation between flesh and spirit, as it is imagined in Buchanan's article, and the paragonal struggle of the sister arts? In other words, could Rossetti's *pairing* of poems and paintings have something in common with his vision of 'the momentary contact with the immortal which results from sensuous culmination'? 'Like Dante', Walter Pater wrote, 'he [Rossetti] knows no region of spirit which shall not be sensuous also, or material.'[21] And the reverse applies: he knows no region of the senses which shall not also be spiritual. This vision of interpenetration may have a significant parallel with the relationship Rossetti's poems have with his paintings, each bringing a *material* element to the other that it is lacking: the materiality of the image to the non-materiality of speech; the discursive embodying or 'fleshing out' of language to the phantom of the image. But each equally brings a *non-material* element too: the spirit of painting illustrating the printed word; the breath of language animating the oils on canvas. In other words, each could

stand either for 'flesh' or 'spirit' in relation to the other. Textuality grounds and materialises the inscrutable magic of the image, while the materiality of paint allows the word a direct and tangible appearance. And for Rossetti this idea of union is both sensuous (sexual) and spiritual (divine).

As such it may be possible to read Rossetti's pairings not merely as paradigms for ekphrasis, but more broadly as pointing towards the aesthetic category itself. The very notion of such a category of experience assumes some common ground or relation between the arts, that they belong to a distinct sphere of human activity and produce a unique kind of response in human beings. This response is one that might usefully be thought of as a union of the sensuous or the material with the non-material, deriving from the notion of a *relation* between the perceiving subject and the aesthetic object, or in this case between the poem and the painting. Although, as we shall see, the term 'aesthetic' had a quite specific cultural meaning in the late Victorian period (and Buchanan is wrestling with that meaning), the traditional assumption of all theories of the arts is that at least there is a *relation* of which to speak. Rossetti's ekphrases may then be considered as exemplary instances or embodiments of such a possibility, even perhaps as allegories of aesthetic experience, since they stage the encounter of poem and painting as a mysterious exchange, or interchange. As we have seen in the previous chapter, the notion of 'aesthetic experience' in this positive sense – as 'mysterious', or as containing profound human truth – falls under suspicion during the last century, partly in response to the writings of Victorian aesthetes. If Rossetti's ekphrastic pairings are allegories of aesthetic experience it might be tempting to read them negatively (as Buchanan did) and to insist that the fleshliness of such an experience has no spiritual content at all. The aesthetic category is often said to have emerged as a concept in the eighteenth century as a means of rationalising and therefore controlling the lawless and disturbing energies and desires of the body. If 'aesthetics' is therefore the branch of philosophy pursuing the theory and regulation of a particular kind of pleasure, then in Rossetti's pairing of poem and painting we could argue that such a project is allegorised as one of lurid appetites, of 'hankering after persons of the opposite sex'.[22] Deconstructing Rossetti's pairings along these lines, the concealed political motivation is only too obvious – the ideology of the aesthetic is as visible as it could be. Unregulated desire and bodily pleasure lead to civil conflict (the Trojan war). Venus Verticordia is the personification of this danger; she clearly stands for 'woman' – disenfranchised though still potent, oppressed but undeniably sexy. While the male propensity for transgression may be regrettable, the

provocation for male desire is the virgin-whore-goddess who should be repressed, or at least sublimated (the processes are not unconnected). What better way to achieve this than through art, which pretends that these specific economic and social relations are in fact part of a greater 'mystery' with profound religious and mythological origins?

Rossetti's poetry and painting are obviously vulnerable to this kind of demystification. One objection to such an account, though, would be its easy reversibility: i.e. we could claim that Rossetti is ironising a phallocentric vision of the world, or that, given the nature of Victorian codes of morality, his idea of sensuous culmination (sex) as participating in the divine must surely constitute a radical and subversive proposition. Indeed, the idea of the sexual female as part divine or holy might, in 1881, appear ideologically revolutionary. This might explain Buchanan's moral outrage. More importantly, hostile readings of Rossetti's aestheticism fail to recognise, or refuse to legitimate, the ways in which the oppositional categories of body and spirit are in fact interchangeable in his work. What seems to be at stake here is the very assumption that there is such a thing as 'spirit', a non-material realm that may be opposed to 'flesh' but which may at particular moments and in specific circumstances partake of the nature of flesh ('the momentary contact with the immortal which results from sensuous culmination'); or, conversely, that there may be an experience of the senses which involves a participation in something *above* the body, something non-material, something of transcendent value. In a period in which Darwinian science (among other developments) seemed to offer the vision of 'man' as a bodily, determined, material creature, the very idea of 'spirit' inevitably becomes a threatened and fiercely contested category. Rossetti's art perhaps adopts more extreme visions of spirituality partly in response to these historical pressures, with a determination not to surrender the idea of the spirit to a wholly positivist and materialist account of existence. It is easy not to take this effort seriously, or to take it seriously but merely as a function of 'ideology'.[23] In Rossetti's case the 'ideology' seems so obvious and crude as to make a mockery of the idea of demystification – though this of course may be one of the methods by which an ideology protects and promotes itself.

Rossetti conceptualised the relationship of the sister arts in terms of the complementarity of flesh and spirit (i.e. word as *both* flesh and spirit to the spirit and flesh of the image), and his career as artist-poet was spent pursuing that idea of artistic transubstantiation, most often through the figures of sexual love. In them he envisaged the possibility of crossing over between categories that seem incommensurable or bound to their separate material elements, or

of moving between spheres (as Orpheus leads Eurydice towards the world). These are large abstract matters to discover in the pairings of poems and paintings, and for that reason are often left aside by theorists of ekphrasis. But others have attempted to make the kind of connections Rossetti pursued all his life. Christopher Braider, for example, describes what he calls 'the inner, metaphysical meaning of the question of representation and the part played therein by the theory of the Sister Arts'. He puts it like this:

> What finally confront each other in painting and writing over the chasm paradoxically opened by the recognition of a common aim and destiny are those complementary opposites, the Carnal and the Spiritual, the Visible and the Intelligible, the Particular and the Universal, the Real and the True, by which, since its very inception, Western thought and experience have seemed condemned to be divided – except, that is, in those rare, fugitive moments when the two sides miraculously coincide in the space of some signal image or exemplary literary text.[24]

Rossetti attempted to match the 'signal image' with the 'exemplary literary text', indeed to make the two 'miraculously coincide'. And yet the coinciding is never one of ease or reconciliation. On the contrary, it is most often attended by danger and resulting in pain. Therefore if we are to read Rossetti's pairings as connected in a larger sense to the idea of the aesthetic, then the allegory is a dark one. This is the important point to recognise: that the relations between Rossetti's poems and paintings are conceived in terms of the crisis Walter Pater identified as the keynote of his work. The poems reveal the moral danger, the catastrophe that is somehow often latent within the image. Here as a final example is Rossetti's sonnet to accompany a painting entitled *The Wine of Circe* (figure 6) by his friend Edward Burne-Jones.

For The Wine of Circe by Edward Burne Jones

Dusk-haired and gold-robed o'er the golden wine
 She stoops, wherein, distilled of death and shame,
 Sink the black drops; while, with fragrant flame,
Round her spread board the golden sunflowers shine.
Doth Helios here with Hecatè combine
 (O Circe, thou their votaress?) to proclaim
 For these thy guests all rapture in Love's name,
Till pitiless Night give Day the countersign?

6 Edward Burne-Jones, *The Wine of Circe* (Image released into public domain by copyright holder. Photo: Bridgeman Art Library)

Lords of their hour, they come. And by her knee
 Those cowering beasts, their equals heretofore,
Wait; who with them in new equality
 To-night shall echo back the sea's dull roar
 With a vain wail from passion's tide-strown shore
Where the dishevelled seaweed hates the sea.[25]

Circe was the mythical sorceress who gave the companions of Odysseus a magic potion that transformed them into swine. Here Rossetti follows Burne-Jones's schema of gold and black, emphasising the sense of incommensurable things, of contrarieties: wine and poison, Helios (the sun, Circe's father) and Hecatè (the witch of the night). The sonnet is structured around such opposites or 'countersign[s]', and around the threat of mistaking one for the other. The world of light and the rapture of love, which Circe shall proclaim to Odysseus's companions, is in fact divided from the world of 'pitiless Night' by the narrowest of borders, suspended by a question mark at the end of the octave. In that pause or breath between octave and sestet the fall from pleasure to shame, and from lordship to animality, takes place. 'Lords of their hour, they come': in their supreme confidence, predictably, as foreseen, in their maleness, Odysseus's companions walk straight into the trap. Drinking Circe's potion will lead to bestial unconsciousness and pure sensuality, reducing them to a 'new equality' with the panthers who cower at her knees. What better phrase for the ideological stakes of this encounter than Rossetti's 'new equality'? And as one element meets another, the shore meeting the ocean, so the sonnet closes with the dark 'countersign' to Love: 'Where the dishevelled seaweed hates the sea'.

The 'countersign' to poetry is painting. And so again Rossetti's sonnet seems on one level to offer us a bold outline of the gender dynamic – a version of the encounter with alterity – frequently identified as a defining feature of ekphrasis: the 'female' image, in its potency and its ability to seduce and deceive, will entrap 'male' language and reduce it to pure materiality. Here the momentary contact with the divine that results from sensuous culmination will, as in the case of *Venus Verticordia*, result in disaster. But it is disaster that is also a form of knowledge, because the poem itself brings to the material image the non-materiality of moral consequence, of final significance. It is again in the sonnet's formal movement from octave to sestet that Rossetti discovers the little space in which the irrevocable choices are made: the drinking of the potion and its subsequent turning of men to beasts. The verbal countersign releases the image from its temporal stasis and returns it to time,

but in doing so it allows the moral content of the painting to become explicit, to take place. One moment becomes the next in the sequence, one thing turns into another – in this case (again) love *turns into* hate. If we connect this to aesthetic experience it would mean discovering in aesthetic pleasure, the pleasure of the body, a moral (or 'spiritual') knowledge that is painful.

NOTES

1 *The Collected Works of Dante Gabriel Rossetti*, ed. William Rossetti, 2 vols (London: Ellis and Scruton, 1886), I, p. 343. (All poems by Rossetti from this edition. Hereafter *CWDGR*). The painting has not been traced. Rossetti said he saw it at an auction.

2 *CWDGR*, I, p. 176.

3 *CWDGR*, I, p. 344

4 John Hollander points out the grammatical ambiguity whereby it is left undecided whether it is Christ's peace or the peace of each spirit that 'abides in the dark avenue'. Such ambiguity is of course germane. Hollander's reading differs from my own in its stronger emphasis on the darkness of the sonnet: 'the poem asks *Is this a picture of Death, rather than of the childhood of Eternal Life?*' See, especially, Hollander's discussion of the phrase 'The Shadow of Death' (a phrase Rossetti takes from the English translation of the twenty-third Psalm). John Hollander, *The Gazer's Spirit: Poems Speaking to Silent Works of Art* (Chicago: University of Chicago Press, 1995), pp. 151–5.

5 I am thinking primarily here of Walter Benjamin's famous essay 'The Work of Art in the Age of Mechanical Reproduction', about which I will have more to say in Chapter 7. There will also be a fuller discussion of the debate about the museum and gallery in Chapter 8. But see also John Berger's discussion of the painting in *Ways of Seeing*: 'Before the *Virgin of the Rocks* the visitor to the National Gallery would be encouraged by nearly everything he might have heard and read about the painting to feel something like this: "I am in front of it. I can see it. This painting by Leonardo is unlike any other in the world. The National Gallery has the real one. If I look at this painting hard enough, I should somehow be able to feel its authenticity. The *Virgin of the Rocks* by Leonardo da Vinci: it is authentic and therefore it is beautiful."' Of course, as Berger points out, the version of the painting in the National Gallery is a second version, the original (or primary version) being in the Louvre. Moreover, the version in the National Gallery is not entirely by Leonardo. The best discussion of these matters is to be found in Pietro C. Marani, *Leonardo da Vinci: The Complete Paintings*, trans. A. Laurence Jenkens (New York: Harry N. Abrams, 2003), pp. 123–5.

6 'The relationship between Rossetti's painting and his poetry is asymmetrical, skewed. This is not true in the sense that one overtly contradicts the other, but in the sense that each exceeds the other, however deliberately they may be

matched, as in the case of *Lady Lilith* and "Body's Beauty". Each says more or less than the other, and says it differently, in ways which have only in part to do with the differences of medium. Either may be taken as the "original" of which the other is the "illustration" or the explanatory poetic "superscription", writing on top of another graphic form. This relation does not depend, of course, on the chronology of Rossetti's actual creation of the two works in question. In each case, however, a secondary version in the other medium is always one way or another a travesty, a misinterpretation, a distorted image in the mirror of the other art.' J. Hillis-Miller, 'The Mirror's Secret: Dante Gabriel Rossetti's Double Work of Art', *Victorian Poetry*, 29:4 (1991), 333–49 (336).

7 *CWDGR*, I, p. 360.

8 Oswald Doughty, *A Victorian Romantic: Dante Gabriel Rossetti* (London: Oxford University Press, 1957), pp. 683–4.

9 Rossetti's comment is from a letter to Alexander Macmillan, and is cited by Jan Marsh, *Dante Gabriel Rossetti: Painter and Poet* (London: Weidenfeld and Nicolson, 1999), p. 280. Evelyn Waugh, *Rossetti: His Life and Works* (London: Duckworth, 1928), p. 136. 'Her hair, like an ill-fitting and inexpensive wig, is arranged like *Helen of Troy's*.' Ruskin's comments are recorded in Andrew Wilton and Robert Upstone (eds), *The Age of Rossetti, Burne-Jones & Watts: Symbolism in Britain 1860–1910* (London: Tate Gallery Publishing, 1997), p. 153.

10 'Setting the head of Venus in a Christian glory forces one to reconsider its entire symbology. So in this picture the elaborate floral decorations do not easily translate either through realistic or iconographic filters. These are flowers culled from a place unknown alike to corporeal eye and rational mind.' Jerome McGann, *Dante Gabriel Rossetti and the Game that Must Be Lost* (New Haven: Yale University Press, 2000), p. 120.

11 Brian and Judy Dobbs, *Dante Gabriel Rossetti: An Alien Victorian* (London: Macdonald and Jane's, 1977), p. 151.

12 Wilton and Upstone (eds), *The Age of Rossetti, Burne-Jones & Watts*, p. 152. Elizabeth Prettejohn, *Rossetti and His Circle* (London: Tate Gallery, 1997), p. 57.

13 McGann, *Dante Gabriel Rossetti and the Game that Must Be Lost*, p. 121.

14 McGann, *Dante Gabriel Rossetti and the Game that Must Be Lost*, p. 122.

15 Wilton and Upstone (eds), *The Age of Rossetti, Burne-Jones & Watts*, p. 153.

16 See Richard L. Stein, *The Ritual of Interpretation: The Fine Arts as Literature in Ruskin, Rossetti, and Pater* (Cambridge, MA: Harvard University Press, 1975), p. 132.

17 Walter Pater, *Appreciations* (London: Macmillan, 1890), p. 220.

18 'The Kiss', sonnet six of *The House of Life*, *CWDGR*, I, p. 179.

19 'All Rossetti's work is haunted by an experience of devastating loss. That loss has always already occurred or is about to occur or is occurring, in memory or anticipation within the divided moment. It occurs proleptically, antileptically, metaleptically, the feared future standing for the already irrevocable past, and

vice versa, in a constant far-fetching reversal of late and early'. Hillis-Miller, 'The Mirror's Secret', 337.

20 Robert Buchanan ('Thomas Maitland'), 'The Fleshly School of Poetry: Mr D.G. Rossetti', in Valentine Cunningham (ed.), *The Victorians: An Anthology of Poetry and Poetics* (Oxford: Blackwell, 2000), p. 834. See also Swinburne's parody of Rossetti, 'Sonnet for a Picture', from his *Heptalogia*, quoted in Hollander, *The Gazer's Spirit*, p. 50.

21 Pater, *Appreciations*, p. 221.

22 The fullest materialist account of the rise and significance of the aesthetic category is found in Terry Eagleton, *The Ideology of the Aesthetic* (Oxford: Blackwell, 1990).

23 See Isobel Armstrong's recent attempt to reappropriate the aesthetic category as a radical mode in *The Radical Aesthetic* (Oxford: Blackwell, 2000). Armstrong 'would refuse the conservative reading of the aesthetic as that which stands over and against the political as disinterested Beauty, called in nevertheless to assuage the violence of a system it leaves untouched, and retrieve the radical traditions and possibilities with which the idea of the aesthetic has always been associated. I would regard with dismay a politics which subtracts the aesthetic and refuses it cultural meaning and possibility' (p. 30).

24 Christopher Braider, *Refiguring the Real* (Princeton: Princeton University Press, 1993), pp. 15–16.

25 *CWDGR*, I, p. 350.

BLISS

PERHAPS poets secretly wish that they were painters, and painters that they were poets. Doubly endowed, twin-gifted, Rossetti is a rare example. His pairings are dialogues between the poet and painter within himself, or rather between the poet-painter and the painter-poet. However, the notion of poetry in some sense *speaking for* or explaining painting is no less complex when the painter himself speaks for his own pictures. In Rossetti's case the poetry seems to turn or return the image to a temporal sequence in which moral agency is manifested – fatal decisions are made, the fall from innocence to knowledge takes place. And yet the moral action – the choice or decision – is already there in the image; paradoxically, it has already taken place.

The last poem in Robert Browning's great collection of 1855, *Men and Women*, is entitled 'One Word More' and is dedicated to his wife. In it Browning recalls two famous examples of artists who had attempted to cross over between the sister arts: Raphael (it is recorded) had written a hundred sonnets to his mistress, whilst Dante had 'once prepared to paint an angel' (a subject for a pen and ink drawing by Rossetti in 1849). Both works have been lost to posterity, and the loss is lamented by Browning. How do we explain this attempt to work in the 'other' discipline?

> What of Rafael's sonnets, Dante's picture?
> This: no artist lives and loves, that longs not
> Once, and only once, and for One only,
> (Ah, the prize!) to find his love a language
> Fit and fair and simple and sufficient –
> Using nature that's an art to others,
> Not, this one time, art that's turned his nature.
> Ay, of all the artists living, loving,

None but would forgo his proper dowry, –
Does he paint? he fain would write a poem, –
Does he write? he fain would paint a picture,
Put to proof art alien to the artist's,
Once, and only once, and for one only,
So to be the man and leave the artist,
Gain the man's joy, miss the artist's sorrow.[1]

Browning regrets that he will 'never, in the years remaining' paint his wife pictures, 'no, nor carve you statues, / Make you music that should all-express me'. Nevertheless, 'One Word More' is the final poem in a collection that had spoken through the personae of others; these last words by contrast are spoken, as it were, in Browning's own person, directly and intimately to his wife. Similarly, the efforts of Raphael as a sonneteer and Dante as a painter are interpreted as attempting a uniquely personal expression ('Once, and only once, and for One only'), a way of being 'natural', or moving out of the medium in which the artist has worked and crossing over in order to achieve a singular and invaluable revelation of the self – the self unadorned or unmediated by art. This would be to find a language in which to express love.

Perhaps this partly explains Browning's fascination with painting and with the possibility of poetry speaking for painting through the dramatic monologue. He understood the longing to cross over into the other discipline, the desire for translation, as well as the fascination with the return journey, that is with bringing an understanding of the processes of painting back to the poem and reporting or revealing that understanding there. In his dramatic monologues for painters, then, Browning draws the artist into speech, or is drawn himself into the artist's speech, creating the illusion that the painter has been allowed to give dramatic expression to 'himself', or equally, that the poet has expressed something of *him*self through the words of the painter. The most famous of these monologues is 'Fra Lippo Lippi', which appeared in *Men and Women* (1855). Browning was familiar with the paintings of Fra Filippo Lippi (c. 1406–69), many of which were in Florence where the poem was written. He also drew on the well-known account of the painter's life in Giorgio Vasari's sixteenth-century work *Lives of the Artists*, which had emphasised Lippo's reputation for pursuing forbidden pleasures:

It is said that Fra Filippo was so lustful that he would give anything to enjoy a woman he wanted if he thought he could have his way; and

if he couldn't buy what he wanted, then he would cool his passion by painting her portrait and reasoning with himself. His lust was so violent that when it took hold of him he could never concentrate on his work. And because of this, one time or other when he was doing something for Cosimo de Medici in Cosimo's house, Cosimo had him locked in so that he wouldn't wander away and waste time. After he had been confined for a few days, Fra Filippo's amorous or rather his animal desires drove him one night to seize a pair of scissors, make a rope from his bed-sheets and escape through a window to pursue his own pleasures for days on end. When Cosimo discovered he was gone, he searched for him and eventually got him back to work. And after that he always allowed him to come and go as he liked, having regretted the way he had shut him up before and realizing how dangerous it was for such a madman to be confined. Cosimo determined for the future to keep a hold on him by affection and kindness and, being served all the more readily, he used to say that artists of genius were to be treated with respect, not used as hacks.[2]

Browning adopted the anecdote. His Fra Lippo Lippi 'speaks' to a group of night watchmen who have accosted him in the street late one evening 'at an alley's end / Where sportive ladies leave their doors ajar' (ll. 5–6). He explains to them that he is lodging with the great Cosimo de Medici, and that he has been 'three weeks shut within my mew, / A-painting for the great man' (ll. 47–8). Leaning from his window and hearing the sound of 'lute-strings, laughs, and whiffs of song', he has acted on an impulse, made a rope from the knotted sheets of his bed and escaped in order to pursue the 'three slim shapes' he had glimpsed in the street. As a monk he immediately perceives the need to explain this kind of behaviour, and so, in his own zesty and irrepressible manner, he proceeds to tell his life's story and argue his artistic credo. For Lippo (as Browning has imagined him, and as Browning has him conceive himself) there has always been a conflict between his instinct to paint from life, with close likeness, and the pressure placed upon him by his religious superiors 'to paint the souls of men', i.e. to raise men's thoughts above the merely material or fleshly. In resistance to this pressure Lippo makes a powerful argument for the importance both of verisimilitude in painting and the significance of 'beauty', by which he means visual beauty. By painting the body well, he argues, he thereby paints the soul; and by rendering homage to beauty (his thoughts are always returning to the Prior's pretty niece) he believes that 'You get about the best thing God invents'. Lippo denies his

capacity to forget or to live without the natural feelings of sexual desire and sensuous pleasure, arguing instead for their meaningfulness. In any case, denying such desires is hypocritical:

> You don't like what you only like too much,
> You do like what, if given you at your word,
> You find abundantly detestable.
> For me, I think I speak as I was taught;
> I always see the garden and God there
> A-making man's wife: and, my lesson learned,
> The value and significance of flesh,
> I can't unlearn ten minutes afterwards.
>
> (ll. 261–8)

Warming to his theme, Lippo argues for the essential value of the physical world, 'The beauty and the wonder and the power, / The shapes of things, their colours, lights and shades', and for the value of an art of mimesis that reproduces these wonders for our contemplation:

> For, don't you mark? we're made so that we love
> First when we see them painted, things we have passed
> Perhaps a hundred times nor cared to see;
> And so they are better, painted – better to us,
> Which is the same thing. Art was given for that;
> God uses us to help each other so,
> Lending our minds out.
>
> (ll. 300–6)

This is an important notion: that painting helps us to see the world more intensely, and to love what we see; and that 'Art' is a kind of lending out of one mind to another: an exchange. Finally, Browning's Lippo describes the painting he intends to paint next. This will be what we now know as *The Coronation of the Virgin* in the Uffizi gallery of Florence (figure 7). In this crowded, vivid picture the ceremony of the coronation takes place in heaven among a close throng of angels. Beneath the Father and the virgin, in the foreground of the painting, St Eustace sits with his two young sons and his pretty wife Theophista. And in this picture, Lippo tells us, he intends to include a portrait of himself:

7 Fra Filippo Lippi, *The Coronation of the Virgin* (1441–47) (Uffizi Gallery, Florence. Photo: Uffizi Gallery)

up shall come
Out of a corner when you least expect,
As one by a dark stair into a great light,
Music and talking, who but Lippo! I! –
Mazed, motionless and moonstruck – I'm the man!

(ll. 360–4).

Visualising the work with great excitement and talking as if the picture were actually alive with real people, Lippo worries that he will feel embarrassment among the 'pure company' of the angels and saints gathered there. But as he foresees himself preparing to beat a retreat, 'a sweet angelic slip of a thing' intervenes on his behalf, and argues for his rightful place in the picture:

Not so fast!'
– Addresses the celestial presence, 'nay –
He made you and devised you, after all,
Though he's none of you! Could Saint John there draw –
His camel-hair make up a painting-brush?
We come to brother Lippo for all that,
Iste perfecit opus!'

(ll. 371–7)

The angel's argument (as presented by Lippo) is that since he (Lippo) has painted this picture ('he made ... and devised' the glorious company among which he is embarrassed) then he deserves to remain there. The artist has a place and function that should be recognised and honoured. And so Lippo imagines himself welcomed among the celestial presence, shuffling sideways with his 'blushing face / Under the cover of a hundred wings', which are spread like the skirts of women, beneath which he has always been happy.

Many commentators have noticed what seem to be mistakes or misconceptions in Browning's grasp of the art-historical context. Most significantly, Browning seems to have mistaken the meaning of the Latin '*iste perfecit opus*' (in the bottom right of the picture) as 'This man did the work', referring therefore to Lippo, when in fact the Latin, which reads '*is perfecit opus*', means 'This man arranged or facilitated the work', and refers to the Canon Maringhi, who commissioned the painting in 1441. He is the figure with his hands closed in prayer who appears to have risen by 'a dark stair' into the right foreground of Lippo's painting, whilst the painter-monk himself stands on the left, leaning on his elbow, slyly looking out at the viewer. This may be an unconscious error

on Browning's part, but to me it seems more likely to have been a deliberate slip. 'Fra Lippo Lippi' is a poem about creation, one that attempts to cross over between different kinds of making and devising, different construals, if you like, of the Latin *perfecit*. Browning is conscious of the doubling at the heart of such an experiment, in other words that it is the poet who has 'made', 'devised' or arranged the painter Lippo, facilitated his speech and brought about the work or *opus* 'Fra Lippo Lippi'. The lines of making and framing are therefore multiple, overlayered and enmeshed throughout the poem. It is the poet who makes the painter speak of the picture he (the painter) will one day paint. But Browning also has Lippo describe his love for God's creation and his belief that the imitation of this creation in art has a value and significance in itself. Artistic acts of making pay homage to the primary act of divine creation. When Browning has Lippo describe the painting that will be Lippo's own creation, *The Coronation of the Virgin*, he makes us see Lippo's work through an act of secondary creation or mimesis – poem delineating picture – which is analogous to Lippo's own thesis of creation as homage. Then Browing has Lippo express his intention to make himself appear in that work: 'who but Lippo! I! ... I'm the man!' But of course Lippo is appearing as a man or an 'I' here in Browning's poem – this is where he declares his appearance, where he rises up 'mazed' and 'motionless' – although this 'I' is not really an 'I' at all since it has been made or devised by Browning (via Vasari) as an impersonation of the historical Filippo Lippi. Lippo's appearance in the painting is similarly complicated. The figure he says he will paint as himself will in fact be the patron of the work, Canon Maringhi, the man who, by paying for it, made it happen. When Browning has Lippo imagine the angel pleading on his behalf before the celestial presence, the supreme maker, the angel argues that Lippo rightfully deserves a place here since 'He made and devised you after all', that is Lippo 'made and devised' the celestial presence in this picture (when of course, ultimately, it is the celestial presence who has made Lippo). These crossed lines of making and devising, creating and perfecting – God, poet, painter, poem, picture, world – raise the question: Who is making what, and who is speaking for whom? Who is the creator, and who is 'arranging' or making the creation? Browning's Lippo describes himself as shuffling 'sideways' in the painting, perhaps anticipating the blurring of his identity with the Canon Maringhi, the 'misplacing' of one for the other. Interestingly, throughout the monologue Lippo has emphasised his poor abilities as a scholar of Latin: 'Lord, they'd have taught me Latin in pure waste! / *Flower o' the clove, / All the Latin I construe is, 'amo' I love!'* (ll. 109–11). In this he is unlike his 'creator' Robert Browning, whose Latin was

sound, but who is said by some critics to have misunderstood the meaning of the Latin tag in the painting. But is this likely? ('Don't you think they're the likeliest to know, / They with their Latin?') Is it possible that Browning was making a joke about the mistaken or overlapping identities of creators and creations in this poem? And, like Lippo, glancing sideways at his audience as if to acknowledge his artifice? Whether or not the author is in conscious control of these ironies, they are perfect. Indeed *'Iste perfecit opus'* could stand as a riddling epigraph to the poem. Who, exactly, arranged or made this work?

'Fra Lippo Lippi' then is a poem about creation, about making something, and about the value of making. It is also about the complexity of such notions as autonomy and authenticity in the creative act: of speaking for oneself, in one's own voice, being 'natural', revealing oneself, appearing. As a dramatic monologue the poem makes Lippo speak and has him describe one of his own acts of creation, while the value and significance he attributes to realism in art, to bringing things to life, has its correlative in the vivid and immediate presence of Browning's speaker in the poem. Lippo appears within Browning's 'Fra Lippo Lippi', picturing himself appearing as if alive within his own picture of the *Coronation*, which is in turn made more alive and brought closer to us through Browning's dramatised act of ekphrasis. This desire to make something live is shared by poet and painter, so that Browning's poem simultaneously articulates and exemplifies a theory of the sister arts. All acts of creation are in some sense reverent copies or duplicates of the original creative act of God. The very notion of *speaking for* Fra Lippo Lippi, of bringing him and his theory of painting to life, is paralleled by Lippo's own theory of the ethical good in realism. In this case the act of representation has not just an ethical but a sacramental value:

> For, don't you mark? we're made so that we love
> First when we see them painted, things we have passed
> Perhaps a hundred times nor cared to see;
> And so they are better, painted – better to us,
> Which is the same thing. Art was given for that;
> God uses us to help each other so,
> Lending our minds out.
>
> (ll. 300–6)

But the poem is also threaded with ironies, not all of them necessarily Browning's own, through which the notion of a shared credo between poet and painter begins to unravel. Who finally is speaking for whom? It is of

course impossible to say whether Browning has represented the 'soul' or inner truth of Lippo Lippi, or whether in fact the ventriloquism of the dramatic monologue refuses to admit such a notion at all. The possible objections to a theory of art or representation as an unequivocal moral good might run along these lines: Lippo's theory, as Browning conceives it, is self-serving (for Lippo) and therefore a piece of cunning psychological realism on the part of the poet. Lippo claims to paint flesh with a kind of innocence as if 'beauty' can only be good, when in fact (as is obvious at the close of the poem in the final metaphor of adultery) the line between innocent pleasure and transgressive desire seems to have been cleverly blurred by his argument. Can Lippo's painting ever transform his lust for the Prior's niece into a convincing realisation of St Lucy, or are the two finally incompatible? Do the arguments that Browning gives Lippo work to persuade us of their truth, or are they rather persuasive examples of the art of persuasion? It might be claimed that Lippo's attempt to elevate his desire for the Prior's niece into a theory of beauty-as-truth is a neat example of the ideology of the aesthetic. The aesthetic argument attempts to transfigure (and in doing so control and regulate) the lust of the body. Browning seems to have intended some such irony in his portrayal, with the result that we have a complex situation in which the realism of Browning's psychology undermines the theory of realism as presented by Lippo. But a further objection might be that in any case the theory of sacramental realism as expressed by Lippo is Browning's own theory brilliantly draped in the costumes of quattrocento Florence, but in fact quite distantly removed from the historical reality of the culture in which Lippo lived. Browning is perceiving retrospectively a development in the theory of art and articulating it in terms that belong to a later historical moment. This of course is inevitable, but it means that the common ground Browning has attempted to discover between Victorian poet and Renaissance painter is not as secure as we might at first have thought. Perhaps the ironies outlined above – of creation, ventriloquism, and framing – hint at this final inevitable problem. This is *not* Fra Lippo Lippi but a fantastic illusion created by Robert Browning. And if what has been made to live in this poem is therefore a phantom masquerading as the 'real thing', speaking for the 'real thing', then the idea of representation as a moral good becomes far less straightforward. This is the danger Plato described in *The Republic* – that the illusions of artworks may be so convincing that they are mistaken for the real thing, and that this is potentially dangerous. If Lippo's arguments are only partly true, or are arguments designed to excuse certain delinquencies of behaviour, or are theories which belong as much to Browning as to the

painter monk, perhaps the idea of 'Lending our minds out' seems much more doubtful.

As a consequence we might read 'Fra Lippo Lippi' as a poem about the troubled relationship between beauty and truth, or between aesthetics and ethics. The fact that Lippo is just one of Browning's fifty men and women, some of whom we are certainly not meant to 'love' as we see them portrayed, underlines the fact that the painter's theory of art stands assailed not only by the ironies of his own monologue but by his words being placed and viewed in the context of the collection as a whole. The extent to which poetry can *speak for* painting in the sense of explaining unique acts of creation, seems, finally, to be limited, or significantly complicated. Furthermore, the idea of a common ethical ideal that might be said to belong to both media (for example, that representation has a straightforwardly sacramental relationship to the real world) appears to be an oversimplification. Browning's Lippo describes the pressure his religious superiors have placed upon him to produce paintings that help people to serve God. He argues that realism does just this because it unveils or reveals the glory of the world to us, and so helps us to see the Good. In this Lippo seems close to Dante Gabriel Rossetti and to the sacramental quality of what Buchanan derided as the fleshly school of poetry. The material and the spiritual are linked together, and momentary contact with the divine is possible through sensuous artworks. But Lippo goes even further than Rossetti or Keats in suggesting that 'beauty' is not merely a pathway to the divine, but is of itself the highest good in creation:

> If you get simple beauty and naught else,
> You get about the best thing God invents:
> That's somewhat: and you'll find the soul you have missed,
> Within yourself, when you return him thanks.
>
> (ll. 217–20)

The problem here is that 'simple beauty' might inspire feelings for which simply offering thanks to God would be inappropriate in a Christian context: feelings of lust, for example, for the Prior's niece. The idea that 'beauty' is in itself unequivocally and always an inspiration to the contemplation or enacting of good is clearly a flawed one. Moreover, Lippo seems a little vague here as to what exactly he means by 'simple beauty'. Is a painting as complex and as intricate as 'The Coronation of the Virgin' a thing of 'simple beauty'? In fact it seems again as if Browning's ekphrasis works to unlock the temporal stasis

of Lippo's image so that by returning it to narrative time it might allow the moral ambivalence of this theory of 'simple beauty' to appear. Nevertheless, Browning has Lippo gesture towards an ethos that would gain strength in the second half of the nineteenth century: that 'beauty' does not need to be positioned in relation to a separate category of moral good, but constitutes its own category of goodness or value. If 'realism' is exalted to a sufficient pitch, as it is here by Lippo, then the 'real' becomes the 'beautiful'. And so if we extricate Lippo from the Christian context of the quattrocento and place him in the 'post-Christian' atmosphere of late Victorian London, for example, the seed of his argument might be seen to have flowered in the doctrines of Aestheticism. Aesthetics and ethics need not be related; in fact they are best left far apart. Beauty is the soul of art, and art isn't *for* anything other than its own sake. Lippo anticipates Oscar Wilde.

In his dialogue *The Critic as Artist: With Some Remarks on the Importance of Doing Nothing* (1890), Wilde has 'Gilbert', lounging in the library of a house in Piccadilly, explain to 'Ernest' his theory of the self-sufficiency of Beauty. 'Beauty', Gilbert argues, 'has as many meanings as man has moods. Beauty is the symbol of symbols. Beauty reveals everything, because it expresses nothing'.[3] The consequence of this, according to Gilbert, is that 'the first condition of criticism is that the critic should be able to recognise that the sphere of Art and the sphere of Ethics are absolutely distinct and separate. When they are confused, Chaos has come again.'[4] Towards the end of the dialogue, he goes even further:

> To be good, according to the vulgar standard of goodness, is obviously quite easy. It merely requires a certain amount of sordid terror, a certain lack of imaginative thought, and a certain low passion for middle-class respectability. Aesthetics are higher than Ethics. They belong to a more spiritual sphere. To discern the beauty of a thing is the finest point to which we can arrive. Even a colour-sense is more important, in the development of the individual, than a sense of right and wrong.[5]

In the same year Oscar Wilde published the novel in which such theories were properly dramatised and tested: *The Picture of Dorian Gray*. Here the 'development of the individual' through the cultivation of a sense of the Beautiful is traced in the story of the young Dorian, who falls under the influence of the theories of Lord Henry Wotton. Early in the novel, just before Dorian first sees his finished portrait, Wotton offers him this panegyric:

'You have a wonderfully beautiful face, Mr Gray. Don't frown. You have. And Beauty is a form of Genius – is higher, indeed, than genius, as it needs no explanation. It is of the great facts of the world, like sunlight, or spring-time, or the reflection in dark waters of that silver shell we call the moon. It cannot be questioned. It has its divine right of sovereignty. It makes princes of those who have it. You smile? Ah! When you have lost it you won't smile ... People say sometimes that Beauty is only superficial. That may be so. But at least it is not so superficial as Thought is. To me, Beauty is the wonder of wonders. It is only shallow people who do not judge by appearances. The true mystery of the world is the visible, not the invisible ...'[6]

On contemplation of the beauty of his portrait by Basil Hayward, Dorian Gray makes a reckless secret wish, a private act of will, offering his soul in return for the unending possession of such beauty. It is the kind of fatal interior action that Rossetti sought to dramatise and in some sense make visible in his painting – though of course in Wilde's case it cannot be made visible, since it is a secret homosexual desire. Granted his wish, Dorian spends his life in the pursuit of pleasure and vice, his own external youth and beauty unchanging, while his portrait displays or represents the signs of his sin. Wilde's parable may be interpreted as an argument about art in two mutually contradictory ways. One would be to read it as an attack on the idea of mixing Art and Ethics. Dorian's sense of his portrait as an exact mirror of his soul, his inner life, or his conscience, is a critical error which causes the beauty of the portrait to be slowly corrupted and destroyed. This is the sordid effect of mere 'realism' in art, the result of thinking that art reflects life *as it is*, rather than transfiguring the conditions of life into something superior. Dorian in fact *reads* this corruption into the painting, he 'criticises' his portrait in a fatal way because he is under the dangerous illusion that art should somehow mirror the ethical life, reproducing the 'reality' of moral choice, action and decision. For Wilde as a theorist of the doctrine of Aestheticism such a notion of realism merely degraded art. It was a mistake to insist that the ethical life should be represented at all by art, or that the language of the conscience, of will and decision, of human intention, politics, right and wrong – all this respectable middle-class stuff – should ever be read into painting. In short, Aestheticism as a doctrine denied the presence of an ethical 'moment' of the kind repeatedly discovered by Rossetti in the artwork. Dorian Gray's portrait (according to this reading) is destroyed by returning it to the temporal sphere in which moral action is made explicit.

However, it is obvious that the parable may be read in precisely the opposite way, which is to say that the attempt to elevate 'beauty' above the ethical life and to live merely for the cultivation of the self as a work of art, leads to catastrophe. If art is capable of revealing the soul through the penetrating truth of its representations, then the notion of escaping or cheating such truth is doomed. Dorian's portrait reveals the cancer of his soul, the corruption of his conscience and will as he slips into absolute egotism. And so the idea of the 'divine sovereignty' of beauty seems oddly compromised by the end of the novel, since that sovereignty has been purchased at the expense of a soul. The beauty of the portrait does not remain in stasis but is delivered to the motion of corruption in time. As is the case with Browning's Lippo then, there seems to be a sense in which the doctrine of beauty is simultaneously proffered as a serious aesthetic theory and subjected to rigorous irony.

If we relate the sphere of the ethical to the inner life, principally to the notion of conscience, or to the ways in which the self talks to and describes itself, we might think of this sphere as inherently a *verbal* one. The kind of self-addressing that constitutes the activity of ethics, the arguing with the self, the prosecution of moral reasoning, seems bound to language and to speech. Without the possibility of self-communion, or of speaking for and against an action, ethical activity would remain a question of sheer instinct and luck. If, on the other hand, the notion of 'Beauty' in a purely pictorial or formal sense seems, as Henry Wotton argues, to 'need no explanation', but to be a kind of 'fact' in itself, then the aesthetic category thus defined clearly stands in a stubborn opposition to the ethical. The difficulty of resolving this apparent opposition has been the central question in the philosophy of aesthetics since Immanuel Kant's *Critique of Judgement* (1790). All acts of ekphrasis attempt to resist the dichotomy by bringing speech and writing to the dumbness of the image. In doing so we might say that they inevitably attempt to open up the aesthetic to the ethical. Wilde's prose analysis of the meaning and consequences of Dorian Gray's beauty, like Browning's ventriloquism of Fra Lippo Lippi, Keats's interrogation of the urn, and Rossetti's sonnets for pictures, opens the aesthetic category to a particularly complex ethical life. Indeed each implicitly refuses to accept the notion of a separate realm of aesthetics, untouched by ethics, uncontaminated by speech or writing. Even Henry Wotton's theory is an ethical argument about art, one that makes ethical propositions and statements about the nature and meaning of the Beautiful. That is why the dichotomy may itself be a false one: aesthetics can never disentangle itself from ethics.

The difficulty of answering the questions 'what is beauty *for*'? or 'what does beauty *do*?', does not mean that the questions are meaningless, or that their unanswerability raises beauty above such interrogation. Oscar Wilde has something in common with Browning's Fra Lippo Lippi in his impatience with the suffocating orthodoxies of the day, the kind of answers that say: beauty makes us good Christians, or good citizens. The idea of beauty cannot be linked to the notion of the good unproblematically. It could be argued that in *seeming* to act as a fact of nature in need of no explanation, beauty is a kind of immorality. In many nineteenth-century novels this is exactly the assumption; that the possession of beauty, or the idealisation of an aesthetic existence, will inevitably go hand in hand with a grotesque and destructive egotism. (Think of Harold Skimpole the aesthete, largely based on Keats's friend Leigh Hunt, in Dickens's *Bleak House*.)

On the other hand, nineteenth-century Aestheticism promotes a level of self-cultivation that it believes to be ethically improving for the individual. Such a notion achieved its highest expression in the 'Conclusion' to Walter Pater's *Studies in the Renaissance*, written in 1868. Pater had been Wilde's tutor at Oxford and had developed a theory of Aestheticism in which the brief 'interval' of life before the annihilation of consciousness in death was to be exploited for its possibilities of refining and deepening the experience of each moment. Pater's famous 'Conclusion' concludes:

> we have an interval, and then our place knows us no more. Some spend this interval in listlessness, some in high passions, the wisest, at least among 'the children of this world', in art and song. For our one chance lies in expanding that interval, in getting as many pulsations as possible into the given time. Great passions may give us the quickened sense of life, ecstasy and sorrow of love, the various forms of enthusiastic activity, disinterested or otherwise, which come naturally to many of us. Only be sure it is passion – that it does yield you this fruit of a quickened, multiplied consciousness. Of such wisdom, the poetic passion, the desire of beauty, the love of art for its own sake, has most. For art comes to you proposing frankly to give nothing but the highest quality to your moments as they pass, and simply for those moments' sake.[7]

We could trace a line of descent (or ascent) through the nineteenth century around this idea of the 'moment': from Keats's 'Ode on a Grecian Urn' with its fascination with the still moment, the for ever now of Art, through Rossetti's sonnets and their rapture with the possibility of the turning

moment, through Pater's project of a 'quickened, multiplied consciousness' that gives nothing but 'the highest quality to your moments', to Wilde's Dorian Gray, and the sacrifice he makes of himself at the high altar of this vision of life. Nineteenth-century Aestheticism moves from the contemplation of the beauty of the 'moment' in painting to the treatment of life as if each instant possessed an analogous quality, an aesthetic value that could be savoured, or appreciated, as a life connoisseur. It wishes to arrest the temporal flow of life-in-time to fashion a sequence of framed pictures, each in itself a work of art of 'the highest quality'. But the ethical movement from 'Art' to 'Life-as-Art' is not an easy one to effect. As a mysterious and cryptic utterance 'Beauty is truth, truth beauty' may usefully capture the feeling we have in contemplating an art object (even an imaginary one), but in the sphere of human relations the merging, or submerging, of the ethical within the aesthetic category is obviously more dangerous and more dubious. How can the pursuit of 'Beauty' or the appreciation of the quality of the moment, or even the cultivation of the sensibility of the individual, act as principles of ethical conduct in our relation to others? By turning inwards to cultivate the sensibility of the self we risk becoming insensitive to what exists outside the self. Browning's Lippo counters this objection by suggesting that we find the 'soul' of beauty within ourselves when we 'return [God] thanks'; in other words, that the contemplation of 'beauty' enlarges our understanding of God and in that sense can rescue us from egotism. But Walter Pater stops the process short of thanking a creator, preferring instead to settle for art's 'proposing frankly to give nothing but the highest quality to your moments as they pass'. For Pater the 'moment' is enough in and of itself, as long as it is perceived as something like a work of art. He discovers a 'quickened, multiplied consciousness' by *arresting* the temporal flow, in the slowing down of time into single moments, quite different from the kind of quickening (and darkening) consciousness Rossetti finds by returning the arrested moment of art to the sequence of time and motion.

Even as the Aesthetic movement of the late nineteenth century posits its realm of 'eternal' or timeless beauty, history is taking its revenge. As we contemplate that movement now its ideas of what constituted the eternally beautiful seem limited and conventional. Perhaps the cult of slowing or arresting time will always have this tendency to stagnation. More often than not the precious things can be ticked off a familiar list: peacock feathers, sunflowers, Japanese prints, blue and white Chinese porcelain, roses, pearl, Dante's Beatrice, lilies, red hair, swans, the new fashion for smoking cigarettes, the scent of orchids, sandalwood, Japanese cabinets, silk damask, Japanese fans,

silk-screens, paper lanterns and so forth. The spectrum of transcendent beauty seems mummified in the 1890s. And if 'beauty' is extracted from the specific examples of what at any given moment in history is considered to possess beauty, it could be argued that it becomes a meaningless word. Similarly, the very idea of the 'aesthete' as a social or cultural stereotype is stuck in that decade. All this merely suggests the commonplace truth that 'beauty' is historically determined and culturally mediated, even though beautiful things seem to rise above such mediation in their apparently self-generating glory. But does the doctrine of Aestheticism have an afterlife? The theory grew out of Victorian writing for art and was nourished in the age of the gallery and museum, but an echo of the phenomenon in the twentieth century may be linked to the larger arguments of this chapter.

One figure immediately presents himself as the heir to the nineteenth-century priests of Aestheticism. Humbert Humbert, the narrator of Valdimir Nabokov's *Lolita* (1959), takes pride in his 'poetic' or aesthetic sensibility, 'the gentle and dreamy regions' of his imagination.[8] He believes that this sensibility places him above the average vulgar person, giving his criminal actions (the statutory rape of his stepdaughter, her kidnapping, the murder of Clare Quilty) a complexity, a quality that he believes (or says he believes) should convince the reader that he 'never was, and never could have been, a brutal scoundrel'.[9] The novel comes with a foreword by the well-meaning and fictitious 'John Ray, Jr., Ph.D', who counterbalances this aesthetic justification by offering us an ethical reading of the novel:

> Still more important to us than scientific significance and literary worth, is the ethical impact the book should have on the serious reader; for in this poignant personal study there lurks a general lesson; the wayward child, the egotistic mother, the panting maniac – these are not only vivid characters in a unique story: they warn us of dangerous trends; they point out potent evils. *Lolita* should make all of us – parents, social workers, educators – apply ourselves with still greater vigilance and vision to the task of bringing up a better generation in a safer world.[10]

John Ray is of course Nabokov's parody of what Wilde had called 'the low passion for middle-class respectability'. He is akin to the Prior and his monks who have found it difficult to conceive of a work of art that does not make us 'better', or the readers of fiction who seek a moral that fits into a conventional code of right and wrong. The scandal and controversy surrounding the novel

prompted Nabokov to write an afterword 'On a Book Entitled *Lolita*', and in this he makes a complicated claim that focuses the larger philosophical questions I have been discussing:

> There are gentle souls who would pronounce *Lolita* meaningless because it does not teach them anything. I am neither a reader nor a writer of didactic fiction, and, despite John Ray's assertion, *Lolita* has no moral in tow. For me a work of fiction exists only insofar as it affords me what I shall bluntly call aesthetic bliss, that is a sense of being somehow, somewhere, connected with other states of being where art (curiosity, tenderness, kindness, ecstasy) is the norm.[11]

Here the aesthetic category *does* actually carry in tow (in the studied parenthesis) aspects of the ethical: 'curiosity, tenderness, kindness'. The terms recall those in which Lippo described the usefulness of art: 'we're made so that we love / First when we see them painted, things we have passed / Perhaps a hundred times nor cared to see'. And while each of the first three elements of Nabokov's 'aesthetic bliss' ideally refers to relations with others, the last word ('ecstasy') suggests that this connection is a happy one for the individual. But the formulation is an elusive one. Fiction is said to afford an 'aesthetic bliss' (elsewhere Nabokov called it 'the telltale tingle between the shoulder blades'), which offers a sense of being connected 'with other states of being' where 'art ... is the norm'.[12] In the tingle or shudder of the pleasure peculiar to art, and which Nabokov described as 'the highest form of emotion humanity has attained', we experience a connection perhaps to the world of heightened sensation Keats imagined in the 'hereafter', or at least to a state of being in which a multiplying of consciousness, as Pater would have it, has occurred – though neither of these parallels quite shares the kind of *humanising* bliss Nabokov is describing.[13] These 'other states of being' outlast our momentary awareness of them, since they are ones in which this quality of consciousness is the 'norm', but they *are* states available to us through art. The claim that fiction can afford us this kind of connection seems in fact to be a powerfully ethical claim, as well as one purporting to describe a particular kind of pleasure.

It may trouble us that Nabokov's afterword sounds like the kind of thing Humbert Humbert might have written, both in its peculiarly affected style (Kingsley Amis pointed out that both Nabokov and his creation sound like a 'Charles Atlas muscle-man of language'[14]) and since it recalls the persistent claims Humbert Humbert makes for 'poetic sensibility' in the novel. But

this isn't the only problem with it as the statement of an aesthetic creed. The philosopher Richard Rorty reads Nabokov's afterword as a piece of wishful thinking:

> If curiosity and tenderness are the marks of the artist, if both are inseparable from ecstasy – so that where they are absent no bliss is possible – then there is, after all, no distinction between the aesthetic and the moral. The dilemma of the liberal aesthete is resolved. All that is required to act well is to do what artists are good at – noticing things that most other people do not notice, being curious about what others take for granted, seeing the momentary iridescence and not just the underlying formal structure. The curious, sensitive artist will be the paradigm of morality because he is the only one who always notices everything ... Nabokov would like the four characteristics which make up art to be inseparable, but he has to face up to the unpleasant fact that writers can obtain and produce ecstasy while failing to notice suffering, while being incurious about the people whose lives provide their material.[15]

The greatness of the novel, according to Rorty, rests in its implicit understanding of this 'unpleasant fact'. In other words, *Lolita* is more subtle and more true than Nabokov's afterword, since in Humbert Humbert it presents us with an example of a particular form of cruelty, the 'genius-monster – the monster of incuriosity', 'the *special* sort of cruelty of which those capable of bliss are also capable'.[16] Humbert Humbert the aesthete, wrapped up in his 'quickened, multiplied consciousness', determined to squeeze the 'highest quality' out of his own passing moments, is incapable of recognising the suffering of Dolores Haze, or is only sporadically able to notice that suffering, but is not curious enough about her separate individual life and consciousness to lessen his cruelty. According to Rorty, the novel itself traps the reader in analogous moments of inattention and incuriosity, moments where we fail to notice important signs or fail to make significant connections, and therefore teaches us the important lesson, the ethical lesson, that we ourselves are inattentive and incurious beings and that our capacity for a certain kind of cruelty is in direct proportion to our stupidity or lack of concentration. For Rorty, then, the novel does come with a specific moral in tow: that aesthetic bliss and poetic sensibility may sometimes preclude tenderness and kindness.[17]

This seems to be a truth firmly comprehended by Victorian writing for art. Robert Browning was aware of the possibility – the potential for an

aesthetic creed to serve narrowly selfish purposes – even as he gave Lippo those powerful and self-vindicating arguments for the goodness of 'beauty'. Rossetti, too, was acutely sensitive to the danger and cruelty that potentially inhered in the aesthetic category, the fall that attended an experience of ecstasy; and Wilde produced the most famous allegory of the narcissism of the aesthetic religion, even as he made some of its most extreme pronouncements. Writing for art, from which aestheticism emerged, seems in fact especially attuned to the potential gap between aesthetic pleasure and the ethical good since the encounter between word and image is so often one in which the cruelty, coldness or simple indifference of the image, even in its 'beauty', is confronted by the impulse of language to return it to the moral logic and consequences of temporal existence. In many examples of ekphrasis there also seems to be a congruent awareness of the limits to human attention, a discovery of the finite capacity for curiosity or tenderness towards the 'other', and an awareness of the impossibility of satisfying the impulse to cross over between separate categories. Nabokov's wish fulfilment – a state of being in which tenderness, curiosity and kindness are connected to aesthetic bliss – is not necessarily the 'norm' discovered in writing about art or aesthetics. The 'bliss' of aesthetic pleasure may be partly constituted by an indifference to, or suspension of, ethical consciousness.

NOTES

1 All quotations from Browning's poems from *The Complete Works of Robert Browning*, ed. Roma A. King et al. VI (Athens: Ohio University Press, 1981), 'One Word More', pp. 141–50.

2 Giorgio Vasari, *Lives of the Artists: Volume One*, trans. George Bull (London: Penguin, 1987), p. 216.

3 Oscar Wilde, *Plays, Prose Writings and Poems*, ed. Anthony Fothergill (London: Everyman, 1996), p. 124 (hereafter *OW*).

4 *OW*, p. 149.

5 *OW*, pp. 161–2.

6 Oscar Wilde, *The Picture of Dorian Gray*, ed. Robert Mighall (London: Penguin, 2000), p. 24.

7 Walter Pater, *The Renaissance: Studies in Art and Poetry*, ed. Adam Phillips (Oxford: Oxford University Press, 1986), p. 153.

8 Vladimir Nabokov, *Lolita*, ed. Alfred Appel Jr (London: Penguin, 1995), p. 131 (hereafter *Lolita*).

9 *Lolita*, p. 131.

10 *Lolita*, pp. 5–6.

11 *Lolita*, pp. 314–15.

12 Vladimir Nabokov, *Lectures on Literature*, ed. Fredson Bowers (New York: Harcourt Brace Jovanovich, 1980), p. 64 (hereafter LL).

13 *LL*, p. 64.

14 *Vladimir Nabokov: Lolita: A Reader's Guide to Essential Criticism*, ed. Christine Clegg (Cambridge: Icon Books, 2000), p. 35. Amis's review originally appeared in *The Spectator* (6 November, 1959). Personally, in almost everything Nabokov wrote I hear the voice of Dr Niles Crane from *Frazier*.

15 Richard Rorty, *Contingency, Irony, and Solidarity* (Cambridge: Cambridge University Press, 1989), pp. 158–9.

16 Rorty, *Contingency, Irony, and Solidarity*, pp. 161; 157.

17 It is consoling to believe that at least you are in possession of the 'unpleasant' facts. Rorty in my view too easily separates Humbert Humbert's aestheticism from what he thinks of as the novel's exemplary ethics. For Rorty, Humbert represents the cruel poet, while the novel is the kindly and tender teacher. But the pleasure of the novel seems intimately bound up with cruelty, black humour, vicious irony, shock, even moral offence. Readers who follow Rorty's line of thinking shy away from a full recognition of this fact, preferring to confine cruelty to Humbert and to credit the novel itself with good ethics due to the verisimilitude with which it has portrayed evil. Art is always thus redeemed. Like Lippo, Rorty believes that in its vivid capacity for realisation, its bringing the world closer to our attention, art can only make us better people. But this is to believe that ultimately whatever art shows us will be good, or will have a positive benefit, or at least will be offered with the best intentions. And it is to pretend that the novel does not work in profound ways upon the connection between pleasure and outrage. In some respects, the novel seems to take Wilde's experiment in *Dorian Gray* to a further limit, exulting in the discovery of a relation between the aesthetic and the unethical, not merely in its narrator but in itself, as a work of art. The paradigm of morality Rorty finds in *Lolita* seems to be something along the lines of 'we must try harder', which is about as helpful as it was on a school report. Unfortunately, even if it were the case that simply trying harder would increase our concentration or attention spans, it does not follow that an increased awareness of the sufferings of another necessarily improves our behaviour towards them.

SUFFERING

THE act of attention that would do justice to the suffering of others is not easy to imagine or define. What would constitute an exemplary moment of concentration? Rorty's suggestion, that good artists display an intentness and curiosity about the world that act as a kind of spur to the rest of us to try harder, doesn't really explain the specific nature of a work of art's own attentiveness. 'What skilled attention they get, all these dying of their wounds', says Clov, repeating what others have told him. Poems and paintings might seek to remind us of the suffering of others, but in doing so they also remind us that suffering is usually a solitary experience and that it is impossible to share another person's pain. These unpleasant facts need not be lessons in callousness, however. The recognition of the enclosed uniqueness of suffering is an important part of our moral sense. Not believing that imaginative acts of empathy can be boundless or complete properly acknowledges the reality of pain. But artworks frequently show us pain as spectacle, suffering on display, and in doing so take us even further away from the direct apprehension of the physical or mental reality. Mysteriously, maddeningly, they may transform or transfigure pain and suffering in ways that are of small help for those who suffer 'outside' art. 'What does it mean to protest suffering, as distinct from acknowledging it?', asks Susan Sontag.[1] In the engagement with suffering there is often an impulse to go beyond mere recognition, a strong ethical imperative to bear witness to the pain of others in ways that seem to protest against that pain. But then of course the protest itself may become a spectacle, even a source of pleasure.

In the rivalry between poetry and painting there is a serious question as to which of the sister arts is best suited to this kind of representation, that is, to making suffering appear. Which medium comes closest to what is finally impossible, and which is best at representing the fact that this is finally

impossible- the awareness or acknowledgment which seems to protest against itself? This impossibility, this failure, I would argue, is revealed particularly sharply in a cluster of ekphrases written for the paintings of Brueghel.

The sixteenth century Flemish artist Pieter Brueghel the Elder painted the *Fall of Icarus* between 1555 and 1558 (figure 8). His source was the tale of the craftsman Dedalus and his unfortunate son, from the eighth book of Ovid's *Metamorphoses*. This is the story of how Dedalus fashioned wings enabling him and his son to fly, and how disaster occurred when Icarus flew too close to the sun. The following version is from Arthur Golding's famous translation of 1567:

> The fishermen
> Then standing angling by the sea and shepherds leaning then
> On sheephooks and the ploughmen on the handles of their plough,
> Beholding them, amazed were and thought that they that through
> The air could fly were gods. And now did on their left side stand
> The isles of Paros and of Dele and Samos, Juno's land,
> And on their right Lebinthus and the fair Calydna, fraught
> With store of honey, when the boy a frolic courage caught
> To fly at random. Whereupon, forsaking quite his guide,
> Of fond desire to fly to heaven above his bounds he stied.
> And there the nearness of the sun, which burned more hot aloft,
> Did make the wax, with which his wings were glued, lithe and soft.
> As soon as that the wax was molt, his naked arm he shakes;
> And, wanting wherewithal to wave, no help of air he takes.
> But, calling on his father loud, he drowned in the wave;
> And by this chance of his those seas his name forever have.
> His wretched father (but as then no father) cried in fear,
> 'O Icarus, O Icarus, where art thou? Tell me where
> That I may find thee, Icarus.' He saw the feathers swim
> Upon the waves, and cursed his art that had so spited him.
> At last he took his body up and laid it in a grave
> And to the isle the name of him then buried in it gave.[2]

W.H. Auden's poem about the *Fall of Icarus* and other paintings by Brueghel in the Musées Royaux des Beaux-Arts, Brussels, dates from 1938:

8 Pieter Brueghel the Elder, *Landscape with the Fall of Icarus* (c. 1558) (Royal Museum of Fine Arts of Belgium, Brussels)

Musée des Beaux Arts

About suffering they were never wrong,
The Old Masters: how well they understood
Its human position; how it takes place
While someone else is eating or opening a window or just walking
 dully along;
How, when the aged are reverently, passionately waiting
For the miraculous birth, there always must be
Children who did not specially want it to happen, skating
On a pond at the edge of the wood:
They never forgot
That even the dreadful martyrdom must run its course
Anyhow in a corner, some untidy spot
Where the dogs go on with their doggy life and the torturer's horse
Scratches its innocent behind on a tree.

In Brueghel's *Icarus*, for instance: how everything turns away
Quite leisurely from the disaster; the ploughman may
Have heard the splash, the forsaken cry,
But for him it was not an important failure; the sun shone
As it had to on the white legs disappearing into the green
Water; and the expensive delicate ship that must have seen
Something amazing, a boy falling out of the sky,
Had somewhere to get to and sailed calmly on.[3]

Auden's ekphrasis looks to understand the 'human position' of suffering. In life a person experiences pain or anguish while the world goes about its business, either not regarding them at all or merely too busy or too indifferent to care. Brueghel's foregrounding of the ploughman might be taken as illustrating a Flemish proverb which says as much: 'No plough is stopped for the sake of a dying man.'[4] Life goes on, as we might say. And this 'human position' is represented, according to Auden, in the composition of Brueghel's *Icarus* by the manner in which 'everything turns away / Quite leisurely from the disaster'. The tiny, scarcely observed legs of Icarus disappear at the corner of the canvas into the green water. Hidden in the undergrowth, scarcely visible, is the head of a corpse. What little attention they get, these dead or dying of their wounds. Norman Bryson puts it this way: 'Brueghel's image implies that in fact what runs the world is repetition, unconsciousness, the sleep of

culture: the forces that stabilize and maintain the human world are habit, automatism and inertia.'[5] At the same time the poem about the painting also records the congruent fact that our attention span for pictures in galleries is limited; we notice a detail here and there, we 'turn away' quite leisurely and move on to the next piece.[6] Few paintings are able to command our attention for long. There is a parallel then between the moral illustrated by Brueghel and the leisured connoisseurship of the poet, his easy pedagogic tone, the sense of someone gently appreciating the 'Old Masters' in a stroll around a museum. All this puts the 'human position' of suffering in relation to art in a clear perspective: art can only displace suffering, it cannot hope to represent it directly. At best (and the best are 'never wrong') painters and poets concentrate upon our inability to concentrate; they do justice to the peripheral, oblique position of actual suffering in art (a play, perhaps, on the word *about* suggests this); they are conscious of the elision of pain in their representations of pain, and in this awareness a kind of victory is snatched from the moral weakness of their own 'human position'.[7]

The easy, urbane confidence of Auden's ekphrasis persuades us of its own authority even as it defers to that of the old masters. But the fact of speaking *for* the painting in this way reminds us that Brueghel's painting is already in a relation to a literary text, to Ovid, and that this relation is not straight-forward. Ovid's account is muted by Brueghel's painting: Dedalus's cries are silenced, Icarus is no longer the centre of attention – which of course is the point. The painting seems in a way to reject the literary source in its careful decentring or marginalising of the central events of the text, while Auden's poem, by contrast, returns us to story-telling, reclaiming narrative time as it describes what has happened and what will happen next. There seems in other words to be a tension between the word and the image, a paragonal struggle around these different ways of telling and showing. The original source has two key naming moments: 'those seas his name forever have', and 'to the isle the name of him then buried in it gave', illustrating the mythic origins of these linguistic signifiers. The painting on the other hand relishes the idea of anonymity in its unnamed ploughman and shepherd (the latter not mentioned at all by Auden), foregrounding an indifference or an ignorance which is not only illustrative of the wider point about suffering but which seems also to be an indifference to the Latin source, indeed to writing as naming, as myth-making. Perhaps there is even a sense in which the labour of the ploughman and the shepherd cannot be interrupted for the leisure of literary story-telling. And yet the painting's title names and points to its literary origin.

But if the painting exaggerates and feigns a kind of ignorance, Auden's poem also knows more than it tells, introducing a quite different narrative altogether without ever explicitly naming it: the story of the Christian passion. The aged 'reverently, passionately waiting / For the miraculous birth', the 'dreadful martyrdom', the 'forsaken cry' all hint at a Christian story – Auden is thinking especially of two other paintings by Brueghel in the Brussels museum on specifically Christian themes: *The Numbering at Bethlehem* and *The Massacre of the Innocents*. That such a narrative is repressed or occluded might mean different things: firstly, that Christ's suffering, having occurred in the midst of ordinary human inertia, nevertheless changes the meaning of human suffering in history, though in ways beyond the telling of either poem or painting. Secondly, that the incarnation has *not* brought an end to human indifference, has not been noticed in its full eschatological sense; human suffering continues, and, like Christ's Passion, goes unnoticed by the rest of the world – and in this poem. (Christ is not named.) In other words, how Christ's suffering relates to the 'human position' of ordinary suffering – and this is not an easy theological question at all – is not made clear by Auden, even though the poem silently points towards the Passion. If Brueghel's choice of the pagan myth itself had a Christian point (opinion is divided on this) – that the mythopoeic world of the Greeks is succeeded and eclipsed by Christianity; that a Christian iconography (the shepherd, the flock, the ploughman) displaces/ignores the figures of Greek myth – then Auden's poem does not make this point explicitly but instead prefers in some way to conflate the pagan and Christian narratives. They are both equally unimportant in a world that cannot pay them much attention, that 'turns away' from the spectacle of significant suffering. Auden wrote 'Musée des Beaux Arts' during the time in which he was returning to Christianity, in other words when he was turning towards a full apprehension of the centrality of the miraculous birth and the dreadful martyrdom. But this turning *towards* also depends upon a recognition that turning *away* is the common human response to pain. An awareness of the limits to our attention, the feebleness of our curiosity, seems in fact to be central to Auden's Christianity, a crucial awareness, and in this sense we might read Auden's ekphrasis as a religious poem, albeit one that rehearses and performs the very symptoms for which it seeks a cure.

The poem comes out of a time of acute political crisis in Europe, the 'low dishonest decade' as Auden would later describe it. It was written in Brussels after Auden returned from the Sino-Japanese war of 1937, and a year after his experiences in Spain. More specifically, this was in the immediate aftermath of the Munich agreement, when the appeasement of Hitler witnessed the

free world quite consciously turn away 'from the disaster' that loomed over the continent.[8] In this context the notion of indifference to suffering, or of a blind persistence in mundane activity, acquire an ominous sense. The short line near the centre of the poem, 'They never forgot', hints that recent historical lessons and sacrifices have slipped out of memory. Not hearing the 'forsaken cry' of those areas of Europe sacrificed to appease Hitler might after all be an 'important failure'. To read the poem with this subtext in mind is to perceive an irony beneath the leisurely, easy tone of the gallery connoisseur. Even if there are important truths in what he says about the relation of art to suffering and about the 'human position' of suffering in life, there is also a historical pressure bearing upon his words which threatens to undermine his own human position. A sinister, luxurious complacency might lie behind this kind of moralising, as if we are meant to hear in it the voice of an old aristocratic Europe, with its swagger and its connoisseurship, incapable of imagining itself as 'wrong', and slipping towards disaster. In what ways does the anaesthetisation of suffering in art bolster an ideology of myopic self-confidence, the confidence of European 'civilisation'? Are gallery-going and art gazing a guilty activity in 1938?

Notwithstanding these ironies, the poem is not a parody exactly since it attempts to keep faith with Brueghel, and particularly with the painting's own study of indifference. The deliberate marginalising of the narrative of Dedalus and Icarus and the concentration upon the ordinary is typical of Brueghel's art, with its commitment not to the fanciful, the 'poetic' or the imaginary, but to a representation of the world in itself. Auden's ekphrasis reads this kind of art as possessing a particular moral significance. To render the world in this way, in its stubbornness, its recalcitrance, is to have a profound understanding of the relativity of human goodness, sympathy, and the capacity to respond to suffering. Brueghel is a master because of his ability to represent this moral vision, while, for Auden, to arrive at such an understanding is a stage on the way back to Christianity. If it is hard to get suffering 'right' in art, at least the Old Masters never got it wrong.

William Carlos Williams refuses to spell out any moral at all, but reads the painting for a purity of indifference:

Landscape with the Fall of Icarus

According to Brueghel
when Icarus fell
it was spring

a farmer was ploughing
his field
the whole pageantry

of the year was
awake tingling
near

the edge of the sea
concerned
with itself

sweating in the sun
that melted
the wings' wax

unsignificantly
off the coast
there was

a splash quite unnoticed
this was
Icarus drowning[9]

Freedom from punctuation creates a syntactical openness that produces teasing
ambiguity. What, exactly, is 'concerned / with itself'? Grammatically the poem
allows different possibilities: it could be the 'pageantry / of the year', i.e. the
colourful seasonal rebirth that seems unconcerned with a boy drowning; it
could be 'the sea' that is concerned only with itself; or the 'splash', that goes
unheard and unseen. It might be that 'Icarus drowning' was concerned only
with himself, caught up in a death-struggle in which the 'tingling', 'sweating'
life of the year was absolutely distant. Or the phrase might seem to stand as a
kind of motto for Brueghel's art: 'concerned / with itself'. In other words, for
Williams this is a painting that refuses to be opened out to moral explication,
but which merely goes busily about a duty to record without an overt ethical
or emotional content. The poem is isomorphic, meaning that the reading-eye
travelling downwards 'mimics' both the fall of Icarus and the experience of
looking at the painting, where the eye ends up finding Icarus in the bottom
right-hand corner having travelled over the farmer, the shepherd, the ship, and

so forth. This attempt to reproduce the experience of looking at the painting, this ekphrastic fidelity, might also be part of the meaning of 'concerned / with itself', as the poem imitates the painting's refusal to comment upon its own representation, attempting merely to 'show'. But there is also a play on the word 'concerned', with its connotation of being only mildly anxious, recklessly short of the kind of response a drowning person might hope for, but also registering the lack of engaged interest a drowning person might have for the pageantry of the spring. What has the spring to do with him, or he with the spring? As with Auden, Williams seems sensitive to the painting's suggestion of the limits to sympathetic correspondence. But with Williams this goes further. The word 'unsignificantly' (not *insignificantly*) suggests more than indifference or coolness; rather, it is the complete failure of the drowning to register or to *signify* at all: a form of unnoticing that suggests the full dumb horror of the gap between the natural world and human suffering. (Again, it also suggests the *un*significance of the spring to a drowning man.) Williams interprets the painting as resolutely facing this fact, and this unsentimental honesty is what he seeks to reproduce in the consciously flat, emotionally neutral language at the end of the poem: 'this was / Icarus drowning'.

But an awareness of insentience as an organising principle is not at all the same thing as insentience, just as the representation of indifference might not be in the least indifferent. The desire to write a poem that is closely equivalent to the painting, imitating its compositional arrangement, its muteness, its neutrality, is a strong one. But what Williams sees as the mute objectivity of the painting, even if this were what Brueghel intended, cannot be successfully imitated in writing, however spare and flat, principally because the poet's language must in some way produce semantic possibilities which will break open the silence of the painting, speaking for it. It does so in the play upon 'concerned / with itself', and in the choice of '*un*significantly'. These words do signify; they connote, they invite us to see *how* Williams is reading the painting. Furthermore, Williams also wants to say something about insentience, particularly about the terrifying insentience or non-connection between a drowning man and the glory of spring, and so the apparently flat ending in fact disguises an emotional charge. The very failure of the spring to *feel* the presence of a drowning man and the failure of the drowning man to *feel* the presence of the spring, and of course the analogous failures of art to feel suffering, or suffering to notice art, has a significance, a troubling searching significance, that Williams wants a reader to experience. If Auden's reading of Brueghel was concerned with the failure of human responses to suffering, Williams reads Brueghel as more about the apparent meaninglessness of

human suffering within the life-cycle of the natural world. His ekphrasis attempts to imitate the painter's unblinking, dispassionate record of that fact.[10] But to record the fact is to comment upon it, not merely to reproduce it. And so the apparent refusal of a moral in Williams's poem itself becomes the moral. For us in our 'human position', the meaninglessness of the natural world is not neutral.

Would Brueghel have recognised his affinities with a modernist avant garde emerging from a post-Christian culture? Perhaps not.[11] It makes more sense to think of Williams's poem (published in 1962) as a reply or correction to W.H. Auden. In its refusal to allegorise or moralise, at least to do so overtly, Williams perhaps sought to return the painting to what he thought of as the more fundamental condition of its mode of representation. The silence of pictorial representation and the emotional possibilities of an art that merely 'shows' constituted a greater attraction for him than Auden's gallery lecture. The materiality of oil paint was analogous to the physical objectivity of the world, and Williams hoped to render the force of this first and foremost, so that the moral problem or challenge of this objectivity might be felt in the silence at the poem's end.

When Randall Jarrell returned to Auden's poem, he too wrote in opposition. 'The Old and the New Masters', published in *The Lost World* (1965), begins with a reading of a painting by de La Tour entitled *St Sebastian Mourned by St Irene*:

The Old and the New Masters

About suffering, about adoration, the old masters
Disagree. When someone suffers, no one else eats
Or walks or opens the window – no one breathes
As the sufferers watch the sufferer.
In *St. Sebastian Mourned by St. Irene*
The flame of one torch is the only light.
All the eyes except the maidservant's (she weeps
And covers them with a cloth) are fixed on the shaft
Set in his chest like a column; St. Irene's
Hands are spread in the gesture of the Madonna,
Revealing, accepting, what she does not understand.
Her hands say: 'Lo! Behold!'
Beside her a monk's hooded head is bowed, his hands
Are put together in the work of mourning.

9 Georges de La Tour, *St Sebastian Mourned by St Irene* (c. 1645) (Gemäldegalerie, SMB. Photo: Jörg P. Anders)

It is as if they were still looking at the lance
Piercing the side of Christ, nailed on his cross.
The same nails pierce all their hands and feet, the same
Thin blood, mixed with water, trickles from their sides.
The taste of vinegar is on every tongue
That gasps, 'My God, my God, why hast Thou forsaken me?'
They watch, they are, the one thing in the world.[12]

(ll. 1–21)

The old masters 'disagree' with each other in that de La Tour's rendering of the pain of St Sebastian does not present the same vision of suffering that we see in Brueghel's *Icarus*. It seems to contradict Auden's theory of the 'human position' of suffering as peripheral and unnoticed. But the old masters 'disagree' with us too in the sense of belonging to a different world and sharing a radically different historical understanding of human suffering. As time goes on, the history of western painting begins to fissure, or disagree with itself: as the unified culture offered by Christianity fragments and breaks down, the shared assumptions about the meaning of human suffering are lost. If Christ's passion haunts Auden's poem as an unspoken and concealed figure of suffering, Jarrell chooses in response a painting in which the Christian mythos is absolutely central and open. And in doing so he implicitly challenges and 'disagrees' with Auden's own (secret) Christian allegory. The painting by de La Tour foregrounds the dreadful martyrdom of St Sebastian and places around the sufferer those whose attitudes are types of Christian piety, so that the scene is in a total relation to the Passion of Christ. The significance of this story is as vital and alive to those depicted in the painting as de La Tour could assume it would be to his audience. Indeed looking at the painting would involve participating directly in its drama since it is arranged as a scene of witness. The painting represents, for Jarrell, a supreme focusing, the act of a single and unified culture in which there is a complete identification between the watched and the watcher: 'They watch, they are, the one thing in the world.' The close of the poem describes the breakdown of this unity and predicts a sorry end for the history of art:

> After a while the masters show the crucifixion
> In one corner of the canvas: the men come to see
> What is important, see that it is not important.
> The new masters paint a subject as they please,
> And Veronese is prosecuted by the Inquisition

For the dogs playing at the feet of Christ,
The earth is a planet among galaxies.
Later Christ disappears, the dogs disappear: in abstract
Understanding, without adoration, the last master puts
Colors on canvas, a picture of the universe
In which a bright spot somewhere in the corner
Is the small radioactive planet men called Earth.

 (ll. 50–61)

Jarrell is not regretting what he sees as the passing of Christianity, or mourning the fact that art is no longer centrally organised around the narrative of Christ. He merely records the unravelling of this historical fabric and allows the poem to spin out from this process into a final vision of post-history, a vision of the ultimate abstract representation. (The 'last master' is a fantasy of an Artist-Creator who paints the universe long after the disappearance of humanity.) Jarrell's 'The Old and The New Masters' opposes the assumption in Auden's poem that human suffering is a constant and unchanging phenomenon, best understood by the old masters, and always pointing towards the Christian passion. 'Suffering' has a history, just as painting does, and is better understood as something experienced historically: that is, in relation to the changing meanings through which it is manifested. Art can only anticipate, respond to and follow these changes. The men who 'come to see / What is important, see that it is not important' suggest both the figurants within Christian paintings (the credulous folk in the nativity scene who will lose their belief) and the audience for art. If, then, an awareness of the relative limits of human sympathy and compassion is important to Auden, Jarrell adds to this an awareness of the historically relative nature of suffering itself. And if it is tempting to think of art as more durable than Christian faith, Jarrell looks towards the end of all human art in a radioactive apocalypse.

All art is pitted against history and the threat of an abyss. Williams was drawn to the paintings of Brueghel partly because they seemed to offer an obdurate reproduction of the materiality of the world, and in doing so perhaps promised to redeem the mundane and the ordinary from the doom to which all life is consigned. In some reticent, hard-nosed way, Brueghel seems to protest rather than merely acknowledge the brute fact of death. This is Williams's poem about Brueghel's *The Hunters in the Snow* (1565) (figure 10):

10 Pieter Brueghel the Elder, *The Hunters in the Snow* (1565) (Kunsthistorisches Museum, Wien oder KHM, Vienna)

The Hunters in the Snow

The over-all picture is winter
icy mountains
in the background the return

from the hunt it is toward evening
from the left
sturdy hunters lead in

their pack the inn-sign
hanging from a
broken hinge is a stag a crucifix

between his antlers the cold
inn yard is
deserted but for a huge bonfire

that flares wind-driven tended by
women who cluster
about it to the right beyond

the hill is a pattern of skaters
Brueghel the painter
concerned with it all has chosen

a winter-struck bush for his
foreground to
complete the picture[13]

'The over-all picture is winter'. Here the notion of the 'picture', the record or representation, the painting, is total, as if the physical world had been comprehensively transposed on to canvas. Over-all is the picture, and the picture (with the hint perhaps of a bleak prognosis) *is* winter. Any notion of story-telling, of allegory or interpretation, any idea of symbolism or of metaphor, is bluntly excised. Williams wants to be faithful to what he sees as Brueghel's own fidelity to the facts of a winter landscape, the stubborn or sturdy objectivity of the world 'over-all'.[14] 'Brueghel the painter' is here 'concerned with it all' ('concerned with itself'), where 'concerned' carries the

sense of a close attention to the way things are, as well as a sense of the necessary economy of sentiment involved in such a form of attention. Lean and economical, the poem mimics this spare picturing. The hard-edged compounds 'wind-driven' and 'winter-struck' suggest the obduracy of a physical world, the elemental yokings and noun-and-verb collisions of a winter landscape in which the simple activities of peasant life determinedly persist. The 'winter-struck bush' has been 'chosen' for the foreground to 'complete the picture', reminding us that the painter has *composed* this scene – it is, after all, a 'picture' ('struck' suggests the brush-'stroke'), but it is a 'complete' picture. No moralising, no interpretation, no reading is required. For Williams, then, it is a picture of the world as it is, cleansed of pictorial convention, purged of iconographical language (the crucifixion is merely an 'inn-sign'). And yet in this strict fidelity to the physical world Williams discovers a high moral principle that he seeks to imitate and reproduce in his own poetics. Against the historical oblivion into which such peasant life will inevitably be plunged, Brueghel creates a pictorial record. This is a rebuke to the outrage of historical oblivion, to the 'over-all' or surrounding darkness, to the 'winter' of eternity in which these hunters, these skaters and these clustering women are lost. It is a kind of moral protest, or act of love, an act of the closest attention and concern, not to be confused with the idea of being 'immortalised' in art, but instead closer to the idea of defiance, of recording the simple and outrageous fact of *having been here.*

John Berryman's poem 'Winter Landscape', responding to the same Brueghel painting, further explores this idea of record and oblivion:

Winter Landscape

The three men coming down the winter hill
In brown, with tall poles and a pack of hounds
At heel, through the arrangement of the trees,
Past the five figures at the burning straw,
Returning cold and silent to their town,

Returning to the drifted snow, the rink
Lively with children, to the older men,
The long companions they can never reach,
The blue light, men with ladders, by the church
The sledge and shadow in the twilit street,

Are not aware that in the sandy time
To come, the evil waste of history
Outstretched, they will be seen upon the brow
Of that same hill: when all their company
Will have been irrecoverably lost,

These men, this particular three in brown
Witnessed by birds will keep the scene and say
By their configuration with the trees,
The small bridge, the red houses and the fire,
What place, what time, what morning occasion

Sent them into the wood, a pack of hounds
At heel and the tall poles upon their shoulders,
Thence to return as now we see them and
Ankle-deep in snow down the winter hill
Descend, while three birds watch and the fourth flies.[15]

Berryman's single sentence circles and returns whilst opening the moment or the 'for ever now' of the painting to the surrounding element of Time. The three men returning to their town and to the 'long companions they can never reach' are like the figures on Keats's urn. They 'are not aware' of what the poem knows, that their placing there upon the brow of the hill will be 'for ever', and that there they will stand 'when all their company / Will have been irrecoverably lost'. However, their immortality, or rather their remaining there, occurs only in the artwork and not in life, or in other words through the pattern of composition and arrangement in which they 'will keep the scene and say / By their configuration with the trees' what their story has been. 'Say' though in what sense? Berryman wants to translate their long endurance out of silence and stillness into a more complete record, one in which the hunters are able to tell 'what place, what time, what morning occasion' sent them into the woods. Somehow the picture will speak perfectly of its specific historical instant because it has survived the 'evil waste of history' in which that instant is buried. But neither painting nor poem can make long art return to brief life. The huntsmen remain anonymous and mute like the figures on Keats's urn, mysterious and disquieting in their silence, and the poem's own single sentence can only return to the 'moment' Brueghel has pictured, unable finally to make the picture *unconceal* itself completely. Nevertheless, Berryman wants to make even more explicitly clear than Williams that Brueghel's vision has

the moral value of witnessing; that is, that there is a significance in the act of 'seeing' these lives which can never redeem or compensate for 'the evil waste of history' in which they are lost, but which nevertheless *stands*. Like Williams, Berryman is drawn to the quiet stoicism that is implied by the activity of the hunters in the painting, and which is reproduced and valued in the hard act of attention paid by the painter to this moment. The final image of three birds watching is taken as an emblem of witness, instinct with moral value, whilst the 'fourth flies' as an emblem of the movement of Time, of the distracted attention or failure of concentration which marks the ending of witness. In its own small and melancholy way, this is a protest against oblivion.

If unconsciousness, unawareness, persistence, habit are the organising principles of the everyday world in which suffering goes unnoticed, they are also the elements which affect us, move us, in those hunters in the snow. They are 'not aware' of art or of the transfiguring of their lives in Brueghel's painting, nor of this future when all will have been lost and which is our present moment of attention. In other words, they are not aware of the death which inhabits their living moment, and which is seen and recorded by the painting. 'Awareness' occurs in the encounter of viewer and picture, of poem and painting. Hence in the very act of returning, or of being for ever on the point of returning, 'coming down the winter hill', there seems in Brueghel's hunters to be a configuration of an enormous human grief and loss. That space between hill and village seems to be a perspective of absolute separation, an irrecoverable distance.[16]

But 'Winter Landscape' may witness and protest more than oblivion. This is what Berryman wrote about the poem in an essay of 1976 entitled 'One Answer to a Question: Changes':

> The poem is sometimes quoted and readers seem to take it for either a verbal *equivalent* to the picture or (like Auden's fine Brueghel poem, 'Musée des Beaux Arts', written later) an *interpretation* of it. Both views I call wrong ... [The] poem's extreme sobriety would seem to represent a reaction ... against the hysterical political atmosphere of the period. It dates from 1938–9 and was written in New York following two years' residence in England, during recurrent crises, with extended visits to France and Germany, especially one of the Nazi strongholds, Heidelberg. So far as I can make out, it is a war poem, of an unusual negative kind. The common title of the picture is *Hunters in the Snow* and of course the poet knows this. But he pretends not to, and calls their spears (twice) "poles", the resultant governing emotion being a certain

stubborn incredulity – as the hunters are loosed while the peaceful nations plunge again into war. This is not the subject of Brueghel's painting at all, and the interpretation of *the event of the poem* proves that the picture has merely provided necessary material from a tranquil world for what is necessary to be said – but which the poet refuses to say – about a violent world.[17]

In Berryman's slippery account the force of the poem is 'pivoted on a missing or misrepresented element in an agreed-on or imposed design'.[18] In other words, there is a darker significance to the poem than might be recognised by an initial reading, one in which witness is borne not to the ordinary, everyday activity of peasant village life, but to the sense of violence unloosed in Europe. The painting was in a sense contaminated for Berryman by this atmosphere, so that its contrast with European hysteria paradoxically results in it suggesting something of that insanity or violence in itself. As such the poem actually has more in common with 'Musée des Beaux Arts' than Berryman realises because Auden's poem is also haunted by the 'evil waste of history' (contemporary history) which might superficially appear to bear no relation to old master paintings. What becomes especially interesting is that the poem seems then to attain a double relation to the painting. It may perfectly easily be read without the missing element provided by Berryman, without the reference to the catastrophe in Europe, so that it remains a poem bearing witness to a wider arc of historical oblivion. But the true protest is a mute one, a 'certain stubborn incredulity' which belongs not to Brueghel but to the poet's historically determinate response. Auden's moral about not noticing significant suffering returns here with an irony Berryman fails to record, since any misreading of this poem, any failure to hear its silent protest is to take its 'extreme sobriety' not as a response to hysteria but merely as an art-historical interpretation. This is to miss the obliqueness of the poem's relation to the painting, the distorting effect of its immediate context, and therefore to *repeat* the narrowness of attention both Berryman and Auden seem to be protesting against. The unawareness, then, that Berryman sees in Brueghel's hunters – hunters who are killers – stands for a much more terrifying abandonment to violence (like the turning away in Auden's poem), and evinces a brutality which goes unnoticed by a reader.

Twentieth-century poets have been drawn to the paintings of Brueghel, and in particular the two I have discussed in this chapter, because his art seems to be grounded in the physical realities, the materiality, of the world. This corresponds to a modern poetics that is interested in the capacity for writing

to represent the solidity of life, the gravity and tangibility of objects, and the *thereness* of the physical world in its non-sentience or non-consciousness. As painters work in a medium that might seem closer to the object world than writing (oils on canvas), ekphrasis has been one means of a direct encounter between writing and the substantivity or *thing-ness* of nature. But as language or writing meets the obduracy of the world, the material visibility of the image, it is inevitably forced to reflect upon the resistance and stubbornness, the dumbness that it meets there. Auden, Williams and Berryman all draw morals about 'unawareness', non-feeling or passivity from Brueghel: for Auden, a truth about the human position of suffering in life; for Williams, an existential truth to be felt and pondered; for Berryman the truth of witness and a kind of tragedy of historical oblivion, but also an image of contemporary horror. In each case the painting has been read not within the terms and schema of art-history, iconography or symbolism, not within a semiotics of pictures and images, but according to a poetics in which Brueghel tells us something about non-feeling, something about the brute plenum of the world.

NOTES

1 Susan Sontag, *Regarding the Pain of Others* (London: Penguin, 2004), p. 36. Sontag does not answer her question.

2 *Ovid's Metamorphoses: Translated by Arthur Golding* (London: Penguin, 2002), p. 243.

3 W.H. Auden, *Collected Poems*, ed. Edward Mendelson (London: Faber, 1976; rev. 1991), p. 179.

4 Or perhaps 'shit happens'. The fable is often taken as illustrating the dangers of over-reaching, dangers perhaps inherent to the activities of the artist-craftsman. As such, we might read the story as an allegory of art's rivalry with the physical world. For Richard Johnson, Icarus represents 'the figure of the aesthete': see Richard Johnson, *Man's Place: An Essay on Auden* (Ithaca and London: Cornell University Press, 1973), p. 41. In his essay on 'Psychology and Art To-day', which appeared in 1935, Auden draws a comparison 'in the widest sense' between a 'man struggling for life in the water' and the 'highbrow' or intellectual, in the sense that he is a person 'who is active rather than passive to his experience'. W.H. Auden, *Prose and Travel Books in Prose and Verse: 1926–1938*, ed. Edward Mendelson (Princeton: Princeton University Press, 1996), I, p. 95.

5 Norman Bryson, *Looking at the Overlooked* (Cambridge, MA: Harvard University Press, 1990), p. 140.

6 'Auden's "Musée des Beaux Arts" places us not merely in a specific location, the museum in Brussels where Bruegel's canvas is to be found, but in a kind of place, one in which we find not only a dying Icarus given scant attention, but

an understanding of the particular virtue of the Old Masters as residing in the fact that they instantiate a kind of *impossibility* of focused attention (it is about this that they are never wrong).' Jonah Siegel, *Desire and Excess: The Nineteenth Century Culture of Art* (Princeton: Princeton University Press, 2000), p. 8. See also Paul H. Fry's essay, 'The Torturer's Horse: What Poems See in Pictures', in *A Defense of Poetry: Reflections on the Occasion of Writing* (Stanford: Stanford University Press, 1995), pp. 70–87: 'it is a poem about more than one picture, hence not about the attitude toward suffering of this or that masterpiece but about the question of suffering – entailing the question whether in fact suffering can be represented – in picturehood in general' (p. 71).

7 'The poem is irritating in its argument, until one realises that its postulation of the "human position" of suffering about which the Old Masters apparently knew everything places this suffering simultaneously in two exclusive positions: it is both daily event and exceptional tragedy ... Its message is: normality and suffering coexist and may indeed be inseparable. Yet neither of the two justifies the other. Art must not try to achieve a reconciliation with suffering: on the contrary, it must expose the contradictory coupling and leave judgements to its percipients.' Rainer Emig, *W.H. Auden, Towards a Postmodern Poetics* (Basingstoke: Palgrave-Macmillan, 2000), p. 129. 'Brueghel, according to Auden's reading, works to erase divisions between the mythic and the prosaic, the past and present, the spectacular and the ordinary. We are made aware, simultaneously, of the banality of Evil and the reality of evil.' Johnson, *Man's Place: An Essay on Auden*, p. 41.

8 'I sit in one of the dives / On Fifty-Second Street / Uncertain and afraid / As the clever hopes expire / Of a low dishonest decade.' W.H. Auden, 'September 1, 1939', W.H. Auden, *Selected Poems*, ed. Edward Mendelson (London: Faber and Faber, 1979), p. 86.

9 William Carlos Williams, *Collected Poems II: 1939–1962*, ed. Christopher MacGowan (Manchester: Carcanet, 2000), pp. 385–6 (hereafter *WCW*).

10 See Christopher Braider, *Refiguring the Real: Picture and Modernity in Word and Image 1400–1700* (Princeton: Princeton University Press, 1993), p. 72: 'What strikes us about Williams's Bruegel is the lack of allegorising exegesis. His lack seems something of a paradox: why after all make pictures talk if not to explain what they mean? But Williams refrains, confining himself to descriptive restatement of their pictorial self-sufficiency ... By insisting how the things seen in the picture *remain* things, the commentary ultimately asserts the irreducible picture.'

11 'And yet for all its rhetorical indifference to the literal surface of Bruegel's paintings, Williams's reading remains just that: a reading; his refusal to allegorise is itself an allegorization ... What Williams sees in Bruegel is his own modernism, the realistic representation of tangible objects divorced from symbolism paradoxically echoing the antirepresentational idiom of the American cubists of the twenties and thirties.' Braider, *Refiguring the Real*, p. 75.

12 *Randall Jarrell: The Complete Poems* (New York: Farrar, Straus and Giroux, 2000), pp. 332–3.

13 *WCW*, pp. 386–7.

14 This is what Svetlana Alpers has described as Brueghel's 'mapped view … an encompassing of the world'. Alpers is discussed in David Pascoe's essay '"Everything Turns Away": Auden's Surrealism', in Katherine Bucknell and Niholas Jenkins (eds), *W.H. Auden: 'The Language of Learning and the Language of Love'* (Oxford: Clarendon Press, 1994), p. 149. Aldous Huxley admired Brueghel's snow scenes for their 'almost disquieting degree of fundamental realism. Those hunters stepping down over the brow of the hill toward the snowy valley with its frozen ponds are Jack Frost himself and his crew.' *Aldous Huxley: On Art and Artists*, ed. Morris Philipson (London: Chatto and Windus, 1960), p. 210.

15 John Berryman, *Collected Poems 1937–1971*, ed. Charles Thornbury (London: Faber, 1990), p. 3.

16 There is a scene in Andrei Tarkovsky's *Solaris* (1970) in which the camera enters Brueghel's painting, into the cold green air above the village. Tarkovsky's film explores and crosses the boundaries between representation and 'reality', between different acts of creation.

17 John Berryman, *The Freedom of the Poet* (New York: Farrar, Straus & Giroux, 1976), pp. 325–6.

18 Berryman, *The Freedom of the Poet*, p. 326.

ILLUSION

ONCE A YEAR, during the run up to the Turner Prize, British newspapers express a general bemusement with contemporary art. The arguments are familiar, especially the negative ones, but the strongest emotions still seem to centre upon the idea of a 'truth-to-reality'. If art seems disengaged from the world as the world is understood by the newspapers, or if it seems to be in an unrecognisable or inaccessible relation to normality (as understood by same) – if it seems whimsical or obscure – this is likely to provoke a hostile reaction. At the same time, since contemporary art rarely seems to offer an idea of life and/or of humanity that to non-experts in art history is affirmative or hopeful (indeed the opposite idea seems to be more or less obligatory), its practical function in life might not be immediately apparent. Artists, or those who style themselves so, may seem under these circumstances to be putting us on in some way. Their apparent detachment or loftiness in relation to the way things really are, might appear to be unearned.

This demand that art should work in some ways like a mirror and reflect things as they are, but at the same time that it should somehow make things better than they are, is a deeply persistent one in our culture. In the mid-1930s, as Europe was turning away from the human disaster W.H. Auden was not alone in foreseeing and while America experienced the pain of economic Depression, the Marxist critic Stanley Burnshaw, writing in *The New Masses*, suggested that Wallace Stevens was a poet in crisis and confusion because he could no longer justify the poetry he had been used to writing, 'the kind of verse that people concerned with the murderous world collapse can hardly swallow today except in tiny doses'. Burnshaw had in mind what Stevens called 'pure poetry'; that is, poetry that was dedicated in an uncompromising way to the exploration and discovery of verbal richness and density, rather than to the rigours of politics or social commentary. Behind such a distinction is the

assumption once again of an antithetical relation between beauty and truth or aesthetics and politics or history, as well as the expectation that art should have a utilitarian purpose in order to justify its existence. What is the use of – what is the excuse for – 'pure poetry' in a time of political crisis? For Burnshaw, Stevens was like a 'man who, having lost his footing, now scrambles to stand up and keep his balance'.[1] In 1937 Stevens published *The Man with the Blue Guitar*, drawing inspiration from Picasso's paintings, and in particular *The Old Guitarist* of 1903 (figure 11). These are the first two sections:

I

The man bent over his guitar,
A shearsman of sorts. The day was green.

They said, 'You have a blue guitar,
You do not play things as they are.'

The man replied, 'Things as they are
Are changed upon the blue guitar.'

And they said then, 'But play, you must,
A tune beyond us, yet ourselves,

A tune upon the blue guitar
Of things exactly as they are.'

II.

I cannot bring a world quite round,
Although I patch it as I can.

I sing a hero's head, large eye
And bearded bronze, but not a man,

Although I patch him as I can
And reach through him almost to man.

If to serenade almost to man
Is to miss, by that, things as they are,

11 Pablo Picasso, *The Old Guitarist* (1903–4) (Helen Birch Bartlett Memorial
Collection, 1926.253, The Art Institute of Chicago. Photography © The Art
Institute of Chicago. © Succession Picasso/DACS 2006)

> Say that is the serenade
> Of a man that plays a blue guitar.[2]

Stevens is dramatising the relationship an artist or poet has with an audience that is baffled by certain kinds of art, but which nevertheless makes strict demands of its artists and poets.[3] Art that is new or peculiar (avant garde) seems not to represent 'things as they are'. The artist responds that 'Things as they are / Are changed upon the blue guitar'. This suggests not only that 'reality' in modern art is depicted in non-representational ways (as in cubist or abstract painting) but also that 'reality' is transformed in *itself* by this process. In other words, Stevens the artist does not want to claim poetry as a refuge or escape from 'reality', but rather as existing in a vital and alchemical relation to the world-as-it-is, with an agency and capacity to transform things as they are.[4] The artist's audience, however, may not understand what this means; plain-speaking and pushy, it seeks a 'tune beyond ourselves, yet ourselves ... Of things exactly as they are'. This is an impossible desire (for an art of straightforward imitation which is not straightforward imitation, but which is also uplifting or transforming); but it is also, paradoxically, a plainly formulated description of what Stevens actually seeks to do and believes *is* possible. 'Reality', then, is not in an antithetical relation to 'Imagination' (the blue guitar), but rather there is, in his own words, an 'incessant conjunctioning between things as they are and things imagined'.[5] Later in his life Stevens was to write that 'the ultimate value is reality', and that 'the great conquest is the conquest of reality'.[6] In a letter to his friend Hi Simons in 1940, offering paraphrases of sections of *The Man with the Blue Guitar*, Stevens writes with echoes of Keats:

> The purpose of writing poetry is to attain pure poetry. The validity of the poet as a figure of prestige to which he is entitled, is wholly a matter of this, that he adds to life that without which life cannot be lived, or is not worth living, or is without savor, or, in any case, would be altogether different from what it is today. Poetry is passion, not a habit. This passion nourishes itself on reality. Imagination has no source except in reality, and ceases to have any value when it departs from reality. Here is a fundamental principle about the imagination: It does not create except as it transforms. There is nothing that exists exclusively by reason of the imagination, or that does not exist in some form in reality. Thus, reality = the imagination, and the imagination = reality. Imagination gives, but gives in relation.[7]

This might not be enough to answer those who wonder in what ways exactly poetry, art or 'Imagination' help those who are unemployed or hungry, and who insist that art must be judged only within such an unflinching rubric. Nevertheless, Stevens is clear in his refusal to allow a dissociation of 'Imagination' (that Romantic watchword) from 'Reality', as if straining to justify the writing of poetry in a time of war. In a later section of *The Man with the Blue Guitar* Stevens quotes Picasso and makes a direct connection between art and the historical crisis Burnshaw had described:

XV

Is this picture of Picasso's, this 'hoard
Of destructions,' a picture of ourselves,

Now, an image of our society?
Do I sit, deformed, a naked egg,

Catching at Good-bye, harvest moon,
Without seeing the harvest or the moon?

Things as they are have been destroyed.
Have I? Am I a man that is dead

At a table on which the food is cold?
Is my thought a memory, not alive?

Is the spot on the floor, there, wine or blood
And whichever it may be, is it mine?[8]

In a conversation of 1935 Picasso had described his own artistic process as 'une somme de destructions' (a sum or hoard of destructions), distinguishing it from the practice of earlier artists who had pursued a 'sum of additions'.[9] To the Marxist critic of the 1930s Stevens's suggestion that the image of the blind, emaciated guitarist in torn clothing may in fact be 'a picture of ourselves … an image of our society' might seem to betray a guilty conscience. It could be argued that there is something self-idealising even in this posture of despair, something mistaken or ethically questionable in conflating the condition of the modern world with the condition of the modern artist, as if the two hang in the same balance.[10] But Stevens is insisting on a connection between art and

'things as they are'. In his prose essay *The Necessary Angel* (1951) Stevens would claim that modern art had 'helped to create a new reality, a modern reality [...] a reality of decreation in which our revelations are not the revelations of belief, but the precious portents of our own powers. The greatest truth that we could hope to discover ... is that man's truth is the final resolution of everything'.[11] Such a philosophy is perhaps the last gasp of an Aestheticism that we have seen unravel from Keats to Humbert Humbert. In this view art couldn't be more important to 'things as they are': it has helped to create modernity; it occupies the space vacated by God; it offers signs of the potential powers of man; it hints at a final resolution of everything.[12] While Stevens, like Jarrell, has an acute sense of an earlier period of civilisation in which (Christian) art enjoyed a centrally privileged place in western culture, this has been superseded by a 'modern reality' in which the central place of anything, least of all art, seems uncertain. But Stevens wants to believe that art still participates in the shaping and potential redemption of this modern reality. Its magic is connected not to religion any more, but to what Pater described as the 'fruit of a quickened, multiplied consciousness', and what Stevens calls 'the precious portents of our own powers'.

What exactly Stevens means by 'our own powers' is unclear, as is the precise moment when the 'modern reality' of *decreation* begins. At what point in history does the artist cease to attempt an accurate record of perception, to 'play things as they are'? Would it be a naive reading of the history of representation to believe that art ever merely played 'things as they are'? Reviewing the drawings of the Mannerist painter Parmigianino (1503–40) in an essay of 1964, the poet and art critic John Ashbery claimed that it was 'possible to see in Parmigianino an ancestor of Picasso and other artists of today' owing to 'the important role distortion plays throughout his [Parmigianino's] work, starting with the self-portrait in which the hand is larger than the head'.[13] The notion of 'distortion' overlaps with Stevens's idea of 'decreation' and Picasso's 'destruction', i.e. this is art that seeks to decreate the visual, to break open the world of appearance by exploring the mechanics of vision. Parmigianino then is an ancestor of Picasso and the 'modern reality' shaped by art. Or we could put it the other way around: Picasso is doing something that falls squarely within the traditions of painting and the developing story of art history. 'Things as they are / Are changed upon the blue guitar.'

In 1975 Ashbery published a collection taking its title from Parmigianino's *Self Portrait in a Convex Mirror* (c. 1524) (figure 12). The title poem, which is a meditation about the painting, has been described as 'the greatest American poem since the work of late Stevens'.[14] It is perhaps the most complex and

12 Girolamo Francesco Maria Mazzuoli (Parmigianino), *Self-Portrait in a Convex Mirror* (c. 1524) (Kunsthistorisches Museum Wien, Wien oder KHM, Vienna)

challenging ekphrasis in contemporary literature, and is closely concerned with the aesthetic question of art's relation to the way things are. The opening lines describe Parmigianino's self-portrait:

> As Parmigianino did it, the right hand
> Bigger than the head, thrust at the viewer
> And swerving easily away, as though to protect

What it advertises. A few leaded panes, old beams,
Fur, pleated muslin, a coral ring run together
In a movement supporting the face, which swims
Toward and away like the hand
Except that it is in repose. It is what is
Sequestered. Vasari says, 'Francesco one day set himself
To take his own portrait, looking at himself for that purpose
In a convex mirror, such as is used by barbers …
He accordingly caused a ball of wood to be made
By a turner, and having divided it in half and
Brought it to the size of the mirror, he set himself
With great art to copy all that he saw in the glass,'
Chiefly his reflection, of which the portrait
Is the reflection once removed.[15]

And the poem is a 'reflection' once removed again. What most interests Ashbery about Parmigianino's experiment is the question of what exactly this is a portrait *of*. The capturing of the image of a reflection, the picture of 'himself' in the mirror, offers an analogue for the capturing (the summoning, the enclosing) of an elusive identity or an innerness, for which Ashbery uses the word 'soul': 'The soul establishes itself', where 'establish' has the sense of 'houses' (its 'establishment'), and also 'proves itself', i.e. it appears substantial, a thing actually *there*. Browning's Lippo had given an account of the pressure placed upon him by his superiors to 'paint the souls of men', to capture in a material sense that element of the non-material. For Ashbery, this is what Parmigianino has attempted to do in his self-portrait. At the same time, the convex surface seems to be a kind of limit or restriction, an imprisoning boundary: 'the soul is a captive, treated humanely, kept / In suspension, unable to advance much farther / Than your look as it intercepts the picture'. The 'soul' (what the painting has captured: the very notion of an invisible innerness or non-material selfhood) cannot escape, and cannot be fully met by a viewer either, merely intercepted. This is to be seized (perhaps to be cut off) as it travels from one place to another, from painting to viewer. In other words Parmigianino's portrait makes the 'soul' approach and recede at once, like an image in a convex mirror:

> The soul has to stay where it is,
> Even though restless, hearing raindrops at the pane,
> The sighing of autumn leaves thrashed by the wind,

Longing to be free, outside, but it must stay
Posing in this place. It must move
As little as possible. This is what the portrait says.
But there is in that gaze a combination
Of tenderness, amusement and regret, so powerful
In its restraint that one cannot look for long.
The secret is too plain. The pity of it smarts,
Makes hot tears spurt: that the soul is not a soul,
Has no secret, is small, and it fits
Its hollow perfectly: its room, our moment of attention.

The illusion betrays a deeper and more painful secret for Ashbery: that a captured identity or 'soul', a secret essence, is itself imaginary. This means not merely that the soul is hard to define and therefore difficult to recognise in a painting (the problem bothering Lippo's superiors) but that it is not there. The painting represents this illusory sense of something existing in our interior that longs to escape us and establish contact with the world outside. The 'gaze' in Parmigianino's self-portrait, so realistic in its 'tenderness, amusement and regret', speaks of the illusion, even as it sustains it. For Ashbery there is great pathos in the portrait's *knowingness* about such illusion. His poetry is intent on exploring the pathos in this knowledge (this knowing-about-illusion) offering us a philosophy or poetics of *being* (an ontology) in which the self is significantly shaped by non-substantive elements. Illusoriness for the poet is therefore complex and closely interwoven with 'things as they are'. Its 'falseness' or distortion is a part of the world, constitutive of 'reality' as it is experienced in the 'incessant conjunctioning between things as they are and things imagined', as Stevens put it. For Ashbery, however, there is a more amorphous or formless aspect to the imaginary than for Stevens. Parmigianino's portrait makes visible the blankness or space that is also constitutive of interiority. We may not notice this, however: 'our moment of attention' (remembering Auden perhaps) is itself 'small', 'hollow', not substantial. Nevertheless, the portrait is the study of an apparition. It announces its own artefactuality, its own trick of appearing: 'But your eyes proclaim / That everything is surface. The surface is what's there / And nothing can exist except what's there.' Paradoxically, and like the illusion of convex depth upon the surface of the wood/mirror, this surface 'is not / Superficial but a visible core'. The 'illusion', then, rises from the depths, is deep; it is a measure of profundity even as it exists only on the surface. The trick of the picture, like that of the soul, is to persuade us of its truth and substance. In a poet such as Keats or Rossetti, this capacity

of the artwork to convince us of a 'visible core' would have been deemed a 'mystery'. For Ashbery, however, the notion of 'mystery' has been downgraded or demystified into that of illusion.

The mirror of course is the most venerable of symbols in art and literature with a double-life as an archetype for art as truth telling or as holding 'a mirror up to nature', but also as an instrument of potential distortion or illusion (the convex mirror does *not* show things as they are). The Renaissance painting is a challenge to think about appearance and its connection with identity, with the capacity to suggest presence, and about the ways in which artistic acts of creation (or decreation) construct significantly persuasive illusions. So, too, is Ashbery's poem. In many respects Ashbery's interest in the picture leads by different routes to the same kind of critique of creation that we saw in Browning's 'Fra Lippo Lippi', the sense of the interpenetrating presences of diverse creators and creatures. As the opening declares, Ashbery intends to do it 'As Parmigianino did it' (Browning's *perfecit*): that is, to offer a self-portrait in a convex mirror. The portrait of 'John Ashbery' is therefore subject to all the distortion of a convex mirror, meaning that it will demonstrate the impossibility of an exact or complete self-representation. The irony of course is that the portrait in a convex mirror achieves a heart-stopping verisimilitude by exactly reproducing the optical effect of looking in the mirror. So Ashbery's poem will produce a credible illusion of John Ashbery. The poet will appear as an observer of the portrait of the painter. He will 'appear' in the act of thinking intensely about the ways in which self-portraits make a 'self' appear. In other words Ashbery takes ekphrasis as an occasion for thinking about (and dramatising) the experience of consciousness, perception and self-awareness. As Ashbery's attention (again remembering Auden) 'turns dully away' from Parmigianino, it becomes wider and more diffuse, admitting all the contingency of the life of the self into the poem: penetration by the lives of others, influences, the insecurity of memory, the impossibility of keeping thoughts still, all the centrifugal force of experience, the factitious, the accidental, the partially true, the misunderstood, the gaps or lacunae of consciousness, the shadowy – all this is acknowledged by the poem in the service of a truth or verisimilitude which is analogous to the truth-of-distortion in Parmigianino's portrait. Since these ideas about the nature of the self and its representation are often said to characterise postmodern writing and to reflect certain strands of modern critical theory (particularly perhaps that of Jacques Lacan), many critics have read the poem as thrillingly up-to-date in its philosophical co-ordinates. 'Self-Portrait in a Convex Mirror' is thus said to 'completely demystif[y] the traditional notions of self and

representation'. Its 'self-decentring' displays 'our illusory atomistic selfhood' or
the 'fragmented mnemonic permanences' of our consciousness; it dramatises
the 'fate of perception, a negative torsion in the commerce between self and
not-self', 'a pathos of never being centered'; it is 'organized around an unstable
set of relations [...] center and circumference, matter and manner, signified
and signifiers, depth and surface, whole and parts, inside and outside, past
and present, present and future, concealment and exposure, self and other'.[16]
Such effects are routinely discovered in literature by contemporary critical
theorists. Are they peculiar to recent literature? It is probably true that John
Ashbery is more consciously interested in the effect of 'an illusory atomistic
selfhood' than previous poets, more focused upon that idea, and he certainly
seems to be in a more sceptical, unstable relation to the notion of 'Art' than
Wallace Stevens. In fact Ashbery takes the notion of *decreation* closer to the
idea of *unknowing* or undoing; this is the sense in which the 'reality' created
by art is in an even more phantasmal and fugitive relation to things 'as they
are' than was imagined by Stevens. This is partly because Ashbery thinks of
things 'as they are' as even less stable or knowable. As the poem continues,
its relation to the Parmigianino portrait also becomes more troubled and
argumentative:

> But something new is on the way, a new preciosity
> In the wind. Can you stand it,
> Francesco? Are you strong enough for it?
> This wind brings what it knows not, is
> Self-propelled, blind, has no notion
> Of itself ...
> ...
> Your argument, Francesco,
> Had begun to grow stale as no answer
> Or answers were forthcoming.

If Parmigianino's self-portrait represents a triumphant argument for art's
capacity for brilliant mimesis, an argument depending upon the self-confident
'consonance of the High Renaissance', Ashbery's poem registers its own
distance from such a historical moment – from the complacency of the old
masters. Parmigianino's overcoming of technical challenges and the success
of his illusion are not enough to answer the question of whether this really is
a portrait of the self. Or, will this do as an illusion of selfhood? Dissatisfied
with the experiment, Ashbery is heralding the arrival of new art, a 'new

preciosity', which is always on the horizon, always on the way. This is not so much a specific development in art history as it is a fundamental condition of living in Time. Ashbery's ekphrasis in this sense is entirely characteristic in its impulse to open the static image up to the temporal. The future will always incur a negative torsion, a destabilising of relations for the historical subject, a disruption of the subject's consciousness or image of its 'self'. This is not something discovered in the last fifty years, but a permanent condition of the temporal. Ashbery wants to make a connection then between what it is like to be a person or being in time, and the self-portrait in art history: the notion of a static or captured truth, an image of the 'self', will always be undone. The experience of living in the present, 'that special, lapidary Todayness', as Ashbery puts it, is disruptive: 'it is self-propelled, blind, has no notion / Of itself'. 'Todayness' is like a wind or explosion, an event with 'no margins'. This is a version of the ekphrastic return to time that we saw in Rossetti, with its insistence on opening up an ethical 'moment' in the painting, except that for Ashbery the 'crisis' is more inchoate, and has no clear moral outline.

It would be wrong, however, to think of Ashbery's ekphrasis as nihilistic in its relation to Parmigianino and the art of the past, or to think of its aesthetic arguments as merely playful. For Ashbery, who made his living writing about art, there is much at stake. The following is taken from an interview with the poet.

> Most reckless things are beautiful in some way and recklessness is what makes experimental art beautiful, just as religions are beautiful because of the strong possibility that they're founded on nothing [...] I feel this also even in the work of great modern painters such as Jackson Pollock or Mark Rothko. Everyone accepts them now as being major artists, and yet, does their work amount to anything? There's a possibility that it doesn't, although I believe in it and want it to exist. But I think that part of the strength of their art, in fact, is this doubt as to whether art may be there at all.[17]

The ordinary scepticism of 'the public' in relation to modern art ('is it *art*?') is acknowledged and incorporated here into Ashbery's 'belief', his act of faith posited on the possibility of being wrong or mistaken. As in Stevens, the phrasing suggests a secular reworking of theological language and thinking, as if art is either a substitute for or successor to God in our 'modern reality'. Unlike Stevens, however, Ashbery is explicit about the doubt and uncertainty that accompanies such a notion – the felt possibility that it 'is founded on

nothing'. 'Self-Portrait in a Convex Mirror' wonders about this possibility too, this space or gap that haunts both the artist (in his sense of self or subjectivity) and the artwork. What kind of illusions are poems, paintings and persons founded on? And what place and value should be given to the act of faith through which order, sense or meaning are established out of illusion? The notion of having a kind of faith in illusion is important to aesthetics. But it is not merely an aesthetic question (it is clear by now that no aesthetic question is *merely* that). Both self and artwork are constituted for Ashbery upon significant illusions or apparitions. They are also made up from the accidental and the contingent, the unintentional, the unplanned, and so inevitably both the self and the artwork seem like distortions from an original source. 'Things as they are', whether in life or in art, are shaped by things as they are not. For Ashbery these spectres of disorientation and disruption are frightening, and at the same time absolutely mundane. His analogy for the distortion that enters all representation and all reception, defeating its purpose but substituting for that purpose another 'necessity', is the party-game of Chinese Whispers:

> This always
> Happens, as in the game where
> A whispered phrase passed around the room
> Ends up as something completely different.
> It is the principle that makes works of art so unlike
> What the artist intended. Often he finds
> He has omitted the thing he started out to say
> In the first place. Seduced by flowers,
> Explicit pleasures, he blames himself (though
> Secretly satisfied with the result), imagining
> He had a say in the matter and exercised
> An option of which he was hardly conscious,
> Unaware that necessity circumvents such resolutions
> So as to create something new
> For itself, that there is no other way,
> That the history of creation proceeds according to
> Stringent laws, and that things
> Do get done in this way, but never the things
> We set out to accomplish and wanted so desperately
> To see come into being. Parmigianino
> Must have realized this as he worked at his
> Life-obstructing task.

Parmigianino must have realised this because it is the discovery repeatedly made by artists. And of course this description equally applies to Ashbery's own poem: it is estranged from its source in an original intention or purpose, if it can be said to have had one, but it acquires a form and integrity of its own through its encounter with randomness (Ashbery himself described it as 'random and unorganized', which is only partly true[18]). The lucidity and cogency with which the process of unravelling is here described, however, represent an important paradox: which is that the artist is aware of the distortion in his work and that he apprehends it even as it is happening, just as the self is aware of a non-self or spectre within its own consciousness of self, and is able to contemplate this 'otherness' with open eyes:

> Is there anything
> To be serious about beyond this otherness
> That gets included in the most ordinary
> Forms of daily activity, changing everything
> Slightly and profoundly, and tearing the matter
> Of creation, any creation, not just artistic creation
> Out of our hands, to install it on some monstrous, near
> Peak, too close to ignore, too far
> For one to intervene? This otherness, this
> 'Not-being-us' is all there is to look at
> In the mirror, though no one can say
> How it came to be this way. A ship
> Flying unknown colors has entered the harbour.

This 'otherness' or 'not being us' is the most important thing in the world, the poem claims. It is a kind of negative of the 'soul' ('fire ... smoke ... vapour'). But a negative, a *not-self* by which the self is partly constituted. This 'otherness' or alterity belongs to Parmigianino's portrait, Ashbery's poem, our ordinary daily self-description, our looking in the mirror.

'Self-Portrait in a Convex Mirror' both approaches and recedes from Parmigianino's *Self-Portrait in a Convex Mirror*. Ashbery is estranged from the notion of 'aping naturalness' in the Mannerist experiment; he is sceptical of the illusions of appearance; but more importantly, he is aware of an elusive and discontinuous element to the 'self', an alterity which art can neither disguise, overcome, nor satisfactorily represent. He therefore dismisses Francesco from the poem. In the paragonal struggle between poem and painting, this final assertion of superiority may seem conventional, or at least characteristic of

ekphrasis. But in this case it seems more extreme than that. The final, eerie lines of Ashbery's poem pursue an unravelling or a destructuring which is not merely that of its relation to the painting, not merely the case of the poem taking leave of its 'other', but a destructuring, a dissolving of its own meaning:

> The hand holds no chalk
> And each part of the whole falls off
> And cannot know it knew, except
> Here and there, in cold pockets
> Of remembrance, whispers out of time.

The hand holding 'no chalk' belongs simultaneously to Ashbery and Parmigianino. The falling-off seems to be describing a cessation of the act of creation, which is like a dimming and fading of view as through the wrong end of a historical telescope, or in the background of an image in a convex mirror – but it is also like a dismantling or dismemberment: 'each part of the whole falls off', as in the slow decay of antique statuary. This process of decay stands for the piecemeal, partially obscured, ruinous relations the poem has explored between self and self-representation, self and 'other', viewer and artwork, artwork and artist's intention, truth and significant illusion, and, perhaps most of all, between poem and painting. It is an amputated, interrupted relation of part to whole. In their own way the final lines of Ashbery's ekphrasis are as enigmatic as those of Keats's ode, except that the sense of an incomplete meaning is experienced not as riddling truth or mystery but as *not* knowing, as blankness, bafflement, or aporia. 'Each part of the whole ... cannot know it knew'. The part cannot know that it possessed a complete knowledge of the whole because it is no longer a part of the whole. The process of not knowing, of forgetting what was once known, of forgetting the fact that something was once known, and of not knowing that this has been forgotten, intervenes in, or *intercepts* all acts of relation.

Ashbery seems closer to Beckett here than to the self-questioning (or self-asserting) Wallace Stevens. The poem closes with this fading out, while proposing that the gleams of a stronger awareness or a more complete knowledge are 'Here and there'. What exactly are these 'cold pockets of remembrance' or 'whispers out of time' (the latter phrase recalling Eliot's *Four Quartets*)? What is this partial, partially erased, whispering knowledge of? '*Out of* time' returns us again to Keats's notion of being teased '*out of* thought' by art and by eternity. Are these whispers 'out of time' reaching us from eternity,

whispers from the silent artwork itself? There is a pun here, though, in that to be 'out of time' is to have run out of time, to not have enough time left to say what you wanted to say. The 'whispers' of knowledge (Chinese whispers?) that close the poem have run 'out of time', they stop before they have fully disclosed their (half-forgotten) content. Parmigianino's self-portrait too is 'out of time', not only in the sense of belonging to the 'eternal' or 'immortal' realm of art but in the negative sense of its anachronism, its failing to have satisfied us. Indeed, the very notion of art belonging to 'eternity' may have run out of time, or ceased to be credible – or appeared to have ceased to be credible – in 1975. Ashbery's poem may merely be a cold pocket 'of remembrance' (conjuring the ghost-cliché 'pocket of *resistance*'), meditating inconsequentially upon a three-hundred-year-old art-historical experiment.

The unravelling and *un*-knowing at the close of the poem take Stevens's notion of decreation further than he ever intended, until it becomes a kind of aphasia. For Ashbery this constitutes the ground of art's particular mode of knowledge. In other words, unknowing or knowing only in part is the paradigm he discovers in art, both as an aesthetic principle and as a truth about 'things as they are'. He believes in, or wants to believe in, the meaningfulness of the artwork (and the person). But this is a belief necessarily pitched upon a doubt 'as to whether art may be there at all'. Parmigianino's self-portrait makes the dilemma visible.

NOTES

1 Stanley Burnshaw, from 'Turmoil in the Middle Ground', *New Masses*, 17:1 (October 1935), 41–2; reprinted in *Wallace Stevens: The Critical Heritage*, ed. Charles Doyle (London: Routledge, 1985), p. 139 (hereafter *WSCH*).

2 Wallace Stevens, *Collected Poems* (London: Faber, 1984), pp. 165–6 (hereafter *WSCP*).

3 See Harold Bloom, *Wallace Stevens: The Poems of Our Climate* (Ithaca: Cornell University Press, 1976), p. 119: 'the poem continually reflects upon an audience that makes the wrong demands upon a poet'.

4 Joseph N. Riddle describes Stevens in the 1930s as being 'preoccupied mainly with the preservation of poetry as a vital act in an anti-poetic age'. See 'Wallace Stevens', in *Fifteen Modern American Authors: A Survey of Research and Criticism*, ed. Jackson R. Bryer (Durham, NC: Duke Univeristy Press, 1969), p. 402.

5 See Frank Kermode, *Wallace Stevens* (Edinburgh: Oliver and Boyd, 1960), p. 67.

6 Kermode, *Wallace Stevens*, p. 67.

7 Helen Vendler, *On Extended Wings: Wallace Stevens' Longer Poems* (Cambridge, MA: Harvard University Press, 1969), p. 137. In June 1939 Stevens wrote: 'I am

in the long run interested in pure poetry [...] No doubt from a Marxian point of view this sort of thing is incredible, but pure poetry is rather older and tougher than Marx and will remain so. My own way out towards the future involves a confidence in the spiritual role of the poet.' *WSCH*, p. 9.

8 *WSCP*, p. 173.

9 Natasha Staller, *A Sum of Destructions: Picasso's Cultures & The Creation of Cubism* (New Haven: Yale University Press, 2001), p. 5. In his essay on 'The Relations between Poetry and Painting', which originally appeared as a pamphlet in 1951 and was later published as part of *The Necessary Angel*, Stevens returned to the Picasso quotation: 'Does not the saying of Picasso that a picture is a horde of destructions also say that a poem is a horde of destructions?' (Stevens, *The Necessary Angel*, New York: Knopf, 1951, p. 161). Interestingly, Stevens has replaced the earlier 'hoard' with 'horde'.

10 See, for example, Charles Altieri, *Painterly Abstraction in Modernist American Poetry: The Contemporaneity of Modernism* (Cambridge: Cambridge University Press, 1989), pp. 323–5. Altieri is responding to the arguments of Gerald Bruns, 'Stevens without Epistemology', in Albert Gelpi (ed.), *Wallace Stevens: The Poetics of Modernism* (Cambridge: Cambridge University Press, 1985).

11 Altieri, *Painterly Abstraction*, pp. 335–6.

12 'The poems [in *The Man with the Blue Guitar*] taken as a whole constitute a special kind of museum, of a very familiar strangeness, located, because of the extent of the poet's awareness, in the middle of everything that concerns us.' Delmore Schwarz, *Partisan Review*, 4:3 (February 1938), 49–52; reprinted in *WSCH*, p. 186.

13 Quoted by John Shoptaw, *On the Outside Looking Out: John Ashbery's Poetry* (Cambridge MA: Harvard University Press, 1994), p. 176.

14 Charles Altieri, *Self and Sensibility in Contemporary American Poetry* (Cambridge: Cambridge University Press, 1984), p. 151. See also David Herd's intelligent reading of the poem in *John Ashbery and American Poetry* (Manchester: Manchester University Press, 2000), pp. 144–78.

15 John Ashbery, *Self-Portrait in a Convex Mirror* (London: Penguin, 1976; first published 1975). (All extracts from the poem quoted from this edition.)

16 Richard Stamelman, 'Critical Reflections: Poetry and Art Criticism in Ashbery's "Self-Portrait in a Convex Mirror"', *New Literary History*, 15 (1983), 611; 615; James McCorkle, *The Still Performance: Writing, Self, and Interconnection in Five Postmodern American Poets* (Charlottesville: University of Virginia Press, 1989), pp. 79; 80; Geoff Ward, *Statutes of Liberty: The New York School of Poets* (Basingstoke: Palgrave, 2003), pp. 157; 162; and Shoptaw, *On the Outside Looking Out*, p. 179. See also David Kalstone, *Five Temperaments* (New York: Oxford University Press, 1977), pp. 176–85; Andrew Ross, *The Failure of Modernism: Symptoms of American Poetry* (New York: Columbia University Press, 1986), pp. 163–5; Lee Edelman, 'The Pose of Imposture: Ashbery's "Self-Portrait in a Convex Mirror"', *Twentieth Century Literature*, 321 (Spring 1986), 95–113.

David Herd comments upon this feeding-frenzy around a poem that is in fact not a 'typical' Ashbery poem at all: 'academic readers in particular having been attracted more to the manner of the poem's argument than to its implications'. Herd, p. 167.

17 'An Interview with John Ashbery', *American Writing Today*, I (Washington: Forum Series, 1982), p. 270.
18 Quoted in Shoptaw, *On the Outside*, p. 174.

PHOTOGRAPHY AND ELEGY

THE denial of images – the deep hatred of visual representation – has had a long historical life, the violence of which always confesses to the power of that which is denied. In recent years iconophobia has taken the international form both of protest and provocation. In March 2001, citing the Islamic prohibition of the making of images, the spiritual leaders of the Taleban government in Afghanistan ignored the offer of Philippe De Montebello, director of the New York Metropolitan Museum of Art, to come over to the town of Bamiyan and cost the exercise of removing and preserving the fifteen-hundred-year-old images of the Buddha carved into the rock-face, which they had threatened to destroy. The destruction went ahead and the western world was forced to check its astonishment by recalling those moments in its own history when similar furies were aroused, a time long before museums and galleries. And yet how could we hope to understand this anachronism? Perhaps it would be difficult enough to recover a sense of the potentially sacred power of the image, what Benjamin described as its 'aura', rooted in an early history of ritualistic ceremony. But then from an apprehension of such purity to find a legitimate reason to deny that power; or to imagine a deep antagonism to the arrogation of that power by the artwork – would such an effort of thought be possible in an iconophilic culture?[1] The Taleban, of course, were destroying statues of Buddha, not Allah, and so perhaps the political exigencies of this are easier for us to grasp. But it would be wrong to assume that our own relation to the image has been thoroughly secularised or demystified. Susan Sontag invites us to choose 'between two fantasy alternatives', the first being 'that Holbein the younger had lived long enough to have painted Shakespeare', and the second 'that a prototype of the camera had been invented early enough to have photographed him'. As Sontag realises, and with no disrespect to the memory of Holbein the Younger, this isn't much of a dilemma at all. 'Having a

photograph of Shakespeare would be like having a nail from the True Cross.'[2]
And then imagine having a photograph of the True Cross.

With the advent of photography in the mid nineteenth century the nature
of the 'image' or the 'picture' entered a new phase, with the paragonal struggle
between word and image changing too. In particular, the stakes seemed
to be raised in the contest of truth-to-reality, since, as Sontag puts it, 'a
photograph is not only an image (as a painting is an image), an interpretation
of the real; it is also a trace, something directly stenciled off the real, like a
footprint or a death mask'.[3] The privileged relationship photography enjoys
with 'reality' has changed again with the development of digital photography
and image-manipulation technology. There is a kind of poetic justice in the
fact that it would now be naive to believe that a photograph, by its very
nature, must display what was actually there. Nevertheless, the invention of
photography offered a quite new order of representation. Indeed it could be
said to offer not 'representation' as such at all but something much closer to
the duplication of its object.[4] One consequence of this was the immediate
perception of the elegiac nature of photographic art. Fox Talbot himself spoke
of the photograph's unprecedented ability to capture 'the injuries of time'.[5]
Since then all theorists of the art form have agreed that however this new
order is said to be constituted, the photographic image has something to do
with Death. As Sontag puts it:

> Photography is an elegiac art, a twilight art. Most subjects photographed
> are, just by virtue of being photographed, touched with pathos. An ugly
> or grotesque subject may be moving because it has been dignified by the
> attention of the photographer. A beautiful subject can be the object of
> rueful feelings, because it has aged or decayed or no longer exists. All
> photographs are *memento mori*. To take a photograph is to participate
> in another person's (or thing's) mortality, vulnerability, mutability.
> Precisely by slicing out this moment and freezing it, all photographs
> testify to time's relentless melt ... Photography is the inventory of
> mortality. A touch of the finger now suffices to invest a moment with
> posthumous irony. Photographs show people being so irrefutably *there*
> and at a specific age in their lives; group together people and things
> which a moment later have already disbanded, changed, continued
> along the course of their independent destinies ... Photographs state
> the innocence, the vulnerability of lives heading toward their own
> destruction, and this link between photography and death haunts all
> photographs of people.[6]

One way of reading Wilde's *The Picture of Dorian Gray* (1891) would be in relation to the relatively new art of photography. In that novel the Gothic topos of the magic or haunted portrait is reworked to suggest a deep anxiety about the nature of the photographic image as *momento mori* or inventory of mortality. The elegiac nature of the photograph is *literalised* within the novel as a way of registering the power of this new order of representation. In this sense photography seems to have realised the mortal knowledge of the captured 'moment', to have made manifest the logic of the temporal.

But the death-haunted nature of the photographic image seems to have spooked certain writers more than others. The novels of Don DeLillo, for example, repeatedly return to its unsettling aura. In a famous passage in *White Noise* (1984) the narrator Jack Gladney accompanies his friend Murray Siskind (a theorist of pop culture) to visit a tourist attraction known as 'the most photographed barn in America'. There they watch as people take pictures of other people taking pictures. 'We're not here to capture an image, we're here to maintain one', Siskind comments. 'Every photograph reinforces the aura ... Being here is a kind of spiritual surrender ... A religious experience in a way.' The experience that is nearly or almost religious, or religious 'in a way', is one DeLillo repeatedly associates with the photographic image. The connection is taken further in *Mao II* (1991), in which a photographer named Brita Nilsson is working on a project of photographing famous writers. Allowed access to the manically reclusive figure of Bill Gray (a famous novelist), Brita feels as if she is 'being taken to see some terrorist chief at his secret retreat in the mountains'.[7] Bill Gray himself draws an analogy between the writer who is reluctant to have his picture taken and the sanction against images of God:

> When a writer doesn't show his face, he becomes a local symptom of God's famous reluctance to appear ... People may be intrigued by this figure but they also resent him and mock him and want to dirty him up and watch his face distort in shock and fear when the concealed photographer leaps out of the trees. In a mosque, no images. In our world we sleep and eat the image and pray to it and wear it too. The writer who won't show his face is encroaching on holy turf. He's playing God's own trick.[8]

In this novel in particular, which some have taken as 'foreseeing' the attacks on the World Trade Center (acts of iconophobia which triggered the American invasion of Afghanistan), DeLillo explores the terror of image-taking and image-consumption. Though there are crucial differences between Bill Gray's

shyness and the Islamic proscription of images, there are also correspondences. The deathwards pull of the image, whether a domestic portrait of the writer at home or the news pictures of crowds (at the Hillsborough disaster, at the funeral of Ayatollah Khomeini), borders the space of terror and, like terror in the novel, is seen as a rival and threat to the word, to the imagination of the novelist, and to life. Whilst Brita is taking his picture, Bill ponders the link between the photograph and death:

> He said, 'Something about the occasion makes me think I'm at my own wake. Sitting for a picture is a morbid business. A portrait doesn't begin to mean anything until the subject is dead. This is the whole point. We're doing this to create a kind of sentimental past for people in the decades to come. It's their past, their history we're inventing here. And it's not how I look now that matters. It's how I'll look in twenty-five years as clothing and faces change, as photographs change. The deeper I pass into death, the more powerful my picture becomes. Isn't this why picture-taking is so ceremonial? It's like a wake. And I'm the actor made up for the laying out.'[9]

It seems likely that DeLillo is recalling the words of Roland Barthes, who had closely analysed the discomfort he experienced when being photographed, the curious split that seems to take place in the human subject of a photograph-portrait. This is from Barthes's *Camera Lucida* (1980):

> I am neither subject nor object but a subject who feels he is becoming an object: I then experience a micro-version of death (of parenthesis): I am truly becoming a spectre ... what I see is that I have become Total-Image, which is to say, Death in person.[10]

From this, Barthes also went on to posit a relation between photography and religion, or with experience that is religious 'in a way':

> All those young photographers who are at work in the world, determined upon the capture of actuality, do not know that they are agents of Death. This is the way in which our time assumes Death: with the denying alibi of the distractedly 'alive', of which the Photographer is in a sense the professional ... For Death must be somewhere in a society; if it is no longer (or less intensely) in religion, it must be elsewhere; perhaps in this image which produces Death while trying to preserve

life. Contemporary with the withdrawal of rites, Photography may correspond to the intrusion, in our modern society, of an asymbolic Death, outside of religion, outside of ritual, a kind of abrupt dive into literal Death. *Life/Death*: the paradigm is reduced to a simple click, the one separating the initial pose from the final print.[11]

If the ceremonial and ritualistic practices in which images were endowed with sacred aura have long disappeared from western culture, then, according to Barthes and Bill Gray, something of the aura returns in morbid form as the Death-Image of a photograph. Photography is thus endowed with some of the *mystique*, the emotion previously attaching itself to religious or ritualistic practice, as indeed Walter Benjamin had argued. It might be objected that this is an exaggeration. 'There were the camera-toters and the gun-wavers and Bill saw barely a glimmer of difference.'[12] Given the choice between facing the gun or the camera most people would discern more than a glimmer of difference. Even so, it is easy to flatter ourselves that we are safely distant from the stereotype of the primitive people who believe that the camera will rob them of their souls. Photographs are capable of confusing our sense of the literal and the metaphorical, or of penetrating the distinction, as they offer us *proof* of the real. And this sense of proof may have a profound emotional effect. Barthes testifies to just such a realisation on discovering a picture of his deceased mother as a young girl in which he saw 'her essential identity, the genius of the beloved face', experiencing thereby the direct apprehension of death or absence – what he calls 'the return of the dead' – the truth of something having been alive and having been lost.[13] This of course makes the photograph an especially powerful substitute for any kind of written elegy: 'by attesting that the object has been real, the photograph surreptitiously induces belief that it is alive ... but by shifting this reality to the past ("this has been"), the photograph suggests that it is already dead.'[14]

The idea that the photographic image offers a direct challenge or threat to language or the written word is not merely the neurosis of a 'famous novelist' with writer's block but a more general fear in our culture, sometimes a panic. The sense of photography having in many ways broken free of the representational constraints of painting and therefore having won a victory over the 'real' that threatens to overwhelm, eclipse, or make obsolete the strength of the written word, partly explains why writing about photography frequently displays an even greater ambivalence, a sharper disquiet about the rival medium, than texts about paintings. Writing about photographs places language in a seemingly direct relation to the visible, to the image-

world – a relation to the apparently *unmediated* visual field. Moreover, the apparent excision of an organising artistic consciousness in photography, the impersonality or authorlessness of the medium, exerts a fascination for poets something like the draw of the 'cold pastoral' of Keats's urn. Here is a kind of perfection that seems to taunt or tease the human. The following is a poem by Thom Gunn dedicated to a photographer:

Song of a Camera
for Robert Mapplethorpe

I cut the sentence
out of a life
out of the story
with my little knife

Each bit I cut
shows one alone
dressed or undressed
young full-grown

Look at the bits
He eats he cries
Look at the way
he stands he dies

so that another
seeing the bits
and seeing how
none of them fits

wants to add
adverbs to verbs
A bit on its own
simply disturbs

Wants to say
as well as see
wants to say
valiantly

interpreting
some look in the eyes
a triumph mixed up
with surprise

I cut this sentence
look again
for cowardice
boredom pain

Find what you seek
find what you fear
and be assured
nothing is here

I am the eye
that cut the life
you stand you lie
I am the knife[15]

The camera toters, the gun wavers and the knife wielders, and barely perhaps a glimmer of difference. As George Santayana put it: 'To complain of a photograph for being literal and merciless, is like complaining of a good memory that it will not suffer you to forget your sins.'[16] But Gunn's poem is only a partial complaint. It attests to the sense of photography's death-dealing, its sang-froid, its tendency to isolate and denude its subject, but also to the contrary impulse in the poet to return the photographic image to language and to the life-bringing medium of the word. The viewer of the photograph 'wants to add / adverbs to verbs ... wants to say / valiantly', returning the image to human agency and moral evaluation, whilst enacting and exemplifying the courage of the poem, the valiant life-gift of 'interpreting'. But there is always a sense in which the words brought to the image risk being extraneous, specious even, or mere sentimental projection: 'Find what you seek / find what you fear / and be assured / nothing is here'. The dumbness of the photographic image, its refusal to speak, invites an act of response, but offers in return a silence thicker even than that of painting because the camera seems to dissolve the agency not only of the subject but of the photographer too, cutting life into 'bits' that resist assimilation, that seem not to be created but rather directly cut out of the 'real'. In this poem,

however, the camera's clinical excisions are paralleled with the activity of writing ('I cut this sentence') and the 'song' itself becomes an example of something merciless, seduced by the coolness of the camera into discovering an analogous cruelty and economy within its own process. By the end of the poem camera and song have become interchangeable and the paradox emerges of the impersonal photographic medium 'speaking' in the first person lyric-voice, directly, menacingly: 'I am the knife'. Again the discovery seems to be that objectivity or indifference can never be merely neutral categories because, as Williams saw in Brueghel's *Icarus*, they summon their own moral force and affect. And Gunn seems to want to connect this with the mode of the lyric poem itself.

This discovery of a parallel between the activity of lyric poetry and the cruelty of the photographic aesthetic is not one often made in contemporary poems for photographs. Gunn's poem yields to and then pulls away from the temptation to add '*valiantly*' to the photographic image or, to put it another way, the temptation to sentimentalise. But the temptation is very often impossible for the poet to resist. As Sontag has argued, the photographic medium tends to turn the past instantaneously 'into an object of tender regard, scrambling moral distinctions and disarming historical judgments by the generalized pathos' of its gaze.[17] Gunn's song of the camera takes a cruel pleasure in denying this effect, in insisting that the photographer's art (like the poet's) is as likely to cheat and lie as to yield objects of tender regard. But the generalised pathos Sontag describes is powerful because it is bound up with the double movement of the photographic effect as described by Barthes. By suggesting that the object has been real, the photograph induces the sense of its subject being alive, but by placing this reality in the past the photograph also suggests that such life is already dead. What haunts all photographs then is the sense of different kinds of knowledge: the knowledge we have of the passing of the photograph's subject is charged with pathos precisely because the subject does not possess such knowledge herself. It is the kind of pathos Williams and Berryman discovered in Brueghel's *Hunters in the Snow*, the sadness of witness and record, but intensified in the case of the photograph by the reality effect of the medium.

This immediate relation with time and death, with the ironies of knowledge and ignorance, seems to invite the modal strategies of ekphrasis. The examples of modern elegies that describe or refer to photographs are so numerous that it seems the photograph like the funeral poem has insinuated itself into the core of our rituals of mourning, which is hardly surprising. I would like to consider two or three examples in which the aesthetic of the photographic

medium itself seems in part to have shaped the elegy, most interestingly perhaps in the temptation to sentimentality.

The first is Philip Larkin's poem upon a photograph of volunteers queuing up to join the army in 1914:

MCMXIV

Those long uneven lines
Standing as patiently
As if they were stretched outside
The Oval or Villa Park,
The crowns of hats, the sun
On moustached archaic faces
Grinning as if it were all
An August Bank Holiday lark;

And the shut shops, the bleached
Established names on the sunblinds,
The farthings and sovereigns,
And dark-clothed children at play
Called after kings and queens,
The tin advertisements
For cocoa and twist, and the pubs
Wide open all day;

And the countryside not caring:
The place-names all hazed over
With flowering grasses, and fields
Shadowing Domesday lines
Under wheat's restless silence;
The differently-dressed servants
With tiny rooms in huge houses,
The dust behind limousines;

Never such innocence,
Never before or since,
As changed itself to past
Without a word – the men
Leaving the gardens tidy,

The thousands of marriages
Lasting a little while longer:
Never such innocence again.[18]

This was written in the summer of 1960. What Sontag has described as 'the innocence, the vulnerability of lives headed towards their own destruction', is especially poignant in a photograph of men signing up to go to war, and especially for the 1914–18 war. That sense of a time of catastrophic historic naivety, of failing adequately to foresee the future, is enhanced by the photograph's natural tendency to suggest an unseen horizon of death. Larkin's elegiac note, however, is not merely for the 'moustached archaic faces', but for a particular vision of Edwardian England, quaint, gentle, drowsy, class-bound, a time when marriages lasted a little longer than they did in 1960 and gardens were tidier. (One day Larkin will admire Margaret Thatcher.) This is the England he imagines having 'changed itself to past / without a word' on entering the First World War. 'Without a word' is the conventional silence encountered in ekphrasis, although here it also evokes certain ideas of decorum and sacrifice: husbands doing the gardening, wives obeying husbands, servants going about their duties, men giving their lives, all 'without a word'. The pathos of silence, of a sealed past, recalls the sentiment Keats entertained for the urn, only in this case the wordlessness is also to do with actual imminent oblivion. There is perhaps a hint of the traditional pastoral elegy's recognition of a grander indifference to human suffering in the natural world ('the countryside not caring'; Williams's *unsignificantly*), but the indifference seems primarily to be that of the medium itself, the cool recording eye of the camera. It is hard to say though exactly what kind of 'innocence' Larkin is invoking. If this is a particular historical judgement it seems partly determined by the quality characteristically presented by a photograph, what Sontag calls 'soft abstract pastness'.[19] It would be hard to say just how this 'innocence' belongs to the moment of 1914 (are times in and of themselves more or less 'innocent' than other times?), or how exactly it is relative to the year 1960. The root of the word means 'unharmful', whereas in Larkin's poem the sense is more 'as-yet-unharmed'. In other words, it is difficult to extricate the quality peculiar to the medium of photography from the broader retrospective vision Larkin has of England and the First World War. By its very nature the photograph carries a powerful invitation to feel the loss of its subject and to fantasise around such loss, allowing a space for Larkin's nostalgia to expand and grow. This is nostalgia for a time of which – as is often the case with nostalgia – Larkin would have had no personal knowledge

but which he would have known about through the stories of his father's generation (Larkin was born in 1922), and of course through photographic images. Would Larkin then be among those described by the narrator of DeLillo's *Americana* (1971) who would be 'willing to die for our country, or for photographs of our country'?[20] The question is really whether this is a poem about a certain historical moment that seems 'innocent' and tragically so from the perspective of 1960, or if the piece is actually about the elegiac nature of photography. Perhaps the medium meets the historical perspective perfectly. Is the poem really thinking about England in 1914, or about photographs of England in 1914? Is there a significant difference between the two in Larkin's consciousness of that moment? And how would we go about distinguishing the one from the other, particularly given the fact that photography is assumed to produce documentary evidence of an impugnably objective value? If what might be called aesthetic considerations about the medium affect our way of reading such evidence, then the issue of historical judgement or moral distinction becomes especially cloudy. The confusion reveals the ways in which photography has, as it were, got inside the elegiac mode Larkin is employing, structuring the poem around the imperatives of its own medium and thereby distorting historical understanding, perhaps producing a form of historical memory which is itself essentially photographic.

Elsewhere Larkin seemed more conscious of this danger. In an earlier poem, 'Lines on a Young Lady's Photograph Album' (1953), he describes the experience of looking at pictures from someone else's family album and apostrophises the medium as so:

> But o, photography! as no art is,
> Faithful and disappointing! that records
> Dull days as dull, and hold-it smiles as frauds,
> And will not censor blemishes
> Like washing-lines, and Hall's-Distemper boards,
>
> But shows the cat as disinclined, and shades
> A chin as doubled when it is, what grace
> Your candour thus confers upon her face!
> How overwhelmingly persuades
> That this is a real girl in a real place,
>
> In every sense empirically true!
> Or is it just *the past*? Those flowers, that gate,

These misty parks and motors, lacerate
Simply by being over; you
Contract my heart by looking out of date.

The photograph simultaneously records its subject with a truthfulness that is emotionally neutral, and bestows upon the subject a pastness that is heart wrenching (the pun on 'contract' suggests physical pain, a shrinking or fear, but also a binding or obligation). And yet Larkin also knows that there is something safe and comforting about the kind of grief he experiences looking at old photographs. This is 'because / It leaves us free to cry. We know *what was* / Won't call on us to justify / Our grief ...'. There is safety in the distance that divides us from the photographed past. We grieve for the things that are 'over' or 'out of date', but nothing demands that we justify this grief. Like nostalgia, it is a form of mourning not without its own pleasure. And it is perhaps indicative of Larkin's own temperament as a poet that he was able to see through this pathos in a photograph of a girlfriend more readily than in a picture of 'England' in 1914.

In fact, photography might just as easily be taken as a model for faulty memory as for the 'literal and merciless'. Larkin's notion of a loss of innocence is of course a mystification, even if photography defies us not to think in this way. The ability for any kind of visual portrait to suggest thoughts about innocence or the fall into knowledge has always been something discovered by literature. In Rossetti's case, as we have seen, it was a recurrent and exalted process. For Wilde it suggested a magical fable. Poems for photographs in the twentieth century discover the same kind of temporal crisis – the imminent oblivion or tragic knowledge which belongs to a captured image. If the discovery of a conjunction between innocence and experience seems more painful because of the photograph's privileged connection to the 'real', at the same time what we might call the *super-poignancy* inherent to the medium – what Sontag labels the 'posthumous irony' – the effect of a poignancy *in excess*, particularly perhaps in photographs of family or loved ones, always brings with it the danger of sentimentality or the temptation to nostalgia. Sentimentality emerges when there seems to be an imbalance between an emotional source and an emotional affect, and this will happen in particular when photographs of the familiar dead are evoked in poetry. It is not surprising that contemporary poets frequently evoke some version of the myth of the Fall when they elegise around the photograph, making the trauma of the image explicit. This is the case, for example, in the opening poem of Ted Hughes's collection of elegies for Sylvia Plath, *Birthday Letters* (1998):

Fulbright Scholars

Where was it, in the Strand? A display
Of news items, in photographs.
For some reason I noticed it.
A picture of that year's intake
Of Fulbright Scholars. Just arriving –
Or arrived. Or some of them.
Were you among them? I studied it,
Not too minutely, wondering
Which of them I might meet.
I remember that thought. Not
Your face. No doubt I scanned particularly
The girls. Maybe I noticed you.
Maybe I weighed you up, feeling unlikely.
Noted your long hair, loose waves –
Your Veronica Lake bang. Not what it hid.
It would appear blond. And your grin.
Your exaggerated American
Grin for the cameras, the judges, the strangers, the frighteners.
Then I forgot. Yet I remember
The picture: the Fulbright Scholars.
With their luggage? It seems unlikely.
Could they have come as a team? I was walking
Sore-footed, under hot sun, hot pavements.
Was it then I bought a peach? That's as I remember.
From a stall near Charing Cross Station.
It was the first fresh peach I had ever tasted.
I could hardly believe how delicious.
At twenty-five I was dumbfounded afresh
By my ignorance of the simplest things.[21]

Hughes attempts to remember the photograph of incoming Fulbright scholars in which he may or may not have first seen Plath's face, and then to read this photograph-memory for signs or portents of things that he would know only later (Plath's 'exaggerated grin' concealing her particular forms of fear and insecurity). He also attempts retrospectively to sketch out a cautious scenario of romance and destiny: 'Maybe I noticed you./ Maybe I weighed you up'. As such, partly because he is aware of the unreliability of the exercise

(the poem twice wonders about seeming and feeling 'unlikely', with a play on the sense of likeness or resemblance), the poem is a paradigm for how we all construct memory, overlaying and inventing, retrospectively filling in and picturing. Most significantly, the poem is about an initial experience or encounter with something life-changing, and the 'first fresh peach I had ever tasted' (with a nod to Eliot's Prufrock) returns us to the myth of the Fall with unembarrassed sentiment.

Birthday Letters opens with a photographic encounter partly because the photograph is this medium of a readymade posthumous irony in which knowledge meets innocence, a medium predisposed to elegy, but also because memories of photographs and what we might call photo-memories play a central role in the collection as a whole. A later poem from *Birthday Letters* is entitled 'Perfect Light':

> *Perfect Light*
>
> There you are, in all your innocence,
> Sitting among your daffodils, as in a picture
> Posed as for the title: 'Innocence'.
> Perfect light in your face lights it up
> Like a daffodil. Like any one of those daffodils
> It was to be your only April on earth
> Among your daffodils. In your arms
> Like a teddy bear, your new son.
> Only a few weeks into his innocence.
> Mother and infant, as in the Holy portrait.
> And beside you, laughing up at you,
> Your daughter, barely two. Like a daffodil
> You turn your face down to her, saying something.
> Your words were lost in the camera.
> And the knowledge
> Inside the hill on which you are sitting,
> A moated fort hill, bigger than your house,
> Failed to reach the picture. While your next moment,
> Coming towards you like an infantryman
> Returning slowly out of no-man's land,
> Bowed under something, never reached you –
> Simply melted into the perfect light.[22]

Every family photograph or portrait is in some sense posed as for the title
'Innocence'. In this piece Hughes is remembering Andrew Marvell's poem
about a picture, 'The Picture of Little T.C. in a Prospect of Flowers' ('See
with what simplicity / The nymph begins her golden days'), in which the
poet wonders and muses on what the future may have in store for the young
subject of the painting, the picture of innocence, and how that innocence may
change into other larger awareness over time.[23] If the photograph of Plath
seems close to a parody of this kind of 'Innocence', the poem is conscious
of the almost absurd poignancy in the picture, resisting it slightly, mocking
its perfect composition: 'Mother and infant, as in the Holy portrait'. But
these archetypes are also seriously invoked: this photograph of mother and
child has acquired for Hughes a preternatural quality of innocence, an aura
that irresistibly recalls sacred art and religious rituals. Whether the personal
significance of the image can be translated into iconographic status without the
risk of a kind of embarrassment occurring for the reader is not clear. The poem
also recalls Wordsworth's daffodils ('I wandered lonely as a cloud') published
in 1807, the flower Wordsworth made emblematic of a certain notion of the
'poetic' – too famous to invoke without an awareness of the burden of literary
history, now on the margins of cliché perhaps, just as this photograph seems
to be on those margins. The memory of the daffodils seen beside the lake
functions for Wordsworth in a way that might suggest to us the photograph
– to be taken out and viewed at a distant date and place – or at least like a
photo-memory, involuntarily returning with pictorial clarity:

> I gazed – and gazed – but little thought
> What wealth the show to me had brought:
> For oft, when on my couch I lie
> In vacant or in pensive mood,
> They flash upon that inward eye
> Which is the bliss of solitude;
> And then my heart with pleasure fills,
> And dances with the daffodils.[24]

Hughes is also invoking the idea of a 'flash upon [the] inward eye', a stored
image, something that is 'the bliss of solitude'. But his relation to the
photograph is less straightforward than Wordsworth's relation to daffodils
because the photograph as memory is not simply sustaining or enriching,
as was the memory of the daffodils. The 'innocence' it seems to stage has
a complex and disturbing power, one that points towards death, one that

summons the counter-principle of knowledge. This is why solitude brings not 'bliss' in the contemplation of this image but rather a redoubled sense of loss. Significantly, it is the silence of the image – indeed more than silence, the loss of a voice: 'Your words were lost in the camera' – that seems most potent or challenging, and it is that sense of lost words from which the poem turns towards 'knowledge'.

The traumas of the marriage of Ted Hughes and Sylvia Plath have stimulated all kinds of interest in readers and scholars, and the publication of *Birthday Letters* contributed further to the intrigue. The 'knowledge' that presses upon the 'innocence' of the picture is the knowledge that comes with the fall from bliss, the price of Hughes's and Plath's experience as husband and wife. This knowledge seems in fact to inhabit the picture, to loom within it, as if it lives inside the hill on which Plath is sitting (ominously a 'moated hill fort, bigger than your house'). As in conventional ekphrastic encounters, the poem seeks to unlock the temporal stillness of the image in order to open it to the future and to the knowledge that the poet possesses of what happened next. The difference with a photograph is that this future is a *real* one rather than one imagined for it by a poet or constructed by a narrative. Hughes's metaphor, picking up the hint of war, is one of the next moment 'Coming towards you like an infantryman / Returning slowly out of no-man's land, / Bowed under something' (the body of a comrade perhaps). And yet this next moment, bearing its burden of knowledge and sorrow, 'never reached you'. Like Hughes, it is stranded in the gulf that separates the photographic present from the poem's present, unable to communicate what it knows. Instead Plath has been fixed in the 'for ever now' of the photographic image, that spurious and galling simulacrum of 'immortality' in which the illusion of being placed beyond future suffering is no help, because, unlike the figures on Keats's urn, Plath *will* live to experience time's injuries. And so the future is melting 'into the perfect light' of this moment in a paradoxical double sense; firstly, as the future is foreclosed or disarmed by this perfect moment it seems to be melting away to nothing, it is harmless (innocent) for the instant; but also, and more darkly, the future, with its burden of knowledge, is melting *into* the photograph rather as a stain or discoloration might mar the perfection of its surface. By closing with the cliché of 'perfect light' – this picture shows you in a perfect light, here you are at your happiest moment – the poem recognises the alchemy of the photographic medium, the wizard process by which light on photosensitive material produces images capable of powerful emotional affect, 'a trace, something directly stencilled off the real' (Sontag). But the threat of the cliché also shows a wariness of the sentimentality and

nostalgia inherent in particular to the family portrait and to the photograph of the familiar dead.

Perhaps Hughes has not quite been able to resist the temptation to control his emotional effects through knowing use of the verbal commonplace (as if to say 'this is a cliché, but it is true') or, like Larkin, perhaps he has simply succumbed to the emotional imperatives of the medium. The photograph *stands in for* grief and absolves the poet of the need to justify that grief; or it obstructs any process of justification by offering a short-cut from source to affect, from private portrait to archetype. But how strict are these emotional imperatives? The photograph will always seem posed for the titles language brings to it, always opening up a super-pathos in its calibration of loss, its images so frequently close to parodies of iconic or sacred art that they may often carry the 'aura' of sanctity in anachronistic ways. In the picture of Sylvia Plath and her laughing children there is an obvious simplicity that begs to be called 'innocence' (again the sense is more 'as-yet-unharmed'). It is not subtle, this immediate and excessive poignancy, this directness of affect. But this may be the reason why it seems to resist or defeat transcription. Benjamin makes the point that 'the cult of remembrance of loved ones, absent or dead, offers a last refuge for the cult value of the picture'.[25] If there is a category of image then that seems to escape the attempts of language to appropriate or reproduce its effect, a form of picturing that resists ekphrasis with the absolute sovereignty of the image, the inviolable and untranslatable private grief, then perhaps it is to be found in photographs of the dead.

Even so, or perhaps as a consequence of this, the suspicion of images and the refusal to verify their 'aura' are equally powerful impulses. A kind of anti-photographic aesthetic may also be discovered in contemporary poetry, one that attempts to resist the elegiac tyranny of the photograph, and in particular the allegory of the 'loss of innocence' staged by the medium. This is John Ashbery's 'City Afternoon' (from the collection *Self-Portrait in a Convex Mirror*):

City Afternoon

A veil of haze protects this
Long-ago afternoon forgotten by everybody
In this photograph, most of them now
Sucked screaming through old age and death.

If one could seize America
Or at least a fine forgetfulness

That seeps into our outline
Defining our volumes with a stain
That is fleeting too

But commemorates
Because it does define, after all:
Gray garlands, that threesome
Waiting for the light to change,
Air lifting the hair of one
Upside down in the reflecting pool.[26]

'If one could seize America'. This was written in 1972, that time in American history portrayed as one of a loss of innocence, a description applied with numbing frequency to events across the decades.[27] The 'veil of haze' protecting the 'long-ago afternoon' pictured in Ashbery's photograph is both the physical deterioration and discoloration of the photograph (old photographs are less durable than old master paintings, their surfaces melt away), and the haze of forgetting by which the past is veiled from us. This process of forgetting, linked here to American history, is one by which we are protected from the past as it is protected from us, from our voyeurism, from our tendency to get it wrong. Ashbery's photograph is not bathed in a 'perfect light', nor even 'hazed over' in Larkin's misty-eyed sense, but is simply a faded and deteriorating photograph of unnamed people, 'most of them now / Sucked screaming through old age and death', who, if alive, have forgotten the afternoon commemorated by the photograph. There is no poignant encounter between innocence and knowledge, and no fond memory stirred by the image. Instead the physical deterioration of the photograph, its stained and blurred outline, is presented as a metaphor for the process of memory, including larger historical memory. A 'fine forgetfulness' (like a fine rain) infiltrates the process. The poem is conscious of the temptations and the apparent possibilities of the photographic medium, the promise of a direct and unmediated representation of an historical moment ('If one could seize America'), and how this in turn might give an opportunity for plangent historical judgement (*seize* suggests 'capture', 'sum up', 'intercept', perhaps also 'stage a coup'). But Ashbery is more interested in the disappointment or distortion of these possibilities. His lines trace the deterioration that begins to assault the photograph, the forgetfulness that 'seeps into our outline' and into our memory, the misprision that thwarts any effort to grasp (comprehend) America, even perhaps the stain that is upon its history. And though these processes of blurring and

forgetting may themselves be merely fleeting, to be replaced by deeper lines of annihilation, nevertheless they are also defining, and so they also in their own way 'commemorate'. That is, just as the blurring and deterioration offer a kind of negative definition of form in a photograph, so the forgetfulness of memory, historical error, misrepresentation, also go about their work of negative definition. This is the same kind of negative ontology Ashbery traced in 'Self-Portrait in a Convex Mirror' in which the self is seen to be partly constituted by alterity or 'otherness', blank spaces, illusions. The final image is one that needs an effort of concentration to visualise, as if the reader must do the work of the brain in processing and correcting the image upon the retina: 'Air lifting the hair of one / Upside down in the reflecting pool': an image of inversion, of an optical trick perhaps, or a photographic negative.

'City Afternoon' refuses the temptations of the photograph to discover posthumous irony, to mourn the loss of innocence, or to behold the past in an exemplifying or symbolising totality. The inevitable deathwards pull of the photographic image is acknowledged in its brutality, but anonymously. For Ashbery, photography is a medium of bad or faulty memory, of haze and fine forgetfulness, of ill-definition and blurred outline. In this it is like language and like poetic elegy.

NOTES

1 A more recent example of the same kind of serious misunderstanding occurred when in September 2005 the Danish newspaper *Jyllands-Posten* published twelve cartoons of the prophet Muhammad. Walter Benjamin's famous essay 'The Work of Art in the Age of Mechanical Reproduction' (1936) argued that the 'aura' of images, icons and paintings, which originated in their use as cultic objects in religious ceremonies, and which became an index of their uniqueness, authenticity and historical witness, largely disappeared in the nineteenth century with the age of mechanical and photographic reproduction of these images. Walter Benjamin, *Illuminations*, ed. Hannah Arendt, trans. Harry Zorn (London: Pimlico, 1970), pp. 211–44.

2 Susan Sontag, *On Photography* (London: Penguin, 1971), p. 154.

3 Sontag, *On Photography*, p. 154

4 See, for example, Roger Scruton's essay arguing that photography is not a form of representation and so (presumably) should not be considered seriously as an art form, 'Photography and Representation', in *The Aesthetic Understanding: Essays in the Philosophy of Art and Culture* (Manchester: Carcanet, 1983), pp. 102–26. Benjamin makes the point that 'much futile thought had been devoted to the question of whether photography is an art. The primary question – whether the very invention of photography had not transformed the entire nature of art

– was not raised' (*Illuminations*, p. 220). See also Jonathan Friday, *Aesthetics and Photography* (Aldershot: Ashgate, 2002). For useful summaries of the aesthetics of photography see Nigel Warburton, 'Photography', in *The Oxford Handbook of Aesthetics*, ed. Jerrold Levinson (Oxford: Oxford University Press, 2003), pp. 614–26, and Patrick Maynard, 'Photography', in Berys Gaunt and Dominic McIver Lopes (eds), *The Routledge Companion to Aesthetics* (London and New York: Routledge, 2001), pp. 477–90.

5 Beaumont Newhall, *The History of Photography* (New York: Museum of Modern Art, 1982), p. 32.

6 Sontag, *On Photography*, p. 15. See also, for example, Isobel Armstrong, *The Radical Aesthetic* (Oxford: Blackwell, 2000), p. 8: 'Photographs are celebrations of the uniqueness of every moment of being, every configuration of shadow and substance, and an elegy upon them.'

7 Don DeLillo, *White Noise* (New York: Viking, 1984), p. 12; *Mao II* (London: Vintage, 1991), p. 27.

8 DeLillo, *Mao II*, pp. 36–7.

9 DeLillo, *Mao II*, p. 42.

10 Roland Barthes, *Camera Lucida* (London: Vintage, 2000), p. 14. See also Susan Williams, *Confounding Images: Photography and Portraiture in Antebellum American Fiction* (Philadelphia: University of Pennsylvania Press, 1997): 'Even as the daguerreotype and other reproductive technologies challenged the pictorial powers of writers, however, they also encouraged those writers to use portraits to create a realm beyond mimetic representation. In particular, antebellum writers found a renewed interest in the Gothic topos of the haunted or magic portrait. Since these fictional portraits could not be illustrated in actual pictures, their full force could be articulated only through writing' (p. 3).

11 Barthes, *Camera Lucida*, p. 92.

12 DeLillo, *Mao II*, p. 197. Sontag discusses the 'irrepressible identification of the camera and the gun, "shooting" a subject and shooting a human being', in *Regarding the Pain of Others* (London: Penguin, 2004), p. 60.

13 Barthes, *Camera Lucida*, pp. 66; 9.

14 Barthes, *Camera Lucida*, p. 79.

15 Thom Gunn, *Collected Poems* (London: Faber, 1993), pp. 347–8.

16 Santayana continues: 'A good memory is a good thing for a good man, and to admit all the facts is the beginning of salvation.' Cited in Jefferson Hunter, *Image and Word: The Interaction of Twentieth-Century Photographs and Texts* (Cambridge MA: Harvard University Press, 1987), p. 1.

17 Sontag, *On Photography*, p. 71.

18 *Philip Larkin: Collected Poems*, ed. Anthony Thwaite (London: Faber, 1988), pp. 127–8 . Whether Larkin is responding to a specific photograph is not clear. However, the poem certainly seems to me to be engaging with the photographic medium and its relationship to memory. All extracts from Larkin are from this edition.

19 Sontag, *On Photography*, p. 71.

20 Don DeLillo, *Americana* (London: Penguin, 1990; first published 1971), p. 132.

21 Ted Hughes, *Birthday Letters* (London: Faber, 1998), p. 3.

22 Hughes, *Birthday Letters*, p. 143.

23 See also John Ashbery's poem 'The Picture of Little J.A. in a Prospect of Flowers', in *Selected Poems* (London: Paladin, 1987), p. 12.

24 William Wordsworth, 'I wandered lonely as a cloud ...' in Stephen Gill (ed.), *William Wordsworth* (Oxford: Oxford University Press, 1984), p. 303.

25 Benjamin, *Illuminations*, p. 219.

26 John Ashbery, *Self-Portrait in a Convex Mirror* (London: Penguin, 1975), p. 61.

27 Most recently with the attacks on the World Trade Center. It may of course be possible to lose innocence, then regain it, only to lose it again, repeatedly. In the case of 11 September this 'innocence' went on display for the public in New York in a show of photographs entitled 'Here Is New York' in Manhattan in late September 2001. These photographs had been taken by professionals and amateurs alike. Sontag discusses the exhibition, which I did not see, in *Regarding the Pain of Others*, p. 24.

PROSE EKPHRASIS

WRITING FOR ART requires a certain amount of nerve, not merely in the poet attempting the 'impossible', but in any description of visual art. The endeavour to describe or explain pictures and sculptures demands 'a heroically exposed use of language', in Michael Baxandall's phrase, and the history of art history, of this heroic willingness to expose language to the visual, might justifiably be presented as a narrative of risk and adventure.[1] Looking back at the beginnings of this history in the work of the classicist Johan Joachim Winckelmann (1717–68), Goethe employed metaphors of daring and discovery, of exploration. 'Like a new Columbus', Goethe wrote, Winckelmann had opened a 'territory whose existence had long been suspected, hinted at, and discussed – one might even say a land which had once been known, but was subsequently lost from view'.[2] Walter Pater went further in his praise, quoting Hegel's comment that Winckelmann was to be regarded '"as one of those who, in the sphere of art, have known how to initiate a new organ for the human spirit"'.[3] Winckelmann's *Reflections on the Imitation of Greek Works in Painting and Sculpture* (1755) described Greek art (or Roman copies of Greek art), with the aim of understanding its historical meaning or its 'spirit'. This is Winckelmann's famous description of the *Laocoön* sculpture, which he had seen in Rome (figure 13):

> The general and most distinctive characteristics of the Greek masterpieces are, finally, a noble simplicity and quiet grandeur, both in posture and expression. Just as the depths of the sea always remain calm however much the surface may rage, so does the expression of the figures of the Greeks reveal a great and composed soul even in the midst of passion.
>
> Such a soul is reflected in the face of Laokoön – and not in the

face alone – despite his violent suffering. The pain is revealed in all
the muscles and sinews of his body, and we ourselves can feel it as we
observe the painful contraction of the abdomen alone without regarding
the face and other parts of the body. This pain, however, expresses
itself with no sign of rage in his face or in his entire bearing. He emits
no terrible screams such as Virgil's Laokoön, for the opening of his
mouth does not permit it; it is rather an anxious and troubled sighing
as described by Sadoleto. The physical pain and the nobility of soul are
distributed with equal strength over the entire body and are, as it were,
held in balance with one another. Laokoön suffers, but he suffers like
Sophocles' Philoctetes; his pain touches our very souls, but we wish that
we could bear misery like this great man.[4]

About suffering, then, the Greek sculptors were never wrong. In Greek legend
Laocoön was the Trojan priest who had warned against receiving the wooden
horse inside the city walls, thus incurring the wrath of Apollo, who sent two
giant sea-serpents to destroy him and his two sons. Their agonising death is
described by Virgil in the second book of the *Aeneid*, here in John Dryden's
translation:

> The Priest thus doubly choak'd, their Crests divide,
> And tow'ring o're his Head, in Triumph ride.
> With both his Hands he labours at the Knots;
> His Holy Fillets the blue Venom blots:
> His roaring fills the flitting Air around.
> Thus, when an Oxe receives a glancing Wound,
> He breaks his Bands, the fatal Altar flies,
> And with loud Bellowings breaks the yielding Skies.[5]

The roars and bellows are silenced by the Greek sculpture, a silence,
according to Wincklemann, that expressed a 'great and composed soul'. It also
revealed the spirit of Greek art in general, of the 'noble simplicity and quiet
grandeur' that is an aesthetic quality and an ethical value, an inner harmony
or composure expressed in outward form. The brute clamour of animal pain
that had been central to Virgil's description and Dryden's translation had
been stilled not merely because marble is mute but because this is how the
Greeks bore their misery.

As in the poetry of ekphrasis, so here in prose, the silence of the artwork
has been given a special significance through its contrast with the sound,

13 Unknown sculptor, *The Laocoön Group* (Vatican Museum, Rome. Photo:
Vatican Museum)

the *speech* of poetry. Winckelmann takes this silence as centrally meaningful, in this case as giving expression to the ethical or historical spirit of a whole culture. But the conventional paradox of ekphrasis is evident here too: as Winckelmann's description takes a verbal form, it becomes like Keats's ode an adjunct to, or violation of the silence of the artwork, speaking up for the piece and saying what this silence means. Others might break the silence in different ways. Gotthold Ephraim Lessing disagreed with Winckelmann's reading of the *Laocoön* sculpture in the opening pages of his treatise *Laocoön: An Essay on the Limits of Painting and Poetry* (1766). He pointed out that Sophocles's Philoctetes is in fact very vocal in his agony, and that, for the Greeks, 'crying aloud when in physical pain is compatible with nobility of soul'. There must therefore 'be another reason' why the sculptor chose not to represent Laocoön's screams:[6]

> The master strove to attain the highest beauty possible under the given condition of physical pain. The demands of beauty could not be reconciled with the pain in all its disfiguring violence, so it had to be reduced. The scream had to be softened to a sigh, not because screaming betrays an ignoble soul, but because it distorts the features in a disgusting manner. Simply imagine Laocoön's mouth forced wide open, and then judge! Imagine him screaming, and then look! From a form which inspired pity because it possessed beauty and pain at the same time, it has now become an ugly, repulsive figure from which we gladly turn away. For the sight of pain provokes distress; however, the distress should be transformed, through beauty, into the tender feeling of pity.[7]

Auden's poem for Brueghel's *Icarus* had argued that great art understood the limited attention human beings were capable of in relation to the suffering of others. Perhaps this is a generous way of putting what Lessing acknowledges here, that the direct representation of the outward signs of pain would merely make art ugly and therefore less pleasurable or affecting to a viewer. The assumption might be that the visual is more *present* to us than the verbal, or that visual beauty possesses a sovereignty that must remain inviolate, undisturbed by the temporal logic of pain. Lessing goes on to argue that the artist 'must set certain restraints upon expression and never present an action at its climax'.[8] The proper subject for art was the 'pregnant moment', that is, the moment *just before* a significant action occurs. Since art was a still, spatial medium, this was its natural sphere, in contrast to the temporal art of

poetry which unfolded in time and could therefore develop a narrative to its very climax, making us hear, for example, the bellowing howls of Laocoön in his death-throes. In other words, the sculptor of the *Laocoön* group was simply observing certain technical proprieties determined by the 'laws' of beauty, rather than expressing an 'idea' of Greek culture as Winckelmann had supposed.

Art history is made from disagreements like this. Who is seeing things as they are, and who is merely seeing things? When does the description of an artwork become a distortion or a hallucination? And if a description is somehow wrong or mistaken, might it not even so have a life or power of its own strong enough to change the way we look at the artwork thereafter? Winckelmann's observations and speculations intoxicated a generation of European art lovers and made them look at Roman copies of Greek statues under his influence. His lengthy descriptions of particular pieces of antique sculpture evoked the objects as meaningful presences, the pain or suffering of which (as in the *Laocoön* group) 'touches our souls'. Through these descriptions he regenerated the study of Greek art and sketched its history not merely as an object for antiquarian interest, but as a quasi-religious, quasi-redemptive cultural phenomenon, something that demanded attention and that might offer his own age the key to a spiritual renewal.

Large claims for art of this nature came to be typical of the later eighteenth and early nineteenth century in Europe, during what Germain Bazin has called the 'museum age'.[9] This period began with the French revolutionary project to create a gallery of European masterpieces in the palace of the Louvre, which then triggered a race towards great public and civic collections across the continent. The uprooting of art from its original contexts in churches or from monarchical or private collections to be displayed in public galleries and museums contributed to the birth of a new culture of art that was increasingly secular, with the power to 'elide original meanings and to substitute for them new aesthetic and art historical significances'.[10] In response to this process the role of the art critic as a mediator between the gallery visitor and the museum 'aura' of famous artworks became of increasing importance. In turn, aesthetic discourse around the beginning of the nineteenth century sought to appropriate the terms of religious worship for the new museum experience, creating what Walter Benjamin called the 'theology of art'.[11] The artwork was thus presented as an object available for pious rapture and absorption on its own terms without reference to its original function within a religious or social order – a notion for which Victor Cousin's motto *l'art pour l'art* became convenient shorthand. Keats, Rossetti and Wilde belong to such a tradition,

but so does Stevens, and perhaps even Ashbery. Writing for art in this mode offered what Bourdieu has described as 'the mystical representation of the aesthetic experience'.[12] 'A taste for the fine arts', William Hazlitt had observed as early as 1814, 'not ill supplies the place of religious enthusiasm.'[13] (*En-theos*: to be filled with the divine.)

But the attempt to make of gallery-going a type of pilgrimage and worship, and of art gazing a quasi-religious form of contemplation, prayer, or ecstatic vision, raises the problem of authenticity. Is this experience *really* like a religious experience, or merely a surrogate? Who is to say? If the museum offers a new kind of holy space, the 'aesthetic church' celebrated by Hölderlin – a place in which to fall into prayer, as Rossetti had in the National Gallery – who exactly may count themselves among the faithful and what would their faith involve?[14] Who are the priests of this new religion? The attempt to mystify the experience of looking at paintings in order to make gallery-going take on a cultic or ritualistic aspect is vulnerable not only to these kinds of questions but to further objections. Foremost is that the theology of art must inevitably disguise the particular historical conditions of privilege upon which it depends – of training and schooling, of leisure and education – whilst at the same time representing the acquirement of a passion or understanding for art as something granted as an inherent capacity or 'gift of nature'.[15] Secondly, that this represents a privileged form of subjectivism or individualism: that is, the bourgeois individual himself (usually male) becomes a kind of emotional barometer for the power of a particular artwork ('it touches our souls'), since it is by emotional affect, individual response, or, to put it crudely, private pleasure, that the 'mystery' of art is seen or felt to work. Private pleasure in the 'transcendent' nature of the artwork is a diversion or screen behind which the true nature of social and economic reality is hidden. These are among the objections readers have had to Keats's 'Ode on a Grecian Urn'; they also seem in a sense to be important responses to the work of Rossetti and Wilde. They haunt the discourse of aesthetics as it develops during the nineteenth century and form a part of the twentieth-century critique of aesthetic ideology.

Prose ekphrases are obviously central to the work of those who make the most significant contribution to the development of art writing, whether in France – Stendhal, Gautier, Baudelaire – or in England: Hazlitt, Ruskin, Pater. This is where aesthetic theories must begin – in the evocation of the painting or sculpture by the written word, in other words by the *praxis* of ekphrasis. The question central to ekphrasis then – can a verbal representation of a visual representation reproduce the artwork in a meaningful way for the reader? – is entangled with aesthetic theory, and in particular with a certain

mode of writing for art practised by 'aesthetes', at its very origin, determining the course that theory takes and the opposition it encounters. In the early years of the nineteenth century the vocabulary of art criticism is bound up with religious language and with the attempt to appropriate that language for art. Terms such as 'vision', 'prayer', 'communion', 'ecstasy', 'transcendence', 'immanence' are transmuted from a religious context to the new experience of the gallery. But the process of discovering or recovering new territory, of developing a 'new organ' for the human spirit, is like any such undertaking always imperilled. The principal danger is that theological terminology merely becomes loose and open in a secular context, free to be appropriated at will, and that this leads to the subjectivism which is often levelled as a charge against Romantic writing. Subjectivism is one of those dirty words in literary criticism that it might be worth thinking about again. Are there truths (the truth of beauty for example) that can be experienced only as intensely subjective truths but which nevertheless are valid beyond the consciousness of the individual? Writing for art is stalked by the possibility of this not being the case. It is a danger sometimes linked to the name of Marie Henri Bayle (Stendhal), and to what came to be known as The Stendhal Syndrome. In this we see the question of art religion come under particular pressure.

A journal entry for 1811 describes a visit Stendhal made to the church of Santa Croce in Florence. The entry records his survey of the tombs of the illustrious dead (Michelangelo, Alfieri, Machiavelli), and makes brief mention of certain paintings by Volterranno and Bronzino on display in the church. Returning to this rather ordinary experience six years later in *Rome, Naples, et Florence* (1817), Stendhal heightened its colour dramatically:

> I was in a kind of ecstasy, from the idea of being in Florence, and close to the great men whose tombs I had come to see. Absorbed in the contemplation of sublime beauty ... I arrived at that pitch of emotion where one experiences the *celestial sensations* granted by fine art and passionate feeling. On leaving *Santa Croce* I experienced heart-palpitations, what in Berlin they call 'nerves'; the life was drained out of me, I walked with the fear of stumbling and sat down on one of the benches in the piazza.[16]

Stendhal's attack of nerves became famous across Europe. The anecdote seemed to exemplify the mode of aesthetics and art-criticism Stendhal had developed in his *Historie de la Peinture* (1811), and had no doubt been touched up in retrospect to provide a foretaste of that criticism. Looking at art would

disturb the body, would be accompanied by physical symptoms; it would be an intense experience, perhaps even a life-threatening one, but one which might also yield '*les sensations célestes*'. These divine sensations are connected to the function not directly of *Santa Croce* as a Catholic church but as a kind of art gallery. In turn, art galleries might cause visitors to react in extreme ways not directly connected to religious belief or feeling, but which would instead seem to arise from the contemplation of art for the sake of art. In the late 1970s Dr Graziella Magherini, a psychiatrist working in Florence, coined the term *the Stendhal Syndrome* to describe the sense of disorientation, temporary amnesia and panic attacks that would overwhelm visitors to the galleries of Florence – a sickness she connected with the ability of artworks to bring to the surface repressed emotional experiences. The Stendhal Syndrome is frequently given a note in modern guidebooks to the city, sometimes with the emphasis simply on exhaustion, sometimes on weird disorientation. As a pseudo-psychiatric condition it has a vivid afterlife that seems to parody its origins. Dario Argento's 1996 horror film *The Stendhal Syndrome* features a Florentine detective Anna Manni on the trail of a deranged serial rapist and killer. As if that wasn't challenging enough, she also suffers from 'a mental condition that makes her retreat into frightening hallucinations when confronted with works of art'. Standing in front of Brueghel's *Fall of Icarus* (not, of course, in Florence), she experiences something like a fit or seizure during which she imagines herself transported inside the painting to be submerged, like Icarus, in the waves. The hallucinations increase in violence and intensity as the film progresses and involve famous paintings by Botticelli, Uccello and Caravaggio. 'Let's try never to use words like "crazy"', her doctor suggests.

Goethe was the first to diagnose 'Romanticism' as a sickness, a malady, and perhaps art hallucination might be thought of as one of its symptoms.[17] Even if we insist on the difference between Stendhal's experience in a church in 1811 and the average exhaustion or nervous breakdown of the tourist in the Uffizi, the case of Stendhal and the Stendhal Syndrome focuses a nineteenth century crux in aesthetic experience. The intense subjective absorption demanded by the gallery or secular space and theorised in the aesthetics of the late eighteenth and early nineteenth centuries seems to contain a negative possibility or threat of nervous collapse. Or to put it another way: what should an intense aesthetic experience be like? Is it possible to mistake heart palpitations for divine sensations? When art is transplanted from its place within a Christian context to enter the radically open discursive space of museum culture, the freedom gained may be disorienting, even oppressive. Argento's translation of the gallery visitor into the drowning Icarus – suffering unnoticed inside

the artwork – reveals an anxiety which we might take as symptomatic of all writing for art. Auden's leisurely stroll becomes a nightmare; Adorno and Beckett look on. A hostile critique of museum culture in which the museum or gallery is presented as a kind of mortuary or mausoleum develops from the very foundations of the Louvre and shadows aesthetic theory throughout the century and well into the next.[18] The Stendhal Syndrome points to the potential for art-worship to turn into a pathological condition of secular culture. The subjective experience of the art gazer and the recording of that experience in 'Romantic' art criticism, heightened with the emotiveness of art religion, in thrall to the 'aura' of the museum, might seem little more than a kind of hysteria, even a retreat into hallucination, rather than a rational encounter with the artwork. And if, as Germain Bazin puts it, 'the act of looking becomes a sort of trance uniting spectator and masterpiece', then the representation of that trance in art criticism requires a secondary form of verbal mystification for the reader to be able to participate in the original experience.[19]

The powerful prose description that seeks to reproduce this kind of experience in a reader might be represented as working then as a form of incantation or evocatory magic that replaces or stands in for the subjective experience of the gallery visitor, instructing that visitor in the correct aesthetic response while mystifying the art object itself. The greatest and most famous examples of these descriptions in the nineteenth century both summon and conceal their objects. They seek to reproduce the presence or 'aura' of the painting or sculpture, whilst at the same time shrouding that presence with their own rival (and of course alien) process of representation. But this pairing – painting and description – can develop into an odd kind of intimacy after a while, as the famous description comes to affect the ways in which the artwork is seen. The examples I will focus upon in this chapter demonstrate the manner in which the most celebrated examples of prose ekphrasis distort and subordinate the objects of their attachment. If the academic discipline of art history develops in reaction to such a process, seeking to dispel some of the nineteenth-century 'magic' of art criticism through the clear light of historical recuperation, the forensic recovery of technique and material, the pursuit of context, nevertheless, all art history and art criticism remains dependent (and often uneasily so) upon the basic unit of verbal *description*. Or in other words, upon prose ekphrasis.

This is John Ruskin's description of Turner's *The Slave Ship* (figure 14):

It is a sunset on the Atlantic, after prolonged storm; but the storm is partially lulled, and the torn and streaming rain-clouds are moving in

14 J.M.W. Turner, *Slavers Throwing Overboard the Dead and Dying – Typhon Coming On (The Slave Ship)* (1840) (Museum of Fine Arts, Boston. Photo: Bridgeman Art Library)

scarlet lines to lose themselves in the hollow of the night. The whole
surface of sea included in the picture is divided into two ridges of
enormous swell, not high, nor local, but a low broad heaving of the
whole ocean, like the lifting of its bosom by deep-drawn breath after
the torture of the storm. Between these two ridges the fire of the
sunset falls along the trough of the sea, dyeing it with an awful but
glorious light, the intense and lurid splendour which burns like gold,
and bathes like blood. Along this fiery path and valley, the tossing
waves by which the swell of the sea is restlessly divided, lift themselves
in dark, indefinite, fantastic forms, each casting a faint and ghastly
shadow behind it along the illumined foam. They do not rise everywhere,
but three or four together in wild groups, fitfully and furiously, as the
under strength of the swell compels or permits them; leaving between
them treacherous spaces of level and whirling water, now lighted with
green and lamp-like fire, now flashing back the gold of the declining
sun, now fearfully dyed from above with the indistinguishable images
of the burning clouds, which fall upon them in flakes of crimson and
scarlet, and give to the reckless waves the added motion of their own
fiery flying. Purple and blue, the lurid shadows of the hollow breakers
are cast upon the mist of night, which gathers cold and low, advancing
like the shadow of death upon the guilty* ship as it labours amidst the
lightning of the sea, its thin masts written upon the sky in lines of
blood, girded with condemnation in that fearful hue which signs the
sky with horror, and mixes its flaming flood with the sunlight, and,
cast far along the desolate heave of the sepulchral waves, incarnadines
the multitudinous sea.[20]

* She is a slaver, throwing her slaves overboard. The near sea is
encumbered with corpses. [*Ruskin's note*]

For Ruskin (twenty-four years old), Turner's intense absorption in the
natural world was a sacramental activity and painting an act of religious
devotion. The strength of this conviction surpasses anything Browning had
Lippo say, and rivals the intensities of Rossetti. Ruskin hoped to rescue Turner
from the misunderstanding and misrepresentation of critics who claimed that
he painted things that had never been seen in the natural world. With minute
and remorseless detail of observation, Ruskin's *Modern Painters I* (1843) argued
that Turner's studies of sunsets, clouds, the sea, rain-storms, mountains, rocks,
the sky, foliage, and so on, were not merely taken directly from nature but were

at least as accurate as, and often considerably more so than, the treatment of these subjects in earlier artists, and, moreover, that the detail recorded could be perceived in nature only with the kind of heightened attention and exalted sense of vision found in a genius such as Turner (and, it would be inferred, Ruskin). What is at stake therefore is the significance of the faculty of vision itself, in its most profound sense.

But does Ruskin's prose help us to 'see' Turner's painting? The description is densest in the effort to convey effects of light and shadow, colour, and the form of the sea. The fact that the ship is a slave-ship and that the sea is littered with its cargo – jettisoned so that the ship's owner might make a large insurance claim – is relegated to a footnote, although certain colours or 'hues' are read metaphorically as conveying a general atmosphere of guilt. Ruskin does not mention the shackled leg and breasts of the black female slave protruding from the waves in the bottom right-hand corner of the canvas. Like the drowning of Icarus in Brueghel, to which Turner may possibly be alluding, her suffering goes unnoticed, although later critics often writing in open hostility to Ruskin's reading seemed to obsess over this particular detail, and indeed the general relation the painting had with the abolitionist movement.[21] The end of the passage adopts figures of writing – 'its thin masts written upon the sky', 'that fearful hue which signs the sky' – and closes with an echo of a phrase from *Macbeth* (an example of English at its most self-consciously Latinate and syllabic). Indeed, the passage seems closely shaped by textual influences – the poetry of Wordsworth and Shelley, the sublime as described by Burke, the apocalypse of the book of Revelation, even, it has been suggested, a pattern of Biblical typology in that the visual here seems to *stand for* a spiritual reality (in this case the diffuse moral evil of the slave trade).[22] In a conventionally ekphrastic sense the picture is returned to time and motion, and it is the adverbial life of the passage ('restlessly ... fitfully and furiously') in which the moral *mood* of the piece is discovered. Elsewhere Ruskin described the picture as 'Turner's sermon against the slave trade'.[23] Ruskin's own sermon for Turner's painting was composed orally, its 'sonorous cadences' reflecting Ruskin's study of the Bible in his childhood.[24] Turner himself appended seven lines of verse to accompany the picture from his own poem *Fallacies of Hope* in the Royal Academy Exhibition catalogue of 1840.[25] His paintings frequently have a close relationship to texts – often with his own, although in this case it has been suggested that passages from James Thomson's *The Seasons* (1727) also provide sources for the painting. Textuality, then, is not introduced by Ruskin, nor is it simply part of the context of the work, but bears a relation to the conception *and* exhibition of the piece.

As with much of Turner's work, especially his late work, there seems to be a tension between an impulse to visual experiment and abstraction (here a study of the atmospheric conditions of a stormy sea) and a more discursive or narrative impulse, in this case to say something about the slave trade. Whether this tension is resolved, perhaps by reading the painting as a kind of visual allegory (storm standing for apocalypse, with its connotation of moral judgement), or whether the impulse to aesthetic experimentation, painterly bravura, obscures the political content of the painting, has been a source of critical disagreement for many years, and Ruskin's prose ekphrasis has merely stoked the argument. Is Ruskin's pleasure in the painting perhaps a little too uncomplicated?

'Cat having a fit in a platter of tomatoes' was the alternative title suggested by Mark Twain. 'Is the painting sublime or ridiculous?' asked William Thackeray, before deciding for the latter.[26] Ruskin's prose might well cause the same question to arise in a reader. It appears now a little 'purple' or lush, its rhythms of heaving and swelling, rising and falling, slightly too obviously mimicking the sea perhaps, or imitating Turner's own composition and brushwork. Ruskin's method of art criticism always insisted on 'seeing the picture as reality', so that what we have is a description of the painting *as if it were* what it represents, or as if the viewer were looking at a slave ship in a storm. Ruskin's language therefore seems to leapfrog the question of the painting's medium, as if it can approach the natural scene immediately and directly through what it takes to be the painting's representational transparency, and as if this immediacy and transparency can be reproduced in prose. But transparency and obscurity remain a problem. For Edmund Burke language was the medium most suited to represent the sublime since it was inherently more obscure than visual media, a claim Turner seemed to spend a lifetime refuting. Here the notion of 'obscurity' is particularly interesting. In what sense, if at all, does Ruskin's prose *represent* Turner's painting? Does it merely obscure it, or does it reproduce its obscurity? Norman Bryson has described the painting as representing 'ontological uncertainty', but this is an uncertainty that frequently emerges in the act of ekphrasis – the kind of encounter with alterity John Ashbery insisted belongs to our perception of artworks. If the passage reproduces an ontological uncertainty, it also suggests an epistemological uncertainty. What do we know of the painting from Ruskin's prose?[27] In any analysis of a verbal description that aims to be a faithful or straight transcription of visual phenomena there are complex and intractable questions of cognition and signification: how for example the words for colours – 'gold', 'crimson and scarlet', 'purple and blue' – work or

do not work to reproduce a visual sense of colour in the mind of the reader. (The vagueness of my terms indicates the problem: visual *sense* of colour in the mind of the reader.) One critic hostile to the painting on its appearance in 1840 described it as 'a freak of chromomania'.[28] Ruskin's purple prose in fact names colours ('purple' for example) that have since faded or disappeared from the picture altogether. But there they remain in Ruskin's prose, if they exist at all. And how does the word 'incarnadine' – turning something crimson or flesh-coloured – combine a memory of the violence of Macbeth with a visual sense of colour becoming apparent, *appearing* there before our eyes? *Crimsoning*. Does the spirit of the painting in some sense materialise or become fleshed out in that final verb, or does Ruskin's figure remain just that, a figure for the untranslatable materiality of the picture – the impossibility of turning oil paint into blood? Again this is the question Rossetti explored: which is flesh to the other's spirit? Is the sea itself in fact something that cannot be 'incarnadined', either by art or by writing – that finally must deny the life-giving capacity of both paint and print?

This is an *evocation* of Turner that attempts a parallel act of concentration and heightened attention, developing an equivalent density of perception. It does so with a conscious awareness of the literary and philosophical modes – Wordsworthianism, the Burkean sublime – through which Ruskin hopes Turner will be better understood. Most importantly of all it seeks to affect the reader, to create an emotional reaction, and so in this sense might seem to belong to a certain strand of Romanticism. But as with all critical observations that conclude with a discovery of emotion, and perhaps especially art-historical insights, the sense of ontological uncertainty merely deepens at this point. Are we reacting to the description of the picture, to the picture itself, or to the scene represented? And what of the pleasure that accompanies our terror, or the moral anger that shadows our pleasure? There is a high nervous pitch to Ruskin's prose that may remind us of the kind of gallery palpitation associated with the Stendhal Syndrome. But then Ruskin might argue that the power and moral gravity of Turner's painting deserve to be registered in a bodily disturbance by the viewer. In any case, when readers who had long been familiar with Ruskin's description came to see the painting for the first time, they often discovered that the emotion produced by the picture turned out to be something quite different from that produced by the prose.

Ruskin's father bought Turner's painting for his son as a New Year gift in 1844, and for twenty-eight years it hung in Ruskin's home.[29] For Turner's reputation the strenuous ardour of Ruskin's *Modern Painters* proved to be contagious. 'I believe, if I were reduced to rest Turner's immortality upon any

single work, I should chose this', Ruskin declared of the *Slave Ship*.[30] It is an
unforeseen irony that if the 'immortality' of Ruskin's own writing rests on any
single passage, then it might well be upon his description of Turner's *Slave
Ship*. The passage from *Modern Painters* became widely cited and repeated,
was frequently anthologised – William Morris used to chant the passage aloud
– and gained a kind of fame that Ruskin was later to find embarrassing.[31]
Indeed it was this fame that contributed to a general hunger among the
public (especially the American public) to see the actual picture. When it was
exhibited in Boston in 1877, *The Boston Evening Transcript* declared that the
painting had not become 'world famous' because of the genius of Turner but
rather through Ruskin himself: 'With his usual eccentricity and his infinite
dogmatism he has imposed on the world of art all that his phenomenal
imagination saw, or thought it saw, in this painting ... In the whole range
of English there is hardly a passage that compares in magnificence with
his description of the slave ship.'[32] At the Museum of Fine Arts in Boston
copies of Ruskin's prose were placed on chairs in the exhibition room in
which the painting was displayed. Thereafter his words became a part of the
general visual perception of the *Slave Ship*, not merely in the sense in which
the reception of the painting was closely influenced by Ruskin's description,
which it undoubtedly was, but in a more profound sense in which the prose
ekphrasis seemed to graft itself upon the object, so that critics hostile to the
work were often in fact hostile to what Ruskin had made them see there. A
prose description of especial potency like this is capable then of reorganising
the visual image so that we can no longer see what was there before it was
written. The process recalls the 'incessant conjunctioning between things as
they are and things imagined', which Stevens had argued was a common truth
about all acts of perception.

In the most extreme cases the relationship between painting and description
becomes almost parasitic or vampiric. The prose ekphrasis is like a ghost that
appears through the medium of the canvas. And the most vampiric of all such
relations is perhaps that between Leonardo da Vinci's *Mona Lisa* (figure 15),
and the following passage from Walter Pater's *The Renaissance*:

The presence that rose thus so strangely beside the waters, is expressive
of what in the ways of a thousand years men had come to desire.
Hers is the head upon which all 'the ends of the world are come,' and
the eyelids are a little weary. It is a beauty wrought out from within
upon the flesh, the deposit, little cell by cell, of strange thoughts and
fantastic reveries and exquisite passions. Set it for a moment beside one

of those white Greek goddesses or beautiful women of antiquity, and
how would they be troubled by this beauty, into which the soul with all
its maladies had passed! All the thoughts and experience of the world
have etched and moulded there, in that which they have of power to
refine and make expressive the outward form, the animalism of Greece,
the lust of Rome, the mysticism of the middle age with its spiritual
ambition and imaginative loves, the return of the Pagan world, the sins
of the Borgias. She is older than the rocks among which she sits; like
the vampire, she has been dead many times, and learned the secrets of
the grave; and has been a diver in deep seas, and keeps their fallen day
about her; and trafficked for strange webs with Eastern merchants: and,
as Leda, was the mother of Helen of Troy, and, as Saint Anne, the
mother of Mary; and all this has been to her but as the sound of lyres
and flutes, and lives only in the delicacy with which it has moulded
the changing lineaments, and tinged the eyelids and hands. The fancy
of a perpetual life, sweeping together ten thousand experiences, is an
old one; and modern philosophy has conceived the idea of humanity as
wrought upon, and summing up in itself, all modes of thought and life.
Certainly Lady Lisa might stand as the embodiment of the old fancy,
the symbol of the modern idea.[33]

In fact she was most probably but by no means incontrovertibly Lisa di
Antonmaria Gheradini who had married the Florentine merchant Francesco
di Bartolomeo del Giocondo, and whose portrait Leonardo began painting in
1503.[34] 'La Gioconda', as the painting is known in Italy, means 'the jocund,
playful, joking lady'.[35] Pater's essay, 'Notes on Leonardo da Vinci', first
appeared in *The Fortnightly Review* in 1869. It had absorbed and assimilated
a French (or specifically Parisian) response to Leonardo which was excited by
the mysterious, unorthodox and sexually ambivalent aspects of the master's
art, and which was part of a broader and older art-historical debate over
whether the artist had been a pious Catholic or some kind of freethinking
homosexual Faustian heretic. This response had been partly anticipated in
England by William Hazlitt, who had written in 1817 of Leonardo's tendency
to blend 'purity with voluptuousness', and who had also observed that the
expression of the women in his paintings was 'equally characteristic of "the
mistress or the saint"'.[36] In mid-century Paris that sense of ambivalence
came to focus upon the *Mona Lisa* and in particular upon her smile, or half-
smile. In 1855 Jules Michelet described the figure as a 'gracieux et souriant
fantôme', while Théophile Gautier wrote of 'cet être étrange avec son regard

15 Leonardo da Vinci, *Portrait of Mona Lisa (La Gioconda)* (1503–6) (Louvre, Paris.
Photo: Bridgeman Art Library)

qui promet des voluptués inconnues et son expression divinement ironique'.[37] Baudelaire described the smiles of Leonardo's figures as 'tout chargé de mystère', and in 1864 Gautier again spoke of 'le regard sagace, profond, velouté, plein de promesse'. Hippolyte Taine grouped the smiles of Leonardo's St Anne, St John and the Mona Lisa as 'mysterieux ... sceptiques, licencieux, épicuriens, délicieusement tendres, ardents, ou tristes'.[38] By 1861 the analogy that seemed most impossible to resist – that is, with the sphinx – had become a commonplace.[39] 'This sphinx of beauty who smiles so mysteriously', wrote Gautier, 'seems to pose a yet unsolved riddle to the admiring centuries.'[40] (Wilde would pick up on these suggestions in his poem *The Sphinx*, first published in 1894.) The *Mona Lisa* 'attracts me, revolts me, consumes me', wrote Michelet. 'I go to her in spite of myself, as the bird to the snake.'[41]

Pater's reverie draws upon this strand of French aestheticism, importing its characteristic sensitivity to mystery into English literary life and expanding and mystifying this mystery even further.[42] There are more common Victorian themes here too: Darwinian evolution ('the deposit, little cell by cell'), the new science of geology with its sense of cosmological deep time ('she is older than the rocks among which she sits'), and Victorian notions of psychological heredity (which so fascinated Wilde in *Dorian Gray*). In some ways it is untypical of Pater's writing on art, more extreme, more rarefied even than the general 'incense-laden atmosphere' of his prose; although in another sense it might be thought of as quintessential (a word Pater was fond of).[43] In this mysterious figure, then, Pater discovers 'the embodiment of the old fancy', that is the notion of a figure who has lived for centuries and in whom historical life is synthesised, human desire recorded and somehow objectified. But she is also the 'symbol of the modern idea' (indeed a central idea of modernism) that art has a mythopoeic function in relation to history.[44] This means that a portrait of a Florentine lady is taken to be a visual matrix through and out of which historical and mythical associations flow and are combined, as if these associations, suggestions and memories are radiating from the single visual centre as from an inexhaustible source. These suggestions cannot of course have been under Leonardo's conscious control, but the artist had nevertheless created, in the enigmatic beauty of a half-smiling face, a hieroglyph for a profound and irreducible knowledge.

But is there anything really there behind the smile, behind the prose? Like the painting itself there is of course something mesmerising about Pater's writing, with its stately cadences and its Latinate syntax ('in that which they have of power to refine and make expressive the outward form'). The prose itself seeks to conjure the painting, to make it materialise before our eyes:

'The presence that rose thus so strangely beside the waters ...' is self-reflexive and performative. It is impossible now to recover a sense of the original effect these sentences had upon Pater's first readers owing to the passage's own self-obscuring fame, although in this sense the description has itself acquired the 'aura' of having long been an object of contemplation, surrounded by the halo of accumulated response and commentary like that which it seeks to penetrate and understand in the *Mona Lisa*, and to which in turn, of course, it has greatly contributed. Like Ruskin's ekphrasis of the *Slave Ship* the passage quickly acquired a form of celebrity, admired by the French *symbolistes*, translated across Europe, often by other major writers – Hofmannsthal in Germany, later by Pessoa in Portugal.[45] The Italian critic and Leonardo expert Lionello Venturi, writing early in the twentieth century, described it as 'a masterpiece apart in all the history of art criticism ... The later variations of poets are obviously included in the magic circle that was traced by Pater's fancy.'[46] When W.B. Yeats edited the *Oxford Book of Modern Verse 1892–1935* (1936) he began his selection with a *vers libre* rendition of Walter Pater's fancy: 'She is older than the rocks among which she sits; / Like the Vampire, / She has been dead many times ...'

But Yeats also measured the damaging effect of the passage, which, he said, 'dominated a generation, a domination so great that all over Europe from that day to this men shrink from Leonardo's masterpiece as from an over-flattered woman'.[47] Marcel Duchamp's 1919 moustachioed version of *La Gioconda* entitled L.H.O.O.Q ('Elle a chaud au cul': 'she's hot in the arse') indicated that the moment had already come when the *Mona Lisa*'s smile – the 'insipid smile of that prim and sex-starved woman', as Somerset Maugham would put it – had ceased to enchant, or had passed into that realm of deeper enchantment that belongs to iconicity, to gallery tourism, and to the Stendhal Syndrome.[48] The very success of Pater's prose engendered similar responses to his writing, the twin reaction of hostility and homage implicit in parody, and the bemusement that obtains when prose of such obvious peculiarity and individuality seems to become a common property. Pater's criticism 'only appeals to minds so enfeebled or lazy as to be afraid of approaching a genuine work of art face to face', wrote T.S. Eliot.[49] Even more so than Ruskin on Turner, Pater's reading of the *Mona Lisa* seemed for many to obscure or spoil their sight of the painting. As Maurizio Ascari puts it, 'Pater's reading ... acquired the value of an *ur-ekphrasis*, a descriptive model that had the power to condition every subsequent interpreter'.[50] Bernard Berenson remembered the effect Pater's passage had upon him as a young man in a 1916 essay 'Leonardo':

Brought up almost exclusively on words, I easily yielded to incantation and talismanic phrases. They put me into states of body and mind not very different from those produced by hypnotic suggestion, and I should have stayed under the spell, if only I had been kept away from the object. But the presence of the object disturbed coma and prevented acquiescence. Its appeals grew and grew until finally it dared come into conflict with the powers of a shaman so potent even as Walter Pater. My eyes were unglamoured and I began to look. What an enchanted adept died in me when I ceased listening and reading and began to see and taste![51]

In this account the rivalry between word and image becomes deadly. The sense is of a prose-magic closing the eyes, putting the senses to sleep, concealing the object and replacing it instead with a fantastic reverie or spell. Pater's prose ekphrasis becomes, as J.B. Bullen writes, a 'verbal "presence", or icon ... necromantically induced by language'.[52] Through a dubious alchemy, a trick or con, it makes the object invisible and stands in its place. And yet Berenson's notion of the painting calling to him, awakening him from the unconsciousness or 'coma' induced by Pater's prose, would seem to rest on the assumption that the object in itself has a more transparent, unmediated quality, or is at least in a more innocent relation to the body of the beholder than is the prose passage. Behind this assumption again stands the myth that the visual exists in a more direct or unmediated relation to 'reality' than the verbal, and that the body, which *sees*, possesses the visual in a way that is prior to language and which thereby forestalls deception – what Roland Barthes described as the 'vague conception of the image as an area of resistance to meaning'.[53] With this painting perhaps especially it seems a false assumption, and one that might just as easily be reversed. The fact that Berenson draws upon *visual* metaphor (the talisman: a decorated charm or amulet) to describe the hypnosis of prose suggests that the principal threat of narcosis originates in the image world rather than the verbal. Is the painting any less hypnotic or narcotic than Pater's prose? Does the prose not respond to and in some way reproduce the somatic spell induced by the gaze of the Lady Lisa? Freud's essay on 'Leonardo' had picked up on Pater's suggestion that the *Mona Lisa*'s 'unfathomable smile' had since childhood been an image 'defining itself on the fabric of his [Leonardo's] dreams'. With predictable ingenuity Freud connected the smile with Leonardo's mother, and, of course, with the loss of her love. What is significant is not so much that Freud (like Pater) assumes that artworks are connected to the unconscious psychological processes of their makers but that that the artwork may be *read* by the viewer for the

signs or hieroglyphs of these processes, since they are in some sense visible. In a Freudian sense the artwork reproduces the nature of dream imagery by displaying the 'manifest content' of hidden psychic urges, imagery which needs to be decoded in order to discover a true 'latent content'. And if the surface of the visual holds the secret to the repressed psychological traumas of the maker, it is only a short step to the syndrome identified by Dr Magherini in which the viewer connects these repressed emotions with his or her own. The visual rather than the verbal is the medium through which these things are brought to the surface, are made to appear, or made to appear to appear. Where Pater differs from Freud is that he cannot give credence to a final unitary explanation based upon Leonardo's psychobiography. In Pater's reading the visual sign offers meaning far in excess of the hidden life of the maker, indeed it offers a plenitude of signs and traces that cannot be contained or exhausted by verbal commentary and which to many have merely sounded like free association. What have the sins of the Borgias, what has deep-sea diving, what has the lust of Rome, got to do with the portrait of Lisa del Giocondo? Pater's prose, with what Stephen Bann has described as its 'rich and recondite symbol cluster', attempts to enact the process whereby the visual image thwarts transparency. The description pursues what has been described as the 'surplus value' of the image, that is, in the words of W.J.T. Mitchell, the 'residue ... that goes beyond communication, signification, and persuasion'.[54] The 'glamouring' then, to adopt Berenson's verb (derived from necromancy), is a process that begins with and is inherent to the visual, as indeed it is inherent to the verbal. We are never 'unglamoured'.

'Who ... cares whether Mr. Pater has put into the portrait of Monna Lisa something that Lionardo never dreamed of?', asked Oscar Wilde's Gilbert in his dialogue *The Critic as Artist* (1890). What was more important was the very fact of criticism itself and the possibility of adding in critical writing something more to the life of the artwork (*artifex artifici additus*):

And so the picture becomes more wonderful to us than it really is, and reveals to us a secret of which, in truth, it knows nothing ... It treats the work of art simply as a starting-point for a new creation. It does not confine itself ... to discovering the real intention of the artist and accepting that as final. And in this it is right, for the meaning of any beautiful created thing is, at least, as much in the soul of him who looks at it, as it was in the soul who wrought it. Nay, it is rather the beholder who lends to the marvellous thing its myriad meanings, and makes it marvellous for us, and sets it in some new relation to the age, so that

it becomes a vital portion of our lives, and symbol of what we pray for, or perhaps of what, having prayed for, we fear that we may receive.[55]

The critical act as a 'new creation' is a stirring notion, although the dangers of this freedom are obvious: you can say what you like about a painting as long as what you say is interesting. The artwork is a mere starting point for the subjective, individual reaction of the viewer, and art criticism is, as it were, a 'wonderful' or 'marvellous' fantasy upon the artwork that will either captivate its audience or not. This, of course, is an epistemological problem that goes back to the roots of ekphrasis in Greek writing and thinking (and has obvious significance to any critical activity). Does ekphrasis add something, or subtract from its object? Does it reveal or conceal? Is it a form of amplification, or rhetorical obfuscation? Pater gives us little or no technical analysis of the painting. The historical details he provides are from Vasari and are therefore limited. As with Ruskin's reading of Turner, the painting's medium goes unnoticed and there is no attempt to describe the technique of composition. 'Leonardo obtained a captivating smile in his *Gioconda* by moulding the line of the mouth on the arc of a circle whose circumference touches the outer corners of both eyes' (Mario Praz). 'Its currently crepuscular appearance is the result of several centuries of protective varnish, tinged yellowish by oxidation ... She wears this veil of lacquer, with its thousands of tiny lesions or craquelures, and it will be a brave restorer who dares to remove the veil to see what lies beneath' (Charles Nicholl). '[We see] that miraculous subtlety of modelling, that imperceptible melting of tone into tone, plane into plane, which hardly any other painter has achieved without littleness or loss of texture' (Kenneth Clark).[56] How far removed all this seems from: 'She is older than the rocks among which she sits ...'.

In one sense then we might take Pater's figure of the vampire as an apt metaphor for the relation his prose ekphrasis has with Leonardo's painting. In a way it battens on the *Mona Lisa*'s blood, it looms *within* the canvas like a parasitic, alien body. Art historians will shun its presence. Students will be warned against it. Standing in the queues of tourists in the Louvre it may well be almost impossible not to recite to oneself, like Oscar Wilde, the prose poem of Walter Pater, but it is also impossible not to wonder, unlike Wilde, whether it matters if the presence that rises thus so predictably in our memory adds or detracts from Leonardo's masterpiece. What do we do with so-called 'creative criticism' of this kind, which departs so boldly from what have become the norms of art history, but which nevertheless remains in that direct and living relation to the art object?

It is easy to exaggerate what is at stake, or to make too much fuss over the categorical separation of criticism from creation. Standing in front of the *real thing* recently I was reminded of the television quiz show contestant who, when asked to name the famous painting by Leonardo da Vinci that shared its title with a film from the 1980s starring Bob Hoskins, offered the answer *Who Framed Roger Rabbit*.

The prose ekphrasis like the poetic attests to the impulse to reproduce the visual in verbal form, which has been the subject of this book. The notion of 'beauty' in some way prompting a duplication or reproduction of itself goes back to Plato. This is the opening paragraph of Elaine Scarry's book *On Beauty and Being Just* (1999):

> Beauty brings copies of itself into being. It makes us draw it, take photographs of it, or describe it to other people. Sometimes it gives rise to exact replication and other times to resemblances and still other times to things whose connection to the original site of inspiration is unrecognisable. A beautiful face drawn by Verrocchio suddenly glides into the perceptual field of a young boy named Leonardo. The boy copies the face, then copies the face again. Then again and again and again. He does the same thing when a beautiful living plant – a violet, a wild rose – glides into his field of vision, or a living face: he makes a first copy, a second copy, a third, a fourth, a fifth. He draws it over and over, just as Pater (who tells us this about Leonardo) replicates – now in sentences – Leonardo's acts, so that the essay reenacts its subject, becoming a sequence of faces: an angel, a Medusa, a woman and child, a Madonna, John the Baptist, St. Anne, La Gioconda. Before long the means are found to replicate, thousands of times over, both the sentences and the faces, so that traces of Pater's paragraphs and Leonardo's drawings inhabit all the pockets of the world (as pieces of them float in the paragraph now before you).[57]

Ekphrasis then is an example both of the creative act itself – through the Greek *mimesis*, imitating, copying – and of the secondary critical act of commentary, description, revelation. Indeed the verbal representation of visual representation is frequently a moment of significant creation (as Ruskin on Turner, Pater on Leonardo, and the many other examples in this book), and therefore potentially subject itself to critical commentary or appreciation, and at the same time it is a moment of criticism, a response to an art object, and

thus always open to disagreement or correction. Curiously then, the most powerful examples of ekphrasis fall into the category of aesthetic objects that may potentially be thought of as wrong. One strand of thinking after Kant has disqualified such phenomena from the aesthetic, since the aesthetic has been predicated precisely upon the feeling of something being 'right', eliciting assent, the sensation of recognition or acquiescence that may be at the core of our pleasure. Ekphrasis fractures this notion in the sense in which it is perfectly possible to believe in Pater's reading of the *Mona Lisa* whilst also believing that it is a distortion.

NOTES

1 Michael Baxandall, *Patterns of Intention: On the Historical Explanation of Pictures* (New Haven: Yale University Press, 1985), p. 10.

2 H.B. Nisbet (ed.), *German Aesthetic and Literary Criticism: Winckelmann, Lessing, Hamann, Herder, Schiller, Goethe* (Cambridge: Cambridge University Press, 1985), p. 245.

3 Walter Pater, *The Renaissance: Studies in Art and Poetry*, ed. Adam Phillips (Oxford: Oxford University Press, 1986), p. 114.

4 Donald Preziosi (ed.), *The Art of Art History: A Critical Anthology* (Oxford: Oxford University Press, 1998), p. 35.

5 *The Works of John Dryden: Poems: The Works of Virgil in English, 1697*, V, ed. William Frost and Vinton A. Dearing (Berkeley: University of California Press, 1987), p. 387.

6 Gotthold Ephraim Lessing, *Laocoön: An Essay on the Limits of Painting and Poetry*, trans. Edward Allen McCormick (Baltimore: Johns Hokpins University Press, 1962), p. 11.

7 Lessing, *Laocoön*, p. 17.

8 Lessing, *Laocoön*, p. 19.

9 The phrase comes from Germain Bazin's study *The Museum Age* (Brussels: Desoer, 1967). Bazin's chapter on the nineteenth century takes the book's title.

10 Andrew McClellan, *Inventing the Louvre: Art, Politics, and the Origins of the Modern Museum in Eighteenth Century Paris* (Cambridge: Cambridge University Press, 1994), p. 113.

11 Walter Benjamin, 'The Work of Art in the Age of Mechanical Reproduction', in *Illuminations*, trans. Harry Zorn (London: Pimlico, 1970), p. 218.

12 Pierre Bourdieu and Alain Darbel, with Dominique Schnapper, *The Love of Art: European Art Museums and their Public*, trans. Caroline Beattie and Nick Merriman (Oxford: Polity Press, 1991), p. 1.

13 The sentence appears in a short piece Hazlitt wrote for *The Morning Chronicle* in 1814, in response to a report from the Select Committee of the House of Commons on the Elgin marbles. It is published as an appendix to *The Collected*

Works of William Hazlitt, ed. A.R. Waller and Arnold Glover, 12 vols (London: J.M. Dent, 1903), IX, p. 491.

14 Cited in Niels von Holst, *Creators, Collectors and Connoisseurs: The Anatomy of Artistic Taste from Antiquity to the Present Day*, trans. Brian Battershaw (London: Thames and Hudson, 1967), p. 216.

15 Pierre Bourdieu, *The Rules of Art: Genesis and Structure of the Literary Field*, trans. Susan Emanuel (Stanford: Stanford University Press, 1996), p. 288. See also Terry Eagleton's *The Ideology of the Aesthetic* (Oxford: Blackwell, 1990).

16 Stendhal, *Oeuvres Complètes*, ed. Victor Del Litto (Paris: Cercle du Bibliophile, 1969), XIII, pp. 325–7.

17 'I call the classic the healthy and the romantic the diseased ... Most of the "new" is not romantic because it is new, but because it is weak, sickly, and ill.' Goethe's remarks appear in J.P. Eckermann's *Gespräche mit Goethe* (Wiesbaden, 1955), p. 310.

18 For a summary of the objections to the new museum culture see Jonah Siegel, *Desire and Excess: The Nineteenth Century Culture of Art* (Princeton: Princeton University Press, 2000), pp. 3–14. See also André Malraux, *The Voices of Silence*, trans. Stuart Gilbert (St Albans: Paladin, 1974).

19 Bazin, *The Museum Age*, p. 265.

20 *The Works of John Ruskin*, ed. E.T. Cook and Alexander Wedderburn, 39 vols (London: George Allen, 1903), III, pp. 571–2 (hereafter *WJR*).

21 See John McCoubrey, 'Turner's *Slave Ship*: Abolition, Ruskin, and Reception', *Word & Image*, 14:4 (1998), 319–53.

22 This is discussed by Richard Read in his essay '"A Name That Makes It Looked After": Turner, Ruskin and the Visual-Verbal Sublime', *Word & Image*, 5:4 (1989), 315–25.

23 Cited by McCoubrey, 'Turner's *Slave Ship*', 347.

24 McCoubrey, 'Turner's *Slave Ship*', 347.

25 The full title of the painting as exhibited at the Royal Academy in 1840 was: *Slaves Throwing Overboard the Dead and Dying – Typhon Coming On*. Turner's verses were as follows: 'Aloft all hands, strike the top-masts and belay; / Yon angry sun and fierce-edged clouds / Declare the Typhon's coming./ Before it sweeps your decks, throw overboard / The dead and dying – n'er heed their chains./ Hope, Hope, fallacious Hope! / Where is thy market now?'

26 Cited by McCoubrey, 'Turner's *Slave Ship*', 345.

27 Norman Bryson, 'Enhancement and Displacement in Turner', *The Huntington Library Quarterly*, 49 (1986), 49–65 (63). Elizabeth K. Helsinger asks: 'Is Ruskin writing as a prose painter or as an educator? Does he want to create a visual composition to dazzle us? Does he want to convey the beholder's experience (which becomes more than visual) in order to educate our perceptions? Both, probably. His descriptive style, translating visual effects rather than simply enumerating them, converting spatial forms into a dramatic narrative, may represent an attempt to rival painting in prose. But the description can also be

read as a demonstration that painting is accessible and comprehensible because, like more ordinary visual phenomena, it can be studied and analysed.' *Ruskin and the Art of the Beholder* (Cambridge MA: Harvard University Press, 1982), p. 22.

28 Cited by McCoubrey, 'Turner's *Slave Ship*', 345.

29 It was sold to an American in 1872. See McCoubrey, 320.

30 *WJR*, p. 572.

31 McCoubrey, 'Turner's *Slave Ship*', 347.

32 McCoubrey, 'Turner's *Slave Ship*', 348; 351.

33 Pater, *The Renaissance*, pp. 79–80.

34 See Charles Nicholl, *Leonardo da Vinci: The Flights of the Mind* (London: Penguin, 2005), pp. 361–9.

35 As Nicholl construes it: '*The Jocund* [or Playful] *Woman, The Joker Lady* – perhaps even *The Tease*' (*Leonardo da Vinci*, p. 361).

36 Hazlitt, 'On the Fine Arts', in *Complete Works of William Hazlitt*, ed. P.P. Howe (London: J.M. Dent, 1933), XVIII, p. 117.

37 Michelet is cited by Barrie Bullen in his essay 'Walter Pater's "Renaissance" and Leonardo da Vinci's Reputation in the Nineteenth Century', *Modern Language Review*, 74 (1979), 268–80 (275). Gautier's phrases are cited by J.B. Bullen in *The Myth of the Renaissance in Nineteenth Century Writing* (Oxford: Clarendon Press, 1994), p. 289.

38 Baudelaire's phrase comes from his poem 'Les Phares'; Baudelaire, Gautier and Taine are cited by Barrie Bullen, 'Walter Pater's "Renaissance"', 276–9.

39 Barrie Bullen quotes Charles Clément's description of the portrait as 'ce sphinx nouveau' ('Walter Pater's "Renaissance"', 278). Wilde's *The Sphinx* paid attention to a 'subtle-secret smile'.

40 Cited by Nicholl, *Leonardo da Vinci*, p. 368.

41 Cited by Nicholl, *Leonardo da Vinci*, p. 368.

42 Mario Praz connected Pater's portrait to the 'Fatal Women of Gautier, Flaubert, and Swinburne'. *The Romantic Agony*, trans. Angus Davidson (Oxford: Oxford University Press, 1970), p. 254. 'During the years round about 1880', Praz writes, 'it became the fashion among the *allumeuses* in certain circles in Paris to affect the enigmatic smile'. (p. 254). Praz reiterated his observations in his study *Mnemosyne: The Parallel Between Literature and the Visual Arts* (Washington: National Gallery of Art, 1970). Pater's passage 'transfers to Leonardo's portrait all the fantasies which the Gautier-Baudelaire-Flaubert-Swinburne tradition had been weaving around the fatal woman' (p. 39).

43 The phrase is from Stephen Bann, 'Walter Pater to Adrian Stokes: Psychoanalysis and Humanism', *Comparative Criticism*, 23 (2001), 201–10 (205).

44 Harold Bloom's view of Pater as the 'chief precursor' of modernism is discussed by Mihály Szegedy-Mazák in his essay 'Pater in Hungary', in Stephen Bann (ed.), *The Reception of Walter Pater in Europe* (London: Thoemmes Continuum, 2004), p. 193.

45 Bann, 'Introduction' to Bann (ed.), *The Reception of Walter Pater in Europe*, p. 13.

46 Maurizio Ascari, 'The Fortune of *The Renaissance* in Italian Art Criticism, 1894–1944', in Bann (ed.), *The Reception of Walter Pater in Europe*, p. 51.

47 *The Oxford Book of Modern Verse 1892–1935*, ed. W.B. Yeats (London: Oxford University Press, 1936), p.vii.

48 Maugham's description is from his novel *Christmas Holiday* (1939), cited by Nicholl, *Leonardo da Vinci*, p. 369.

49 Eliot's essay is discussed by René Wellek, *A History of Modern Criticism: 1750–1950: The Later Nineteenth Century* (London: Cape, 1966), pp. 381–2.

50 Ascari in Bann (ed.), *The Reception of Walter Pater in Europe*, p. 51.

51 The passage appears in Berenson's *The Study and Criticism of Italian Art* and is cited by Lene Ostermark-Johansen, 'Serpentine Rivers and Serpentine Thought: Flux and Movement in Walter Pater's Leonardo Essay', *Victorian Literature and Culture*, 30:2 (2002), 455–82 (455).

52 Bullen, *Myth* p. 296. Angela Leighton provides an interesting reading of Pater in her chapter 'Aesthetic Conditions', in Lauren Brake, Lesley Higgins, Carolyn Williams (eds), *Walter Pater: Transparencies of Desire* (University of North Carolina, Greensboro: ELT Press, 2002): 'Pater's bizarre reading of da Vinci's portrait, far from setting it apart in a museum space of untouchable preciousness, in fact takes the painting out of the gallery and loads it with unlikely contextual references … What passes through the picture is a movie of history, and of history presented as transient and relative. Pater is less concerned with the art work for art's sake than with the ways in which it might express a passing panorama of time, with all creeds, moralities and myths reduced to an egalitarian flux' (p. 16–17). Wolfgang Iser discusses the ways in which Pater's prose 'transforms the object through the act of grasping it … instead of leading the observer deeper into what the work of art represents, it subjugates the work in order to represent itself'. *Walter Pater: The Aesthetic Moment*, trans. David Henry Wilson (Cambridge: Cambridge University Press, 1987), p. 33.

53 Roland Barthes, 'Rhetoric of the Image', in *Image Music Text*, trans. Stephen Heath (London: Fontana, 1977), p. 32.

54 Bann (ed.), *The Reception of Walter Pater in Europe*, p. 203. W.J.T. Mitchell, *What Do Pictures Want? The Lives and Loves of Images* (Chicago: University of Chicago Press, 2005), p. 9.

55 Oscar Wilde, 'The Critic as Artist', in *Plays, Prose Writings and Poems* (London: Everyman, 1996), pp. 122–3.

56 Praz, *Mnemosyne*, p. 87. Nicholl, *Leonardo da Vinci*, p. 362. Kenneth Clark, *Leonardo da Vinci* (London: Penguin, 1989; new edition), p. 172.

57 Elaine Scarry, *On Beauty and Being Just* (Princeton: Princeton University Press, 1999), p. 3.

SELECT BIBLIOGRAPHY

Adams, Pat (ed.). *With a Poet's Eye: A Tate Gallery Anthology* (London: Tate Gallery, 1986)

Adorno, Theodor. *Aesthetic Theory*, trans. Robert Hullot-Kentor (London and New York: Continuum, 2002)

Aisenberg, Katy. *Ravishing Images: Ekphrasis in the Poetry and Prose of William Wordsworth, W.H. Auden and Philip Larkin* (New York: P. Lang, 1995)

Alpers, Svetlana. *The Art of Describing: Dutch Art in the Seventeenth Century* (Chicago: Chicago University Press, 1983)

Altick, Robert. *Paintings from Books: Art and Literature in Britain, 1760–1900* (Columbus: Ohio State University Press, 1985)

Altieri, Charles. *Self and Sensibility in Contemporay American Poetry* (Cambridge: Cambridge University Press, 1984)

—— *Painterly Abstraction in Modernist American Poetry: The Contemporaneity of Modernism* (Cambridge: Cambridge University Press, 1989)

Armstrong, Isobel. *The Radical Aesthetic* (Oxford: Blackwell, 2000)

Ashbery, John. *Self-Portrait in a Convex Mirror* (London: Penguin, 1976)

—— *Selected Poems* (London: Paladin, 1987)

Auden, W.H. *Collected Poems*, ed. Edward Mendelson (London: Faber, 1976)

—— *Selected Poems*, ed. Edward Mendelson (London: Faber, 1979)

—— *Prose and Travel Books in Prose and Verse: 1926–1938*, ed. Edward Mendelson (Princeton: Princeton University Press, 1996)

Auerbach, Eric. *Mimesis: The Representation of Reality in Western Literature* (Garden City, N.Y.: Doubleday Anchor, 1957)

Bann, Stephen. 'Walter Pater to Adrian Stokes: Psychoanalysis and Humanism', *Comparative Criticism*, 23 (2001), 201–10

—— (ed.). *The Reception of Walter Pater in Europe* (London: Thoemmes Continuum, 2004)

Barrell, John. *The Political Theory of Painting from Reynolds to Hazlitt: The Body of the Public* (New Haven and London: Yale University Press, 1986)

Barthes, Roland. *Image Music Text*, trans. Stephen Heath (London: Fontana, 1977)

—— *Camera Lucida* (London: Vintage, 2000)

Bate, Walter Jackson. *John Keats* (Oxford: Oxford University Press, 1963)

Baxandall, Michael. *Patterns of Intention: On the Historical Explanation of Pictures* (New Haven: Yale University Press, 1985)

Bazin, Germain. *The Museum Age* (Brussels: Desoer, 1967)

Beckett, Samuel. *Molloy, Malone Dies, The Unnameable* (London: John Calder, 1959)

—— *Proust and Three Dialogues with Georges Duthuit* (London: John Calder, 1965)

—— *Samuel Beckett: The Complete Dramatic Works* (London: Faber, 1986)

Bender, John. *Spenser and Literary Pictorialism* (Princeton: Princeton University Press, 1972)

Benjamin, Walter. *Illuminations*, trans. Harry Zorn (London: Pimlico, 1970)

Bennett, Andrew. *Keats, Narrative and Audience* (Cambridge: Cambridge University Press, 1994)

Berger, John. *Ways of Seeing* (London: BBC and Penguin, 1972)

—— *The Freedom of the Poet* (New York: Farrar, Straus & Giroux, 1976)

Bergmann, Emilie L. *Art Inscribed: An Essay on Ekphrasis in Spanish Golden Age Poetry* (Cambridge MA: Harvard University Press, 1979)

Berryman, John. *Collected Poems 1937–1971*, ed. Charles Thornbury (London: Faber, 1990)

Bloom, Harold. *Wallace Stevens: The Poems of Our Climate* (Ithaca: Cornell University Press, 1976)

Bordieu, Pierre. *The Rules of Art: Genesis and Structure of the Literary Field*, trans. Susan Emanuel (Stanford: Stanford University Press, 1996)

Bourdieu, Pierre and Alain Darbel, with Dominique Schnapper, *The Love of Art: European Art Museums and Their Public*, trans. Caroline Beattie and Nick Merriman (Oxford: Polity Press, 1991)

Braider, Christopher. *Refiguring the Real: Picture and Modernity in Word and Image 1400–1700* (Princeton: Princeton University Press, 1993)

Brake, Lauren, Lesley Higgins and Carolyn Williams (eds). *Walter Pater: Transparencies of Desire* (University of North Carolina, Greensboro: ELT Press, 2002)

Brooks, Cleanth. *The Well Wrought Urn: Studies in the Structure of Poetry* (London: Denis Dobson, 1949)

Browning, Robert. *The Complete Works of Robert Browning*, ed. Roma A. King Jnr, Morse Peckham, Park Honan and Gordon Pitts, 16 vols (Athens: Ohio University Press, 1969-)

Bryer, Jackson R. (ed.). *Fifteen Modern American Authors: A Survey of Research and Criticism* (Durham, NC: Duke University Press, 1969)

Bryson, Norman. *Vision and Painting: The Logic of the Gaze* (Basingstoke: Macmillan, 1983)

—— 'Enhancement and Displacement in Turner', *The Huntington Library Quarterly*, 49 (1986), 49–65

—— *Looking at the Overlooked* (Cambridge, MA: Harvard University Press, 1990)

Buchwald, Emile and Ruth Roston (eds). *The Poet Dreaming in the Artist's House* (Minneapolis: Milkweed Editions, 1984)

Bucknell, Katherine and Nicholas Jenkins (eds). *W.H.Auden: 'The Language of Learning and the Language of Love'* (Oxford: Clarendon Press, 1994)

Bullen, J.B. *The Myth of the Renaissance in Nineteenth Century Writing* (Oxford: Clarendon Press, 1994)

—— *The Pre-Raphaelite Body: Fear and Desire in Painting, Poetry, and Criticism* (Oxford: Clarendon Press, 1998)

Carrier, David. 'Ekphrasis and Interpretation: Two Modes of Art History Writing', *British Journal of Aesthetics*, 27:1 (1987), 20–31

—— *Writing about Visual Art* (New York: Allworth Press, 2003)

Carroll, Lewis. *Lewis Carroll: The Complete Works* (London: CRW Publishing, 2005)

Carroll, Noël. *Philosophy of Art: A Contemporary Introduction* (London and New York: Routledge, 1999)

Clark, Michael P. *Revenge of the Aesthetic: The Place of Literature in Theory Today* (London: University of California Press, 2000)

Clegg, Christine (ed.). *Vladimir Nabokov: A Reader's Guide to Essential Criticism* (Cambridge: Icon Books, 2000)

Clements, Robert J. 'Brueghel's *Fall of Icarus*: Eighteen Modern Literary Readings', *Studies in Iconography*, 7–8 (1981–82), 253–68

Cook, Albert. *Figural Choice in Poetry and Art* (Hanover: University Press of New England, 1985)

Coombes, John E. 'Constructing the Icarus Myth: Brueghel, Brecht, and Auden', *Word & Image*, 2 (1986), 24–6

Cunningham, Valentine (ed.). *The Victorians: An Anthology of Poetry and Poetics* (Oxford: Blackwell, 2000)

Danto, Arthur C. *The Transfiguration of the Commonplace* (Cambridge MA: Harvard University Press, 1981)

—— *The Abuse of Beauty: Aesthetics and the Concept of Art* (Chicago: Open Court, 2003)

Davidson, Michael. 'Ekphrasis and the Postmodern Painter Poem', *Journal of Aesthetics and Art Criticism*, 42 (1983), 69–89

DeLillo, Don. *White Noise* (New York: Viking, 1984)

—— *Americana* (London: Penguin, 1990)

—— *Mao II* (London: Vintage, 1991)

Derrida, Jacques. *The Truth in Painting*, trans. Geoff Bennington and Ian Mcleod (Chicago: Chicago University Press, 1987)

Dobbs, Brian and Judy. *Dante Gabriel Rossetti: An Alien Victorian* (London: Macdonald and Jane's, 1977)

Doughty, Oswald. *A Victorian Romantic: Dante Gabriel Rossetti* (Oxford: Oxford University Press, 1957)

Doyle, Charles (ed.). *Wallace Stevens: The Critical Heritage* (London: Routledge, 1985)

Dryden, John. *The Works of John Dryden*, ed. E.N. Hooker, H.T. Swedenberg Jr et al., 20 vols (Berkeley: University of California Press, 1956–2000)

Eagleton, Terry. *The Ideology of the Aesthetic* (Oxford: Blackwell, 1990)

Edelman, Lee. 'The Pose of Imposture; Ashbery's "Self-Portrait in a Convex Mirror"', *Twentieth Century Literature*, 32:1 (Spring 1986), 95–113

Eliot, Alistair (ed.). *Virgil: The Georgics, with John Dryden's Translation* (Ashington: Mid Northumberland Arts Group, 1981)

Eliot, T.S. *Selected Essays* (London: Faber, 1964)

—— *The Complete Poems and Plays of T.S. Eliot* (London: Faber, 1969)

Emig, Rainer. *W.H. Auden: Towards a Postmodern Poetics* (Basingstoke: Palgrave-Macmillan, 2000)

Empson, William. 'Rhythm and Imagery in English Poetry', *The British Journal of Aesthetics*, 2:1 (January 1962), 36–54

—— *The Structure of Complex Words* (London: Chatto & Windus, 1969)

Esrock, Ellen J. *The Reader's Eye: Visual Imaging as Reader Response* (Baltimore: Johns Hopkins University Press, 1994)

Foucault, Michel. *Ceci n'est pas une pipe* (1973), trans. James Harkness (Berkeley: University of California Press, 1982)

Fowler, Alastair. *Renaissance Realism: Narrative Images in Literature and Art* (Oxford: Oxford University Press, 2003)

——*The Order of Things: An Archaeology of the Human Sciences* (London and New York: Routledge, 2004)

Frazer, Roy. 'The Origin of the Term *Image*', *English Literary History*, 27 (1960), 149–62

Freedberg, David. *The Power of Images: Studies in the History and Theory of Response* (Chicago: University of Chicago Press, 1989)

Friday, Jonathan. *Aesthetics and Photography* (Aldershot: Ashgate, 2002)

Fry, Paul H. *A Defense of Poetry: Reflections on the Occasion of Writing* (Stanford: Stanford University Press, 1995)

Furbank, P.N. *Reflections on the Word 'Image'* (London: Secker and Warburg, 1970)

Gaut, Berys and Dominic McIver Lopes (eds). *The Routledge Companion to Aesthetics* (London and New York: Routledge, 2001)

Gelpi, Albert (ed.). *Wallace Stevens: The Poetics of Modernism* (Cambridge: Cambridge University Press, 1985)

Golahny, Amy (ed.). *The Eye of the Poet: Studies in the Reciprocity of the Visual and Literary Arts from the Renaissance to the Present* (Lewisburg: Bucknell University Press, 1996)

Gombrich, E.H. *Symbolic Images: Studies in the Art of the Renaissance* (London: Phaidon, 1972)

—— 'The Visual Image', *Scientific American*, 227 (September 1972), 82–96

—— *Art and Illusion*, 6th edition (London: Phaidon, 2002)

Gunn, Thom. *Collected Poems* (London: Faber, 1993)

Hagstrum, Jean. *The Sister Arts: The Tradition of Literary Pictorialism and English Poetry from Dryden to Gray* (Chicago: University of Chicago Press, 1958)

Hazlitt, William. *The Collected Works of William Hazlitt*, ed. A.R. Waller and Arnold Glover, 12 vols (London: J.M. Dent, 1903)

Heffernan, James. 'Space and Time in Literature and the Visual Arts', *Soundings*, 70 (1987), 95–119

—— 'Ekphrasis and Representation', *New Literary History*, 22 (Spring 1991)

—— *Museum of Words: The Poetry of Ekphrasis from Homer to Ashbery* (Chicago: University of Chicago Press, 1993)

—— *Cultivating Picturacy: Visual Art and Verbal Interventions* (Waco, TX: Baylor University Press, 2006)

Heidegger, Martin. 'The Origin of the Work of Art', in *Poetry, Language, Thought*, trans. Albert Hofstadter (New York: Harper and Row, 1971)

Helsinger, Elizabeth K. *Ruskin and the Art of the Beholder* (Cambridge MA: Harvard University Press, 1982)

Henricksen, Bruce (ed.). *Murray Krieger and Contemporary Critical Theory* (New York: Columbia University Press, 1986)

Herd, David. *John Ashbery and American Poetry* (Manchester: Manchester University Press, 2000)

Hillis-Miller, J. 'The Mirror's Secret: Dante Gabriel Rossetti's Double Work of Art', *Victorian Poetry*, 29:4 (1991), 333–49

Hollander, John. 'Words on Pictures', *Art and Antiques*, 1:1 (1984), 80–91

—— 'The Poetics of Ekphrasis', *Word & Image*, 4:1 (1988), 209–19

—— 'The Gazer's Spirit: Romantic and Later Poetry on Painting and Sculpture', in *The Romantics and Us: Essays on Literature and Culture*, Gene W. Ruoff ed. (New Brunswick and London: Rutgers University Press, 1990), pp. 130–67

—— *The Gazer's Spirit: Poems Speaking to Silent Works of Art* (Chicago: University of Chicago Press, 1995)

Holst, Niels von. *Creators, Collectors and Connoisseurs: The Anatomy of Artistic Taste from Antiquity to the Present Day*, trans. Brian Battershaw (London: Thames and Hudson, 1967)

Hughes, Ted. *Birthday Letters* (London: Faber, 1998)

Hunter, Jefferson. *Image and Word: The Interaction of Twentieth-Century Photographs and Texts* (Cambridge MA: Harvard University Press, 1987)

Iser, Wolfgang. *Walter Pater: The Aesthetic Moment*, trans. David Henry Wilson (Cambridge: Cambridge University Press, 1987)

Jack, Ian. *Keats and the Mirror of Art* (Oxford: Oxford University Press, 1967)

Jarrell, Randall. *Randall Jarrell: The Complete Poems* (New York: Farrar, Straus and Giroux, 2000)

Johnson, Richard. *Man's Place: An Essay on Auden* (Ithaca: Cornell University Press, 1973)

Kalstone, David. *Five Temperaments* (New York: Oxford University Press, 1977)

Kant, Immanuel. *Critique of Judgment*, trans. J.H. Bernard (London: Macmillan, 1951)

Kaufman, Robert. 'Negatively Capable Dialectics: Keats, Vendler, Adorno, and the Theory of the Avant-Garde', *Critical Inquiry*, 27 (Winter 2001), 354–84

Keane, Robert. *Dante Gabriel Rossetti: The Poet as Craftsman* (New York: Peter Lang, 2002)

Keats, John. *Letters of John Keats*, ed. Robert Gittings (Oxford: Oxford University Press, 1970)

—— *John Keats: Selected Poetry*, ed. Nick Roe (London: Everyman, 1995)

Kenner, Hugh. *The Pound Era* (Berkeley: University of California Press, 1971)

Kermode, Frank. *Wallace Stevens* (Edinburgh: Oliver and Boyd, 1960)

Krieger, Murray. 'Ekphrasis and the Still Movement of Poetry; or, Laokoön Revisited', in Frederick McDowell, ed., *The Poet as Critic* (Evanston: Northwestern Press, 1967), pp. 3–25

—— *Ekphrasis: The Illusion of the Natural Sign* (Baltimore: Johns Hopkins University Press, 1992)

Larkin, Philip. *Collected Poems*, ed. Anthony Thwaite (London: Faber, 1988)

Lee, Rensselaer W. *Ut Pictura Poesis: The Humanistic Theory of Painting* (New York: Norton, 1967)

Lessing, Gotthold Ephraim. *Laocoön: An Essay on the Limits of Painting and Poetry*, trans. Edward Allen McCormick (Baltimore and London: Johns Hopkins University Press, 1962)

Levinson, Jerrold (ed.). *The Oxford Handbook of Aesthetics* (Oxford: Oxford University Press, 2003)

Levinson, Marjorie. *Keats's Life of Allegory: The Origins of a Style* (Oxford: Oxford University Press, 1988)

Longley, Edna. 'No More Poems about Paintings?', in *The Living Stream: Literature & Revisionism in Ireland* (Newcastle: Bloodaxe, 1994)

McClellan, Andrew. *Inventing the Louvre: Art, Politics, and the Origins of the Modern Museum in Eighteenth Century Paris* (Cambridge: Cambridge University Press, 1994)

McCorkle, James. *The Still Performance: Writing, Self, and Interconnection in Five Postmodern American Poets* (Charlottesville: University of Virginia Press, 1989)

McCoubrey, John. 'Turner's *Slave Ship*: Abolition, Ruskin, and Reception', *Word & Image*, 14:4 (1998), 319–53

McGann, Jerome J. *Dante Gabriel Rossetti and the Game that Must Be Lost* (New Haven: Yale University Press, 2000)

Maclagan, David. *Psychological Aesthetics: Painting, Feeling and Making Sense* (London: Jessica Kingsley, 2001)

Mahon, Derek. *Derek Mahon: Selected Poems* (London: Penguin, 1990)

Marani, Pietro C. *Leonardo da Vinci: The Complete Paintings*, trans. A. Laurence Jenkens (New York: Harry N. Abrams, 2003)

Markiewicz, Henryk. 'Ut Pictura Poesis: A History of the Topos and the Problem', *New Literary History*, 18 (Spring 1987), 535–58

Marshall, David. *The Frame of Art: Fictions of Aesthetic Experience, 1750–1815* (Baltimore and London: Johns Hopkins University Press, 2005)

Meisel, Martin. *Realizations: Narrative, Pictorial, and Theatrical Arts in Nineteenth Century England* (Princeton, NJ: Princeton University Press, 1983)

Meltzer, Françoise. *Salome and the Dance of Writing: Portraits of Mimesis in Literature* (Chicago: Chicago University Press, 1987)

Mitchell, W.J.T. (ed.). *The Language of Images* (Chicago: Chicago University Press, 1980)

—— *Iconology: Image, Text, Ideology* (Chicago: University of Chicago Press, 1986)

—— 'Ekphrasis and the Other', *South Atlantic Quarterly*, 19:3 (Summer 1992), 695–720

—— *Picture Theory: Essays on Verbal and Visual Representation* (Chicago: University of Chicago Press, 1994)

—— *What Do Pictures Want? The Lives and Loves of Images* (Chicago: University of Chicago Press, 2005)

Nabokov, Vladimir. *Lectures on Literature*, ed. Fredson Bowers (New York: Harcourt Brace Jovanovich, 1980)

—— *Lolita*, ed. Alfred Appel Jr (London: Penguin, 1995)

Newhall, Beaumont. *The History of Photography* (New York: Museum of Modern Art, 1982)

Nicholl, Charles. *Leonardo da Vinci: The Flights of the Mind* (London: Penguin, 2005)

Nisbet, H.B. (ed.) *German Aesthetic Literary Criticism: Winckelmann, Lessing, Hamann, Herder, Schiller, Goethe* (Cambridge: Cambridge University Press, 1985)

Osborne, Peter (ed.). *From an Aesthetic Point of View: Philosophy, Art and the Senses* (London: Serpent's Tail, 2000)

Ostermark-Johansen, Lene. 'Serpentine Rivers and Serpentine Thought: Flux and Movement in Walter Pater's Leonardo Essay', *Victorian Literature and Culture*, 30:2 (2002), 455–82

Ovid. *Metamorphoses, Translated by Arthur Golding* (London: Penguin, 2002)

Park, Roy. '"Ut Pictura Poesis": The Nineteenth Century Aftermath', *Journal of Aesthetics and Art Criticism*, 28 (1969), 155–64

Pater, Walter. *Appreciations* (London: Macmillan, 1890)

—— *The Renaissance: Studies in Art and Poetry*, ed. Adam Philips (Oxford: Oxford University Press, 1986)

Philipson, Morris (ed.). *Aldous Huxley: On Art and Artists* (London: Chatto and Windus, 1960)

Phinney, A.W. 'Keats in the Museum: Between Aesthetics and History', *Journal of English and Germanic Philology*, 90 (1991), 208–29

Praz, Mario. *Mnemosyne: The Parallel Between Literature and the Visual Arts* (Washington: National Gallery of Art, 1970)

—— *The Romantic Agony*, trans. Angus Davidson (Oxford: Oxford University Press, 1970)

Prettejohn, Elizabeth. *Rossetti and His Circle* (London: Tate Gallery, 1997)

—— *Beauty & Art* (Oxford: Oxford University Press, 2005)

Preziosi, Donald (ed.). *The Art of Art History: A Critical Anthology* (Oxford: Oxford University Press, 1998)

Read, Richard. '"A Name That Makes It Looked After": Turner, Ruskin and the Visual-Verbal Sublime', *Word & Image*, 5:4 (1989), 315–25

Richards, I.A. *Practical Criticism: A Study of Literary Judgement* (London: Kegan Paul, 1929)

Rogers, I.A. Franklin. *Painting and Poetry: Form, Metaphor, and the Language of Literature* (Lewisburg: Bucknell University Press, 1986)

Rorty, Richard. *Philosophy and the Mirror of Nature* (Princeton: Princeton University Press, 1979)

—— *Contingency, Irony, and Solidarity* (Cambridge: Cambridge University Press, 1989)

Ross, Andrew. *The Failure of Modernism: Symptoms of American Poetry* (New York: Columbia University Press, 1986)

Rossetti, Dante Gabriel. *The Collected Works of Dante Gabriel Rossetti*, ed. William Rossetti, 2 vols (London: Ellis and Scruton, 1886)

Ruskin, John. *The Works of John Ruskin*, ed. E.T. Cook and Alexander Wedderburn, 39 vols (London: George Allen, 1903)

Sallé, Jean-Claude. 'The Pious Frauds of Art: A Reading of the "Ode on a Grecian Urn"', *Studies in Romanticism*, 11 (1972), 79–93

Scarry, Elaine. *On Beauty and Being Just* (Princeton: Princeton University Press, 1999)

Scott, David. *Pictorialist Poetics* (Cambridge: Cambridge University Press, 1988)

Scott, Grant F. 'The Rhetoric of Dilation: Ekphrasis and Ideology', *Word & Image*, 7:4 (October–December 1991), 301–10

Scruton, Roger. *The Aesthetic Understanding: Essays in the Philosophy of Art and Culture* (Manchester: Carcanet, 1983)

Sheppard, Anne. *Aesthetics: An Introduction to the Philosophy of Art* (Oxford: Oxford University Press, 1987)

Shoptaw, John. *On The Outside Looking Out: John Ashbery's Poetry* (Cambridge, MA: Harvard University Press, 1994)

Siegel, Jonah. *Desire and Excess: The Nineteenth Century Culture of Art* (Princeton: Princeton University Press, 2000)

Simpson, David. *Irony and Authority in Romantic Poetry* (Totowa, NJ: Rowman and Littlefield, 1979)

Smith, Lindsay. *Victorian Photography, Painting and Poetry: The Enigma of Visibility in Ruskin, Morris and the Pre-Raphaelites* (Cambridge: Cambridge University Press, 1995)

Smith, Mack. *Literary Realism and the Ekphrastic Tradition* (Pennsylvania: Pennsylvania State University Press, 1995)

Sontag, Susan. *On Photography* (London: Penguin, 1971)

—— *Regarding the Pain of Others* (London: Penguin, 2004)

Sperry, Stuart M. *Keats the Poet* (Princeton: Princeton University Press, 1973)

Spiegelman, Willard. *How Poets See The World: The Art of Description in Contemporary Poetry* (Oxford: Oxford University Press, 2005)

Spitzer, Leo. *Essays on English and American Literature* (Princeton: Princeton University Press, 1962)

Staller, Natasha. *A Sum of Destructions: Picasso's Cultures & The Creation of Cubism* (New Haven: Yale University Press, 2001)

Stamelman, Richard. 'Critical Reflections: Poetry and Art Criticism in Ashbery's "Self-Portrait in a Convex Mirror"', *New Literary History*, 15 (1983)

Stein, Richard L. *The Ritual of Interpretation: The Fine Arts as Literature in Ruskin, Rossetti, and Pater* (Cambridge, MA: Harvard University Press, 1975)

Steiner, Wendy. *The Colors of Rhetoric: Problems in the Relation between Modern Literature and Painting* (Chicago: University of Chicago Press, 1982)

——*Pictures of Romance: Form Against Context in Painting and Literature* (Chicago: University of Chicago Press, 1988)

Stevens, Wallace. *Wallace Stevens: Collected Poems* (London: Faber, 1984)

Stendhal, Marie Henri Bayle. *Oeuvres Complètes*, ed. Victor Del Litto (Paris: Cercle du Bibliophile, 1969)

Stillinger, Jack. *The Texts of Keats's Poems* (Cambridge, MA: Harvard University Press, 1974)

Treuherz, Julian, Elizabeth Prettejohn and Edwin Becker (eds). *Dante Gabriel Rossetti* (London: Thames and Hudson, 2003)

Vasari, Giorgio. *Lives of the Artists*, trans. George Bull (London: Penguin, 1987)

Vendler, Helen. *On Extended Wings: Wallace Stevens' Longer Poems* (Cambridge MA: Harvard University Press, 1969)

—— *The Odes of John Keats* (Cambridge, MA: Harvard University Press, 1983)

Ward, Geoff. *Statutes of Liberty: The New York School of Poets* (Basingstoke: Palgrave, 2003)

Waugh, Evelyn. *Rossetti: His Life and Works* (London: Duckworth, 1928)

Weisstein, Ulrich. 'Comparing Literature and Art', in Zoran Konstantinovic, Steven P. Scher and Ulrich Weisstein (eds), *Literature and the Other Arts* (Innsbruck: Inst. für Sprachwiss. D. Univ., 1981)

Wellek, René. *A History of Modern Criticism: 1750–1950: The Later Nineteenth Century* (London: Cape, 1966)

Wilde, Oscar. *Plays, Prose Writings and Poems*, ed. Anthony Fothergill (London: Everyman, 1996)

—— *The Picture of Dorian Gray*, ed. Robert Mighall (London: Penguin, 2000)

Williams, Susan. *Confounding Images: Photography and Portraiture in Antebellum American Fiction* (Philadelphia: University of Pennsylvania Press, 1997)

Williams, William Carlos. *Collected Poems*, ed. Christopher MacGowan, 2 vols (Manchester: Carcanet, 2000)

Wilson, Douglas. 'Reading the Urn: Death in Keats's Arcadia', *Studies in English Literature, 1500–1900*, 25:4 (Autumn 1985), 823–44

Wilton, Andrew and Robert Upstone (eds). *The Age of Rossetti, Burne-Jones & Watts: Symbolism in Britain 1860–1910* (London: Tate Gallery Publishing, 1997)

Wimsatt, W.K. *The Verbal Icon: Studies in the Meaning of Poetry* (Kentucky: University of Kentucky Press, 1954)

Wolf, Bryan. 'Confessions of a Closet Ekphrastic', *Yale Journal of Criticism*, 3:3 (1990), 181–200

Wolfson, Susan J. *The Questioning Presence: Wordsworth, Keats, and the Interrogative Mode in Romantic Poetry* (Ithaca: Cornell University Press, 1986)

INDEX

Note: 'n.' after a page number indicates the number of a note on that page. Page numbers in *italic* refer to illustrations.

Lightning Source UK Ltd.
Milton Keynes UK
UKHW021354030222
398155UK00013B/83